THE 12-HOUR ART EXPERT

THE 12-HOUR ART EXPERT

Everything You Need to Know about Art in a Dozen Masterpieces

NOAH CHARNEY

ROWMAN & LITTLEFIELD
Lanham • Boulder • New York • London

Published by Rowman & Littlefield
An imprint of The Rowman & Littlefield Publishing Group, Inc.
4501 Forbes Boulevard, Suite 200, Lanham, Maryland 20706
www.rowman.com

86-90 Paul Street, London EC2A 4NE

British Library Cataloguing in Publication Information Available

Library of Congress Cataloging-in-Publication Data

Names: Charney, Noah, author.
Title: The 12-hour art expert : everything you need to know about art in a dozen masterpieces / Noah Charney.
Description: Lanham : Rowman & Littlefield, [2022] | Includes bibliographical references and index. | Summary: "His novel, The Art Thief, was a bestseller in five countries and is translated into 17 languages. His The Art of Forgery, Stealing the Mystic Lamb and Slovenology were international bestsellers. His book Collector of Lives: Giorgio Vasari and the Invention of Art was nominated for the Pulitzer Prize. Charney is now a professor at University of Ljubljana in Slovenia, where Charney has lived for many years"— Provided by publisher.
Identifiers: LCCN 2021053596 (print) | LCCN 2021053597 (ebook) | ISBN 9781538156599 (cloth) | ISBN 9781538156605 (epub)
Subjects: LCSH: Art appreciation.
Classification: LCC N7477 .C43 2022 (print) | LCC N7477 (ebook) | DDC 701/.18—dc23/eng/20211231
LC record available at https://lccn.loc.gov/2021053596
LC ebook record available at https://lccn.loc.gov/2021053597

Contents

To my mother and father, the rarest sort of professors who actually love teaching. Thank you for supporting me endlessly.

List of Artworks

Acknowledgments

Books are collaborative projects. The author is the architect, bricklayer, and carpenter, but there are all manner of tradesmen involved throughout, helping to improve the finished product. I'm grateful to the team at Rowman & Littlefield for entrusting me with this, our third book together.

Charles Harmon is a wonderfully supportive editor and Erinn Slanina has ably assisted on all three. The promotional team and the external publicists at Pubvendo have been a pleasure to work with. Thanks, as always, to my intrepid agent, Yishai Seidman. To my art history teachers who shaped my love for the field: Veronique Plesch, Michael Marlais, David Simon, Sheila McTighe, and Madame Poupard, who took me throughout Paris when I was living there as a cow-eyed sixteen-year-old. Thanks also to Refik Anadol and Tom Ross, as well as to the Gagosian Gallery, JAŠA, and Meta Grgurevič, for generously allowing us to use their images. I must thank all my students, from young teens to octogenarians, who have taught me how to teach in a way that didn't feel like anyone was learning (for those for whom the term does not inspire affection).

Let's smash the intimidation that glasses in art.
This book is your hammer.

Art Is for All

Key Work: *Fayum Mummy Portrait* (circa third century CE)

ART HAS AN INTIMIDATION PROBLEM. IT ALSO HAS AN ELITISM PROBLEM, and these two elements are linked.

There are too many people who feel that art is not *for* them, that they won't "get it" and therefore do not want to try, even if they think they might like it. And there are certain communities within the art world that seem to enjoy the sense that art is a private club, that not everyone is invited.

What a silly idea.

I am a proponent of making art feel accessible to anyone who is willing to meet it halfway—to give it a little bit of attention, to be open-minded and not dismissive. The dismissive approach (i.e., "I don't like modern art because *I* could do it") is usually borne of fear of not understanding (and feeling diminished because of this).

There's no need. Art has endless levels of study and understanding, but a broad and quite deep basic "white belt" in art is not hard to achieve. I have heard powerful insights from people without any degrees at all and I've heard hot air and nothingness from bow-tied gents with PhDs. You do not need extensive training to understand art, much less to enjoy it. Consider the art critic Jerry Saltz. He is one of my favorites to read, he offers brilliant insights, and he is almost entirely self-trained, having turned to art criticism with a background in art handling (he worked for an art delivery service).

I am stridently antielitist. One of the reasons I can get away with this stance is that I come from within the club. I've studied at fancy institutions, I have a PhD and a pair of master's degrees, I spent time working at museums and auction houses, and I've taught at top universities. But I've never been interested in speaking to a closed group of peers who are often so

busy with infighting that they wind up typing (or sometimes shouting) into an echo chamber, just bouncing ideas, arguments, and jealousies off one another in a grumpy game of badminton played on a court paved with pages of peer-reviewed academic journals. This is of no interest to me.

That's why I write for popular magazines and newspapers, publish best-selling books, and host TV programs. I feel more like I've succeeded if the taxi driver taking me to my talk at the National Gallery is familiar with my work than I would with the professor who is about to host me there. My goal is to make art as accessible, understandable, enjoyable, and intriguing as possible for as many people as are willing to be open-minded and consider engaging with it.

This is the goal of the book in your hands, with its intentionally reductionist title and subtitle. Of course you won't become a true expert in just twelve hours or by reading any one book. But the leap you will feel between the first page and the last will be the most exten-

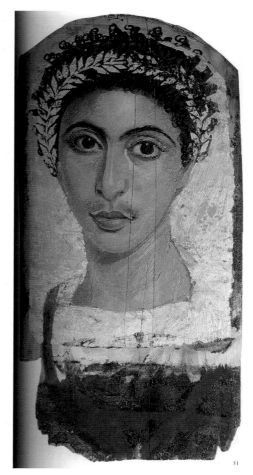

This is one of a number of strikingly naturalistic painted portraits accompanying mummies found in the Hellenistic city of Antinoopolis in what is today Egypt, made circa the first century CE. This gentleman looks as though tonight he's gonna party like it's 1999.
PHOTO COURTESY OF WIKIART BY ELOQUENCE.

sive jump possible, the one that brings the most satisfaction and a feeling of empowerment that you can and do understand a world that, before you began reading, felt complex and intimidating. I have taught art history at every level, from high school students to postgraduates and even fellow professors. My favorite age group to teach is the youngest one, because the leap in knowledge, from right around zero to cruising speed—the feeling

that, yes, you *can* do this; you can understand and fully enjoy art—is the most palpable and significant. They key is tearing down the ramparts of intimidation, lifting portcullises of jargon—of long words in foreign languages, of endless -*isms*—and making even the complicated ideas feel clear, simple, and accessible. Doing this successfully is the mark of a good teacher and a good writer.

This intro level to covering all the basics is as useful for young readers as it is for adults. It is designed to be *the* book you should read if you are only going to ever read one book about art. But you could also think of it as a benevolent gateway drug, a concise wardrobe through which you walk, passing into the magical, wondrous world that is art.

The format is intentionally streamlined. Twelve chapters are built around a big idea and a famous masterpiece—the sort you'll find in Art History 101 books, the art you really should know and that offers a useful point of reference. I mention many other works along the way, but this isn't meant to be a lavishly illustrated book. There are two chapters covering art history that include a flurry of artworks, and any that are not reproduced in this book are just a quick internet search away. I will reference other works as we go, but the core is reduced to an easily digestible, easy-to-remember ore of beauty and information.

Reductionism is an established approach by scientists: You take a giant problem that feels impossible to solve and either slice it into bite-sized pieces, each one of which feels manageable, and thus slowly work your way to solving the entirety, or you boil down the big problem into the most basic possible form that feels easier to handle. Nobel Prize winner (and occasional art historian) Dr. Eric Kandel unlocked the secrets of how the human brain works by using a reductionistic approach. The human brain is vastly complex, so he focused his studies instead on a brain that is physically as large as possible yet as uncomplex as possible. He settled on the brains of giant sea snails. These proved much easier to analyze, and the information gleaned was applicable to human brains—and led to a Nobel Prize. (He also authored a book called *Reductionism in Art and Brain Science*, which we'll visit in chapter 9.) That's an example of boiling down the big problem into one you can reasonably tackle. We'll use that approach in this book with each individual "big idea." How can we understand Surrealism, for instance? By taking that sprawling concept, home to hundreds of artists and tens of thousands of works, and home in on just two (one famous and one that should be more famous), pulling out just a few key takeaways that will firm our grip on the big idea. We'll also employ the former approach, cutting the big issue into bite-sized pieces. Want to know about art? No problem. I've sliced that marvelous cake into twelve pieces. Consume one at a time, and

before you know it, the cake of art knowledge will be within you. (I promise to work on the analogies as we go.)

Reading this book should take you less than twelve hours (average reading speed for adults is two hundred words per minute, so this book should actually take you around four and a half hours—there, you already learned the first of many fun facts). If you have extra time, you can spend it visiting museums (in person or virtually) and putting your new knowledge to the test. Imagine a situation in which you are suddenly transported to a museum, anywhere in the world, without knowing which one, and asked to speak thoughtfully about the art you see around you. After reading this book, you will feel empowered to do so. You will also absolutely rock cocktail parties, dinner soirees, and gallery openings.

Consider, for starters, the key work in this chapter. It's a striking portrait that looks so realistic we might think it is modern. It looks a lot like the musician Prince, doesn't it? So is it circa 1999 (as in "Tonight we're gonna party like it's . . .")? *Au contraire, mon frère,* as the French say. This is a portrait of a deceased, mummified gentleman who likely died in the first century CE. He was an ancient Egyptian who lived under the Roman rule of Egypt near the Faiyum oasis, south of Cairo, among the ruins of a city called Antinoopolis. The reason I include it to kick off our journey together is to invert the cliché of art history beginning with the oldest possible work, inevitably something abstract, like a cave painting or a pre-Columbian statue or a prehistoric fertility statue (all of which we'll cover). The idea that art moved smoothly from abstract work that didn't look realistic, due to the inability of artists to make something that looks like the real thing, and eventually got to a level of realism is incorrect. Let's blow that one up right from the start. This gilded portrait could be by Gustav Klimt or it could be a picture from the album notes of *Purple Rain.* Abstraction is most often an artistic decision, not a sign of inability. Let the clichés fall!

This is the book you need to kick-start your love and knowledge of art.

Now, to begin: what the heck *is* art, anyway?

Is It Even Art?

Defining Art and the Human Need for Creativity

Key Work: Marcel Duchamp, *Fountain* (1917)

PICTURE THIS: YOU AND A FRIEND BUY A RICKETY WOODEN BOAT IN FRANCE and patch it together. You sail it together to a Scottish island 733 kilometers away. You film the journey. When you arrive, you dismantle the boat and use the wood to make a barrel. The barrel is filled with top-of-the-line Scottish whiskey. The whiskey ages in the barrel, which has been kissed by ocean spray and salty winds. The flavor of your voyage infuses the whiskey. You produce 733 bottles of it. The journey footage becomes a documentary film. The photos you took, sketches you made, and your story all become a book. You've just completed a work of art.

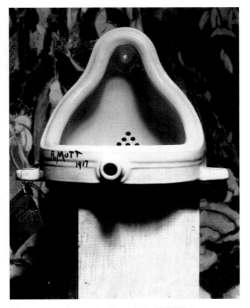

Marcel Duchamp's *Fountain* (1917) is one of the most iconic, and iconoclastic, artworks ever made. Or, rather, bought, turned on its side, signed, and presented as art.

PHOTO COURTESY OF WIKICOMMONS BY REMITAMINE.

When I heard this, I wanted to sign up to be a contemporary artist. It sounded like the sort of thing two buddies would do for fun. What, then, makes it a work of art? And is it conceptual or a performance or something else entirely? I'm an art history professor, so I suppose I should know these things. But I grew up studying long-dead white

European men who painted and sculpted art that looked like its subject. This is a bold new world for me, but one I'm open to—if, that is, the work is good. And beautiful. And interesting. For me, the aforementioned journey-as-performance-artwork, *Hogshead 733* (2015–2020), by Mark Požlep and Maxime Berthouis, is brilliant. I'll get to why I think that later. But first, how do I separate it from the, well, less-than-brilliant nonsense?

I'll say it straight up: I don't like most concept-based contemporary art. Most of it I find silly, self-indulgent, and pretentious. But I'm intrigued by it. It's a multibillion-dollar industry. It is full of rock-star personalities and lifestyles. It is hard work. It confuses people. And it *is* art. Why it can be considered such is a complex and interesting question.

In 1917, Cubist painter Marcel Duchamp (possibly inspired by a friend and fellow artist with a wonderful name, Baroness Elsa von Freytag-Loringhoven) bought a urinal from a factory, turned it on its side, added the signature of an invented artist (R. Mutt), and claimed he'd discovered an ingenious new sculpture. He was at first dismissed, but eventually he had the last laugh. The work, called *Fountain*, was a revolutionary touchstone in the art world and became the most influential sculpture of the twentieth century. It also caused art to split in two distinct directions.

We're Already Name-Dropping Aristotle?

Prior to *Fountain*, art had to fulfill three criteria that were originally described by Aristotle more than two millennia earlier: Art had to be good (meaning that it was the fruit of a skillful hand), it had to be beautiful (aesthetically and/or morally), and it had to be interesting. From *Fountain* onward, art forked. You can still find the classical style: good, beautiful, and interesting. But that separate branch, the Duchampian avenue, said that art didn't *have* to be "good" or "beautiful"; it *only* had to be interesting. The fact that this signed urinal took off and remains the cutting-edge of art today is, well, interesting.

I come to the question of "is it art?" honestly. Though I usually write about traditional art history, I sometimes spin off in other directions. I've applied this question to food (Should great chefs be considered artists?) and even to athletes: I wrote about whether my favorite baseball player, David Ortiz, can be considered an artist. I applied his artistic act—hitting a baseball—to three criteria set out by Aristotle around 300 BCE. This method, plus two other Italian terms we'll get to in a moment, can be applied to *anything* to answer the question of "is it art?" though more precisely, it should answer the question of "is it *good* art?"

Though this seems like a cheating definition, art can be anything created by someone who considers it art. That is a broad net to cast, but it's a subjective question. Art is creative output. It could be lousy; it could be wonderful. The "is it art?" question is easy to answer: It is art if someone considers it to be. It's like the question of "is it lunch?" If someone will eat it, then it's lunch.

But is it *good* art? That's more subtle and worth addressing. Renaissance thinkers looked to Aristotle and his tripartite (fancy art critic talk for "three-part") definition to determine what art was "good," and we can do the same today. Aristotle encouraged each one of us to ask the following questions.

1. *Is it good?* Does the work successfully achieve what we imagine the artist set out to achieve? Keith Haring's stick figures are "good" by this definition, because he was trying to paint stick figures. If he had been trying to paint photorealistic portraits, but they came out as stick figures, well, it ain't good. In traditional art terms, "good" usually means that the work exhibits remarkable and distinctive skill on the part of the artist. But in less traditional, more conceptual pieces, it must only successfully achieve the artist's intention.

2. *Is it beautiful?* This is a subjective question, but one that covers both physical and also moral beauty. Matthias Grünewald's *Isenheim Altarpiece* (painted between 1512 and 1516), a particularly gruesome crucifixion in which Christ also suffers from a horrible skin disease, is not exactly beautiful in the traditional sense, but it is morally elevating. The Greek word *kalon* is what Aristotle used. It can be translated as "beautiful, handsome, noble, ennobling"—aesthetic or moral beauty

3. *Is it interesting?* This is the most difficult question to answer, because whether a work is interesting often relates to how much the viewer knows about its subject or how it looks in relation to other works of the same subject. Essentially, the question is whether the work prompts thought or a change in your mood. Do you feel or think differently after your encounter with the artwork than you did before you saw it? This may come down to context and knowledge. Why would we be interested in viewing thirty different Annunciation paintings (the Annunciation is the moment in the New Testament when God's emissary, the Archangel Gabriel, appears before the young Virgin Mary and tells her that she will bear the son of God, and with his words, she becomes pregnant), or even three different Annunciations, all by the same artist? The way one differs from the other, in

terms of the thought process behind the work, its conceptual design prior to its execution, is what might make it a more interesting interpretation than another painting that depicts the same moment from the Bible.

This specific test has been applied, since the Renaissance, to determine whether a work of art is good, and it is worth examining in greater detail. Based not on a direct quote from Aristotle but rather a collection of his ideas about poetry and drama from *On Poetics*, this tripartite definition of what makes for good art was appropriated during the Renaissance to apply to fine art by artists who sought classical sources on art to add prestige and weight to their profession.

This was important in the fifteenth century, because at that time in Europe, artists were considered nothing more than skilled craftsmen, like cobblers or cabinetmakers. But painters, sculptors, and architects aspired to a higher social standing. This was a time when a rebirth (the word Renaissance is French for "rebirth") in interest in the classical world, particularly ancient Athens and imperial Rome, was at its height. Scholars combed through monastic libraries in search of lost or forgotten manuscripts in Greek or Latin. Ancient Athens, above all, was considered the zenith of what civilization was capable of, and its writers and thinkers were appropriated to indicate how contemporary (that is to say, fifteenth-century) people should think and behave. This is why the writings of ancient Athenians like Aristotle and his teacher, Plato, were so valued.

Rather than quote Aristotle directly, it is easier to describe how Renaissance thinkers and artists molded his words about poetry and drama into a series of rules about what makes for good art. Aristotle did employ a term that might be translated as "art" (he used it sixteen times across the text of *On Poetics*), but never actually talking about painting or sculpture. But imagine, as Renaissance artists did, that one might swap out "poetry" for "painting." If we could do that, then the following quote might very well describe the Mannerist style inspired by Michelangelo, for example:

> If a poet has chosen to imitate something, but has imitated it incorrectly, through want of capacity, the error is inherent in the poetry. . . . If he describes the impossible, he is guilty of an error; but the error may be justified, if the end of the art be thereby attained . . . if, that is, the effect of this or any other part of the poem is thus rendered more striking.

Aristotle would approve of Michelangelo's Christ in *The Last Judgment* (1534–1541), rippling with more muscles than exist in the human body,

including an eight-pack where his six-pack should be. Mannerism is all about the intentional distortion of reality for dramatic effect. If Aristotle thought it was cool, then his word, as a respected classical thinker, made it cool for Renaissance contemporaries. The very fact that ancient writers—the long-dead "influencers" of Renaissance Europe—wrote on art helped to elevate the status of art and artists, legitimizing it and bringing to it prestige.

The other ancient philosopher who is important enough to understanding art that he makes the cut for our twelve-hour tour is Plato.

WE'RE GONNA NAME-DROP PLATO, PEOPLE!

Plato's key contribution is a metaphorical story of a cave that, for more than two millennia, has provided the theoretical basis for how art is understood. "The Cave," a parable from Plato's *Republic*, published in 380 BCE, has long been considered an allegory (the embodiment of an idea in the form of a story) for both art and the human experience. The whole parable is short enough that we can quote it in its entirety:

> "And now," I said, "let me show in a figure how far our nature is enlightened or unenlightened. Behold! Human beings living in an underground den, which has a mouth open to the light and reaching all along the den. Here they have been from their childhood, and have their legs and necks chained, so that they cannot move, and can only see in front of them, being prevented by the chains from turning their heads around. Above and behind them a fire blazes in the distance, and between the fire and the prisoners there is a raised path; and you will see, if you like, a low wall built along the path, like a screen which marionette players have in front of them, over which they show the puppets."
>
> "I see."
>
> "And do you see," I said, "men passing along the wall, carrying all sorts of vessels and statues and figures of animals made of wood and stone and other materials, which appear over the wall? Some of them speak, others are silent."
>
> "You have shown me a strange image, and they are strange prisoners."
>
> "Like ourselves," I replied. "And they see only their own shadows, or the shadows of one another, which the fire light throws on the opposite wall of the cave?"
>
> "True," he said. "How could they see anything but the shadows, if they were never allowed to move their heads?"

"And of the objects which are being carried in a like manner, they would see only the shadows?"

"Yes," he said.

"And if they were able to converse with one another, would they not suppose that they were naming what was actually before them?"

"Very true."

"To them," I said, "the truth would be literally nothing but the shadows of the images."

This allegory (which often requires an accompanying illustration to show what Plato was describing, in his slightly convoluted terms) has long been used as an analogy for what art *is*. Art, we might say, is like the shadow dancing on the back wall of the cave in which we are all chained: It is a shadow of reality, not reality itself. Art is not the actual creation of a horse, for example, but a man-made re-creation of a horse in paint or stone, a "shadow" of a horse.

French philosopher Michel Foucault penned an entire book about a painting by the Belgian Surrealist René Magritte called *The Treachery of Images* (1929). Magritte's work of that title is a painting of a pipe, below which is written (in intentionally grammatically incorrect French), "This is not a pipe." True, Foucault argues; it is not a pipe but a *picture* of a pipe. It is what the inhabitants of Plato's cave see: not the pipe itself, which is outside the cave and which they cannot see directly, but a representation of the pipe that they *can* see, that shadow of reality thrown onto the back of the wall by the firelight. Aristotle praised Homer for having taught other writers "the art of telling lies skillfully." What better analogy for what an artist does: convincing the viewer, through skillful illusionism, that the painting or sculpture is a glimpse of reality, when in fact it is a mere shadow, or reproduction, of it? If this sounds like *The Matrix*, a layer cake of realities, then it's with

Magritte's *The Treachery of Images* (1929). It's not a pipe. It's not a painting of a pipe. It's a printed digital photo of a painting of a pipe. Take that, Foucault!

good reason, as this parable inspired the concept of the film. Magritte did not make a *real* pipe. He painted a picture of a real pipe, and reminded us of this, for sometimes we need reminding, by writing beneath it, "This is not a pipe." (He also made a joke, because *une pipe* in French was, at the time, slang for a blow job. Who says that great artists can't also be funny?)

THE EARLIEST ARTWORKS

From an allegorical cave, let's step back in time to the literal caves our proto-ancestors once called home.

Consider the world's oldest musical instrument. It is housed not far from where I live, at the National Museum of Slovenia in Ljubljana, and it consists of a fragment of what was once a recorder made around forty-three thousand years ago from the femur of a cave bear. It was discovered in a cave called Divje Babe (translated as "wild hags," which would be a great name for a rock band). Though broken at both ends, it is a usable flute—in fact, a musician recorded an album in which he performed on an exact duplicate of it. At least forty-three thousand years back (the Late Stone Age), when our ancestors had a lot of things to worry about—hunting, gathering, freezing, disease, not being eaten by a saber-toothed tiger—they nevertheless took the time to create something sculptural (the flute) the purpose of which was to create art (to play music). This is a testament to the human compulsion to create objects that have no practical survival purpose for the body yet do something for the soul, as cheesy as that sounds.

There can be no doubt as to the earliest known works of art proper: the cave paintings of El Castillo, which were only recently discovered.

In the cave of El Castillo in Spain, deep in the dark recesses where no light shines aside from torches or flashlights carried in by humans, there stands an astonishing array of handprints and geometric shapes left here to convey some message by our ancestors around the same time that the "wild hag" flute was made. Using a technique called uranium-thorium dating, scientists concluded that the El Castillo paintings are, in fact, the world's oldest: at least 40,800 years old. The previous record-holder had been the animal paintings at Chauvet, in France, which are around 4,000 years younger than those at El Castillo. The paintings at the cave of Altamira, which feature red-colored, club-shaped symbols, are relative youngsters, at only 35,600 years old.

In addition to wall paintings in caves, the earliest sculptures date from similar periods—the "wild hag" flute, for instance. Most art history books kick off the sculpture section rather later, since the earliest three-dimensional carved objects,

like these flutes, had a functional use and were not merely decorative. The *Venus of Willendorf*, a 4.25-inch-high limestone and red ochre statuette of a voluptuous female hailing from Germany, circa 28,000 BC, begins many a survey of Western art history. It was likely used in some form of fertility rite, as its generous belly, engorged breasts, and pubic mound suggest pregnancy or fecundity.

Were the cave paintings likewise part of some religious rite—or rather, shamanistic ceremony, since they predate the concept of religion as we know it? The popular idea of cave paintings features animals and human forms engaged in a hunt, and these indeed may be found. But what is particularly interesting about the El Castillo paintings is that they do not feature naturalistic attempts at depicting animals (that comes later), but abstract-style shapes (which may have had a symbolic value: a circle for the sun, for instance) as well as handprints. The handprints were made by blowing a natural dye out of one's mouth and around one's hand as the hand was held palm-down on the cave wall.

Was this an early sort of signature? Were the hands symbolic, like the nonfigurative shapes found around them? Was it part of a proto-religious ceremony? We cannot know with the information currently available, and archaeologists have a variety of theories, none of them certain. But this discovery does shift the perception of how early humans, who we now know interbred with Neanderthals, used art. Whereas it was previously thought that cave painting was a cultic ritual surrounding the hunt and the relationship between animals and early humans, it now seems that painting was both

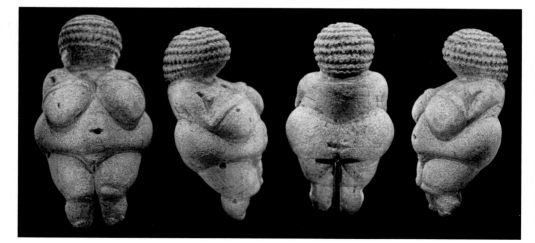

Venus of Willendorf, looking ravishing and, dare I say, Rubenesque, made approximately 25,000 years ago. PHOTO COURTESY OF WIKICOMMONS BY BJORN CHRISTIAN TORRISSEN.

more abstract and symbolic (rather than literal) and may also have been more personal (leaving one's handprint may have been for posterity, or signaling one's presence or ownership).

There is an inherent human desire to leave one's mark (consider Hamlet's dying entreaty to Laertes to tell his story, or the carved initials of condemned men in lonely dungeon cells) that predates the concept of the modern human. The drive to create something that does not have a direct function is likewise innate within us and perhaps unique to our species, although apes in captivity, given materials, have been known to paint, and perhaps there is an artistry to spider webs, beaver dams, and so on. What is certainly unique to our species is the definition of art and the idea that we can create something and determine that it is art—that art is what we deem it to be.

But the tremendous age of these cave paintings suggests that the urge to create precedes a consciousness about what we are creating. These pre-ancient humans wanted to leave a mark on a space they inhabited, probably doing so in darkness or against the gutter of makeshift firelight, and without the certainty that other humans in the future would ever see it. That creative urge does not only come when all basic needs are met; it can also come when basic needs go wanting. Past theorists have considered that art, and indeed civilization, arises only when basic needs are covered: We must be certain that we will eat and can sleep in the warmth and safety of a shelter, and only then do we have the mind space and time to create art. But cave dwellers created art while hunting and gathering, following herds and trying not to be eaten by cave bears. While we cannot know their situation and comfort level when they decided to place their handprints on the El Castillo walls, they did so long before we tend to think of the rise of art, which earlier history books placed after the agricultural revolution, when established farming rituals and domesticated animals assured food in a stable location and allowed for long-term dwellings and eventually cities.

How Vasari "Invented" Art

We would do well to first recognize that there are two definitions of art: one employed throughout the ancient world, not in overt terms but in terms of a general understanding of art, and one that shaped the modern concept of art. That modern conception of art, the "invention" of art as we might conceive of it today, owes its popularization, if not its origin, to a man who lived five hundred years ago.

There are a series of truths that we who grew up in the Western, Eurocentric tradition believe about art, and these hold true even for people who never

studied art and don't profess a particular interest in it. Just like you might not be interested in physics but know a story about Isaac Newton and an apple tree, our cultural oxygen shimmers with latent facts and opinions about various topics, art history included. But what you might not realize is that the vast majority of these vaporous, universal "truths" about what art is good, how art should be displayed, which artists represent the summit of their media, and more, are all the opinion of a single man named George.

Giorgio Vasari is a gentleman we will encounter multiple times during our twelve hours together. He was a sixteenth-century painter and architect working primarily for the leading family in Florence, the Medici. But while he was an excellent artist, he is best known to posterity as the founder of the field of art history, having penned the first group biography of artists (many of whom Vasari knew personally) in his *Lives of the Most Eminent Painters, Sculptors and Architects*.

Vasari wasn't the first person to write about art, but he is responsible for most of what we think about art and museums today. His *Lives*, with editions published in 1550 and 1568, is considered the first art history book. The book is divided into short biographies, turning the focus from the art (which, during the Middle Ages, was the only important thing, with no record kept, in many cases, of who created the art) to the artist as a sort of cult figure, to be admired and investigated personally for clues about how to interpret his (and aside from a few outliers, it was inevitably "his") art. The book was a Renaissance bestseller, hugely popular and highly influential, fairly early in the history of printed books. It is certainly biased: Vasari, born in Arezzo but working in Florence and Rome, was trying to promote his own style of art, the Mannerism inspired by his idol and friend Michelangelo, and the art of Tuscany, above all others. Artists who worked in a different style or hailed from a different region or country got short shrift. Various personal vendettas also played out in his text: for instance, his dislike of Baccio Bandinelli led to such vilification that the artist draws comparisons to Satan. Its appealing format, strong literary verve, and cornucopia of great, memorable stories not only made it popular to read but also inspired many others to take up the pen and write similar biographies—often spurred by the desire to correct what they perceived as Vasari's errors or oversights. And there were many—reading Vasari's *Lives* today, which is required of the half-million-plus undergraduate art history students every year, is an exercise in corrective annotations. Vasari had his own agenda but he also researched in a modern, albeit flawed, way: by asking people for their recollections and recording these anecdotes as historical fact. Vasari's *Lives* remains the go-to source

for a first-person account of the Italian Renaissance, the first port of call for researchers dealing with any of the more than one hundred artists described in it. It is as culturally important as any book and has been constantly in print, in scores of languages, and read by scholars and students the world over.

This work, the first art history book penned by the godfather or art history (who also happened to be a wonderful artist), has been circulating for half a millennium, and it is no wonder that its lessons have filtered out beyond the confines of the millions who have read it, affecting us all. Part of what made these ideas stick is the fact that they were implemented, in practice in museums, initially thanks to the efforts of Dominique-Vivant Denon, the first director of the Louvre Museum, from which so many subsequent museums drew their inspiration. Denon took Vasari's ideas about art and translated them into how art museums would display art to the public.

He's also responsible for the Western "taste" for Florentine Renaissance artists as more famous and "better" than others. Ask most people to name some famous artists, and they're likely to begin with the Teenage Mutant Ninja Turtles: Donatello, Raphael, Michelangelo, and Leonardo. Although Donatello is the outlier (living a century before the other three—the fourth Ninja Turtle, if we're getting technical, should have been named Titian, after the real contemporary rival to Raphael, Michelangelo, and Leonardo), these are the names that most people would list, when asked about the great Old Masters. The preference for Leonardo above Albrecht Dürer, for example, or Michelangelo above Jan van Eyck, is not one of objective better-ness. Leonardo and Michelangelo were part of Vasari's own tradition—in Michelangelo's case, in Vasari's close personal circle—so it's more about tribalism. Dürer and Van Eyck are every bit as good as the Ninja Turtles, but they were sidelined by Vasari because their style and geography didn't match his pro-Tuscan thesis. And yet Vasari's personal opinion was translated into fact over the centuries, so that Average Joe is likely to list Michelangelo and Leonardo as the best artists in history, regardless of whether they know where they got this notion or have ever seen the work of either.

Though it may seem obvious to group artists by style and region, studying, for instance, medieval French sculptors together, it is still a legacy of Vasari. The idea that naturalism, making art more realistic and giving painting the illusion of three dimensions, is the ultimate goal of great art is likewise Vasarian, as he presented art as an evolution culminating in Michelangelo, the greatest artist who ever was and ever could be. Some might reasonably uphold this thesis, but it is overly simplistic and does not take into account styles that chose to differ

from this one. Even the way museums are curated—not just by period and movement, but in hanging key works in such a way that they provide central points in the distance to draw the eye and move toward, like a painting at the far end of a series of galleries framed by their thresholds—is informed by Vasari.

The story of art, its "invention" in the sense not of having been the first to create art, but the first to create how we, humans, think about it, is down to our man Giorgio.

INVENZIONE AND DISEGNO

As we discuss the development and history of human thoughts *about* art, we would do well to spend a bit of time considering the role of art in the ancient world leading up to Vasari.

All known human civilizations, from prehistory to the present, have produced images (two-dimensional paintings and three-dimensional sculptures). Once humans became more settled and religious rituals and spaces were built to last and decorated, art shifted to the creation of functional objects with decoration: vases, ceramics, textiles, armor, arms, religious statuary, and so on. These objects were largely considered as the product of craftsmen, not artists in our modern sense (the Greek term **techne** and the Latin **ars** convey "the ability to do something specific," a sort of mastery, not creative genius), even if they were lovely to behold and even if they were more beautiful than functional. As Salvatore Settis notes, "Classical civilizations, although certainly not shying away from judgments about quality and value, never raised the barriers familiar to us between what deserves to be called art and what does not."

Therein lies the main difference between the way art was considered pre-Vasari and post. Prior to Vasari's era, artists were generally lumped in with skilled craftsmen, and the object created—not the reputation, identity, and genius of its creator—was what was important. In Vasari's era, this shifted. A cult of the artist rose, in part helped by Vasari's *Lives* but afoot before he was born—he is an exemplar and scribe of the phenomenon, not its strict turning point. But when King François I, the sixteenth-century ruler of France, wrote to Leonardo, Raphael, Michelangelo, and other Italian artists he admired, and requested something, *anything*, by their hand, it marked a sea change. François was a "fan" of these artists, an admirer of them as ingenious, talented people. He didn't care what he owned, as long as it was a work by them. He even tried to recruit them to move to France and work at his court, collecting them as much as their art (and he succeeded in recruiting Leonardo, Benvenuto Cellini, and Rosso Fiorentino, among others, though Raphael and Michelangelo turned

him down). Gone was the era of an anonymous craftsman laboring over an altarpiece, a work that would last the centuries while his name was forgotten. This was the era of the cult of artistic personality, one that continues to this day. If some doofus next door breaks a vase, it's an accident. If the great Chinese artist Ai Weiwei breaks a vase, it's art, and it's worth a fortune. Through Vasari we will see how this shift took place, and Vasari's role in it. The "invention of art" is more about the "invention" of someone deemed an artist, whose every product is of value simply because he made it.

Adding to the Aristotelian tripartite definition of art (which is what you should call it to impress people at cocktail parties), the distinction of the concept behind a work from how that concept is physically executed by an artist may be best defined with two Italian terms popularized by Vasari: *invenzione* and *disegno*. **Invenzione**, unsurprisingly, means "invention," but more broadly it means "concept" or "idea." **Disegno** can mean "design" or "drawing" or "blueprint," but it essentially refers to the physical execution of the *invenzione*. A great artist must excel at *invenzione* and *disegno*. *Disegno* can be taught—a top copyist may be good in *disegno* but might not be able to invent his own compositions. A theoretician might be able to conceive, in his mind, of an amazing artwork, but be unable to physically create it himself, lacking in *disegno*.

Try this experiment. Close your eyes and picture a battle.

What did you see? For everyone, the image of a battle will be different. You may have imagined a real battle that you witnessed, or a battle from a film, or a painting of a battle, or perhaps you even threw one together from bits and bobs in your imagination. If one hundred people were asked to imagine a battle and then paint it, we would probably end up with one hundred very different scenes. That image in your head is the *invenzione*, the concept.

If you were asked to paint the scene you imagined, the result would be your *disegno*. In our tripartite Aristotelian definition of what makes for good art, *invenzione* is tied to the third question, "Is it interesting?" *Disegno*, on the other hand, is what the first two questions cover: artistic skill and whether the resulting artwork is beautiful.

I'm a terrible artist, but I could probably conceive of some interesting ideas for artworks. My *invenzione* could be good, but I don't have the physical ability to turn the idea into a nice painting, so I'd fail in the *disegno* department. Likewise, there are many decent painters, like the folks in Piazza Navona who will be happy to paint your portrait as a souvenir, who are fine in the *disegno* department, but who don't have the *invenzione* to paint something original and intriguing.

Now let us return to the seafaring whiskey journey as artwork, *Hogshead 733*. Is it good? Is it beautiful? Is it interesting? What is the *invenzione*? How would we define the *disegno*? The main issue is that it is in the Duchampian vein. It cannot really be called "good" or "beautiful" in the traditional sense. It is good that the two artists survived the voyage. Their photographs and drawings and the documentary film they made about it afterward, the relics of the durational performance, are well done, and I find them to be beautiful (but that's just me). I think the concept is beautiful: a voyage from tree to boat to barrel to beverage, imbuing a shared adventure of two friends into a consumable end product; it is very cool. Is it interesting? Certainly. The *invenzione*, the concept, is clever and new. The *disegno*? That loops back to the "good" and "beautiful" questions. It's hard to say, in this case, because this is not a traditional work. It is a descendant of Duchamp's *Fountain*. It succeeds because it is certainly interesting and it is part of a category of art that only needs to be interesting. That it has good and beautiful elements is, for me, a bonus point. That, and I like whiskey.

Your next date will be wowed by your casual employ of the ideas of Plato, Aristotle, and Vasari. When you next visit a museum, try applying these concepts to each work you see. You should feel empowered to make personal, subjective decisions about each. A pair of buddies boating their way to a Scottish island to make whiskey may be my idea of "good" art, but it doesn't have to be yours. Either way, we can enjoy their whiskey together and have an informed chat about it.

CHAPTER 3

Art as Object and Technique

Key Work: Utagawa Kuniyoshi, *Triptych of Takiyasha the Witch and the Skeleton Spectre* (1844)

NOW THAT WE HAVE A SENSE OF WHAT ART IS IN THEORY, THE NEXT STEP IS to talk about how to talk about it in actuality. There are some specific terms that are useful to know, but not to worry: the number of art-specific words is finite. If I told you that you could understand a whole new language by learning just a few dozen words, that suddenly you could comprehend 80 percent of what people say in that language with a relatively light amount of study, it would sound like a pretty good deal, right? It's like that with the vocabulary of art. In this chapter we'll go over the most common art-specific terms used to describe

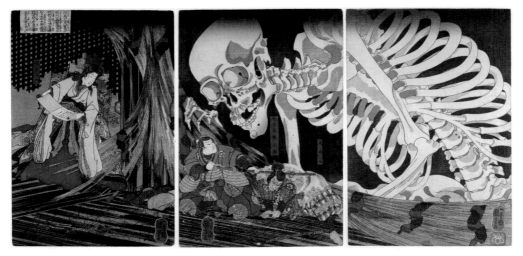

An inspiration for manga and Japanimation adventures is the wonderfully named *Triptych of Takiyasha the Witch and the Skeleton Spectre* (1844) by Utagawa Kuniyoshi.
PHOTO COURTESY OF WIKICOMMONS.

artwork as objects as well as the various media and techniques you are most likely to encounter. In the next chapters, we'll shift to learning various artistic movements or styles, those sometimes-dreaded *-isms*, and then a visual vocabulary of symbols in art. These are the most common points of intimidation. Unless you know how to speak Slovene, it's understandable that you might be shy about wandering among Slovene speakers. But if you have the basics down, you might be up for it. And if getting the basics down is quick and easy—just a chapter or two's worth of study—then new horizons are yours: Hop on a plane to Slovenia, fly to Ljubljana, climb Mount Triglav, yodel in the Alps, watch Luka Dončič play basketball and Slavoj Žižek expectorate on philosophy, eat a slice of potica. That's the plan here—replacing "Slovenia" with "the art world."

It's actually a shame that vocabulary can put people off engaging with art. These terms are just ways to facilitate conversation about objects and their history. And yet the words can act like a war dance, a Maori *haka*, intimidating outsiders and warning them away. There is no need. The invitation to the club, the "secret" words that will allow you to participate in the conversation, are relatively few and easy to learn and not actually a secret. It's no different from any other distinct field. Take cooking, for instance. Professional chefs will talk about "julienne" and "brunoise," French terms that sound scary, but really just mean "slice into long, thin strips" and "chop into tiny cubes," respectively. Once you realize how simple the terms are, you'll feel empowered—and possibly wonder what all the nervousness was about in the first place.

THE MEDIUM IS THE MESSAGE

The most basic terms are those that describe types of art and how they are made, considering the art as a physical object (setting aside, for now, the theme and style of the work, which are questions of content and the artist's imagination).

We'll focus on the most common and basic terms that will open the most doors with the least work for you. Most art that we encounter is in the form of painting, drawing, print, photograph, or sculpture. There may be more exotic outliers (stained glass, video art, performance, installation) but our goal here is to give you maximum knowledge in a streamlined word count.

Painting and Drawing

When you think of art, you're likely to first think of paintings. Add the word "history" to "art" and an image of Leonardo's *Mona Lisa* (circa 1503) is probably the first association. But it's possible that you've never thought about what a painting is. Paintings involve the application onto a flat surface, called

a **support**, of **pigment**. Pigments were originally from entirely natural sources, like carbon (aka charcoal) to make black and crushed bugs (female cochineal insects, to be precise) to make carmine, a deep purply red. Cobalt blue was made from ground lapis lazuli, a rare stone that, during the Middle Ages, was mined only in the region of Afghanistan and had to make its way to Europe on the long, perilous Silk Road. Lapis lazuli was the single most expensive thing one could buy, by weight, at this time, and the color was reserved for the garment of the Virgin Mary or Christ, as in the International Gothic painting *Coronation of the Virgin* (1407–1409) by Lorenzo Monaco, or a Babylonian seal made entirely of lapis lazuli stone.

Supports were usually one of four surfaces: planed wooden panels, canvas, plastered walls, or paper. Paint is pigment plus a **binder**, a substance that makes the color adhere to the support. The oldest paint type is **tempera**, which uses egg yolk as a binder. Tempera painting (the Monaco *Coronation* is a fine example) is as simple as a painter grinding pigment into a powder, dipping his brush into a fresh egg yolk and then into the pigment, then applying his brush

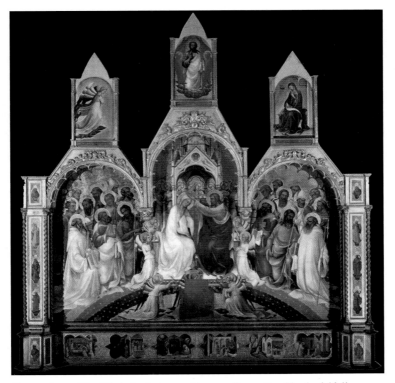

Coronation of the Virgin by Lorenzo Monaco (Larry the Monk, 1414).
PHOTO COURTESY OF WIKICOMMONS FROM THE WEB GALLERY OF ART.

to the support. This is the historical paint type that worked best for painting directly onto a wall, as tempera paint is opaque: If you paint green tempera onto a surface, let it dry, then paint red on top, you'll see only the red, with none of the green showing through.

During the Renaissance, tempera was replaced by oil painting as the preferred medium. The key material difference is in the binder: As the name implies, instead of egg yolk, natural oils (usually linseed or nut oil) were used. In practice, the oil made the paint translucent so that each layer subtly shows the layers beneath. If you paint a surface with green oil paint, let it dry, then paint red on top, you'll see the green ghosting through, altering the hue of the red. Oil paint techniques allowed for a lot more subtlety than tempera. Jan van Eyck (who was the first artist to demonstrate the true capabilities of oil paint; his 1432 masterpiece *The Adoration of the Mystic Lamb* is considered the first truly great oil painting) used brushes as tiny as a single badger hair, for minuscule details, and included astonishingly realistic elements, like the reflection of light in a horse's eye and ingrown hairs on a man's face. The layering of oils also allowed for more subtlety in conveyance of emotion: *Mona Lisa's* enigmatic smile is a layer cake of slightly different positions of the corners of the mouth, projecting a mixture of feelings.

Sometimes paint was applied directly onto a wall. A wall painting is a **mural**, and the most renowned technique for making pigment stick to a wall for the long haul, rather than peeling off over time, was to make a **fresco**. For a fresco (Italian for "fresh"), the artist applies wet plaster to a portion of the wall that they think they can paint in a day, before the plaster dries. This portion of wall is called a *giornata* (Italian for "a little day"). When applied to wet plaster mixed with animal glue (a white substance called **gesso)**, the paints lock into the plaster as it dries, resulting in a painted wall that can last for centuries. Applying pigment to a dry wall can lead to the paint flaking off and a brief anticipated life span for the artwork. One of the most famous frescoes, Leonardo da Vinci's *The Last Supper* (1495–1496), involved a technique called **fresco seccho** (Italian for "dry fresco"), with Leonardo applying paint to a dry wall. It's a small miracle that his *Last Supper* has survived to this day, as it was crumbling off the wall within years of completion.

Painters could also use a carefully planed wooden **panel** (usually pearwood, which was naturally insect-resistant) or **canvas**, originally made of hemp cloth stretched over a framework of wood called a **stretcher**, as supports. Early illustrated books used **vellum**, a predecessor to paper made from dried, stretched animal skin.

In the nineteenth century, artists began to use **watercolors**, soluble pigment mixed with water and applied to paper, as well as the first industrially produced paints—pigment and binder premixed and purchasable in tubes. In the twentieth century, synthetic **acrylic** paint was often used, for instance, by Jackson Pollock in his famous drip paintings. Prior to these industrial advents, artists would have to buy pigments and mix their own paints—or rather, their apprentices and assistants would do the busywork.

It's important to keep in mind that it is a modern misconception that artists work alone and create their artworks solo, from start to finish. Historically, master artists ran studios that might be staffed by a dozen or more.

The life of an apprentice in a master's workshop, or *bottega*, was one of constant work and instruction. Consider young Leonardo da Vinci, who was apprenticed to the painter and sculptor Andrea del Verrocchio. During his apprenticeship, Leonardo lived, along with other apprentices (typically aged eight to seventeen), in lodgings provided by the master. His fellow apprentices included some of the future rock stars of Florentine painting: Pietro Perugino and Domenico Ghirlandaio, and Sandro Botticelli would pop in regularly. Leonardo's tasks were occasionally mundane, such as grinding pigments according to the master's preferred recipes, applying the preparatory white gesso layer to panels before the master began a painting, and running errands and picking up groceries (the Renaissance equivalent of an intern in Hollywood being sent out for lattes by a film producer). But he was also given assignments that were more purposeful: lessons in drawing, painting, proportions, mathematics, and sculpture with the master himself, and careful assignments both to practice techniques and to paint portions of the work commissioned of the master. Apprentices and assistants were often charged with painting in landscapes, still lifes, architectural features, and sometimes secondary figures, all under the master's supervision. The master would design the commissioned painting and would handle the most difficult aspects, notably faces and hands, but the more peripheral elements might be entirely the work of assistants. For some works, the master might barely touch the painting, and yet such a work emerging from Verrocchio's studio would be considered a Verrocchio.

In Verrocchio's studio, fitted out for both painting and sculpture commissions, Leonardo would scamper among leather-smocked assistants, the smell of linseed oil and varnish saturating the still air. In one corner an apprentice might be grinding fresh pigments, charcoal for black or vermilion for red, or the extremely rare and expensive lapis lazuli for a bright blue.

A separate section of the studio was dedicated to sculpture, full of sketches, clay, wax, and fabric that could be soaked in wet clay and then modeled onto a wax mockup of the final sculpture. Poplar panels sat carefully in a corner, padded by blankets so as not to damage them before they could be painted—these were expensive, the work of master planers, and were painstakingly prepared so they would last for centuries. The panels would be covered in gesso, the omnipresent mixture of plaster and glue made from boiling leftover bits of animals (hooves and such), which would act as a white base layer upon which to paint.

When an apprentice or assistant (assistants were paid members of a master's workshop, while apprentices were essentially interns) felt that he was ready to set out and open his own workshop, he would submit a **masterpiece** to the local guild, a professional union that monitored a craft in a given region (most painters' guilds were named after Saint Luke, the patron saint of painters). Today we use the word "masterpiece" to mean any great work of art, but the original meaning is the work submitted by a young artist, the merit of which would determine whether the local guild would allow him to become a master himself and open his own workshop.

Young artists learned by drawing, with painting a rare opportunity. The reason for this was that the raw materials to create a painting were expensive. It was not until the seventeenth century that artists began to regularly create work "on spec," painting whatever they liked and hoping to sell the works later. Before this, artists made art only on commission. Contracts often specified not only the medium and size of a work, but also details about its subject matter, what to include, and often the number of "heads" in a work, as heads and faces were considered the most difficult to paint, so more faces meant a higher price. Drawing was an opportunity to practice and learn, but even paper was expensive until the Industrial Revolution.

Before making a painting, artists would sketch their ideas and concepts on paper, then often make a full-sized preparatory drawing to show the commissioner what the final would look like. These full-sized drawings are where we get the word **cartoon**, which comes from the Italian *cartone*, meaning a large piece of paper. Drawings might be made with chalk, charcoal, silverpoint (a predecessor to pencil, using silver to make very light gray lines), or pastels. Artists could transfer the cartoon onto canvas, panel, or a section of wall by drawing a grid of lines over it and a grid on the new support, then copying the contents of each grid by hand. Another trick was to prick holes along all the lines of the cartoon, hold the cartoon up to the new support, and blow ash

through the holes, resulting in a sort of connect-the-dots of ash wherever the holes touched the new support.

Paintings began with the preparation of the ground, usually starting with gesso as the base layer. Then, for oil paints, a solid color was applied (traditionally an olive green if the painting was to be a portrait, blue for a seascape, and brown for a landscape). The artist then sketched out the basic forms of the painting (contours of bodies or buildings) and then added oil paint, one layer at a time, waiting for each layer to dry before starting a new one. Artists would have many paintings underway at once, working on one as the others dried. This is why oil paintings could take months or even years to complete.

Paint was applied with various brushes or a chisel. Sometimes brushstrokes were smoothed out and all but eliminated, for a homogenous, almost glassy finish, as in the work of Bronzino. This style is referred to as **unpainterly**, as you cannot see the brushstrokes. The opposite style is **painterly**, where the brushstrokes are unabashedly visible, as in the paintings of Vincent van Gogh, who globbed on a topography of paint that made his canvases almost sculptural, chunks and glops of paint so high that they cast shadows.

The subject matter of painting was long considered hierarchical—there were subjects that were more elegant and noble and others that were dismissed as lowly. In this hierarchy, so-called **history paintings** (of important historical events or personages, which included biblical scenes, like the Old Testament incident of Judith beheading Holofernes (an example of which, by Artemisia Gentileschi, appears in chapter 5) or scenes from classical mythology) were at the top. **Portraits** of important people came next, as in a portrait of the Ottoman sultan Mehmet II made by the Venetian Gentile Bellini (after whom the cocktail from Harry's Bar in Venice—prosecco and white peach juice—is named). Low on the list were **genre paintings** (scenes of everyday life, such as peasants loitering before a country inn, as in the work of Jan Steen), **landscapes**, and, lowest of all, **still lifes** (arrangements of objects, flowers, fruit). Starting in the seventeenth century, this hierarchy began to fade, but it remained a presence until the end of the nineteenth century. In seventeenth-century Rome, Italian painters refused to "debase" themselves by painting genre scenes and yet had to wait and compete for the big commissions from princes, cardinals, and popes of history paintings. They were thoroughly annoyed by Dutch painters in the city, who sold modestly sized (and priced) genre paintings to a rising middle class of collectors. There was such animosity that rival street gangs, Italian history painters versus Dutch expat genre painters, would rumble and fight over such matters.

For a long time, there was a rivalry, too, between artists trained at official **academies** and those who were independent. Once again, we must tip our hat to Vasari, who established the first major painting academy in Florence in 1563. Others rose in Rome and Bologna, then in Paris and London and beyond, mirroring where ground zero for art was throughout the Renaissance. The "places to be" if you were an artist were Florence and the Lowlands (Belgium and the Netherlands) in the fifteenth and sixteenth centuries, Rome and the Netherlands in the seventeenth, Paris in the eighteenth and nineteenth, then New York in the twentieth (and we might add London and Berlin as the "it" places so far in the twenty-first). The establishment of academies followed. Today, calling someone an "academic painter" is almost an insult, suggesting that they are staid and boring and overly traditional (the great art writer Julian Barnes called them trapped in the "permafrost of the Academy"). Academies replaced the medieval guild system, and from the sixteenth through the late nineteenth centuries, academies, which often ran **salons**, or annual exhibitions of new work, were the main influencers and dictators of style.

Sculpture

Sculpture is the creation of three-dimensional artwork, usually in stone or bronze, though it may also be in **terra-cotta** (baked clay), wood, or other media.

Relief sculptures are meant to be viewed from only one side and are attached to walls. They are carved into surfaces, and generally, the more shadow you see in them, the more skill they exhibit, as this means they were carved deeply. Roman sarcophagi were sometimes decorated with elaborate relief sculptures.

Statues are three-dimensional sculptures meant to be viewed from more than one angle. They can be **busts** (statues of people shown from the shoulders up only) or full body. They are often carved out of marble, a soft and particularly beautiful stone with a crystalline surface that refracts light. Marble quarried in Carrara, Italy (near Pisa), was particularly prized, and many of the most famous statues in Europe were carved from this stone, including Michelangelo's *David* (1501–1504). Marble was quarried in large blocks that were roughly shaped into cubes. In order to carve them, artists used charcoal to draw a grid on all sides and the top and draw onto each side the view of the finished statue from that respective angle. Then the artist used a hammer and chisel to carve in spirals around the block, removing all the excess stone to reveal the statue he envisioned within the stone. It was as if Michelangelo's *David* were frozen inside a block of ice: Michelangelo could "see" his form through the ice and chipped away at everything around him until he set David free. Then he set

about honing the details. The final product was then sanded smooth. Bernini, the greatest sculptor of seventeenth-century Europe, liked to finish marble sculptures by tapping them all over with a hammer wrapped in felt. This further shattered the crystalline surface of the marble, refracting more light and giving his statues the sense that they were almost glowing, surrounded by a halo of light as it bounced off them, like a diamond.

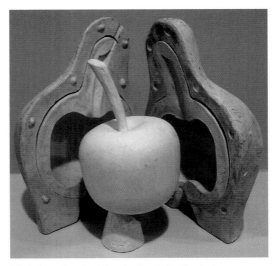

Model made of rubber to illustrate the lost-wax method, a clay version of this would be used as a mold to cast an apple out of bronze. PHOTO COURTESY OF WIKICOMMONS BY JOSÉ-MANUEL BENITO ALVAREZ (2006).

Sculpting in bronze was another story entirely, and far more akin to making bells and cannons, a truly industrial process, than work in marble or wood. We have Donatello to thank for having rediscovered, or rather relearned, the **lost-wax method** of bronze casting. Donatello and his best friend, Filippo Brunelleschi (most famous for designing the dome of the cathedral of Florence), spent two years in Rome studying ancient sculpture and the ruins of ancient buildings to learn the secrets, largely forgotten since the fall of Rome a thousand years earlier, of how the Romans worked. Brunelleschi benefited from the fact that Roman buildings were in various states of ruin, because their inner workings, which would have otherwise been covered up by plaster or marble paneling, were revealed. Donatello likewise learned the lost-wax method more easily because many of the ancient bronzes he admired in Rome were damaged or in pieces, so he could see inside them.

The great conundrum was this: since bronze was so expensive and heavy, how could one create a sculpture that featured just a skin of bronze but was otherwise hollow?

Imagine you wanted to make a bronze sphere. You could dig a sphere-shaped hole in the earth, line it, and pour in molten bronze. The result would be a solid bronze sphere (otherwise known as an expensive cannonball), but this would use a huge amount of bronze, cost a bundle, and weigh a ton. How, then, could you make a hollow sphere that only had a thin skin of bronze?

The ancient method for bronze casting was largely forgotten, aside from the casting of cannons and church bells. By adapting this technology for art and seeing the broken works of the ancients, Donatello taught himself the preferred technique for bronze casting. It works something like an Oreo cookie.

A terra-cotta (clay) full-sized model of the desired figure (in our example, a sphere) is made and fired so that it hardens, leaving a hard clay sphere (the inner chocolate biscuit of our Oreo). This shape is then covered in a layer of wax (the cream inside the Oreo). Then another layer of clay is added around the internal clay form and atop the wax (the outer chocolate biscuit of the Oreo), then likewise fired so that it hardens. We are left with a wax sandwich, with hard-baked clay inside and out.

This double mold is buried and holes are drilled into the outer layer only, complete with clay "chimneys" that allow the molten bronze to be poured in and gases, which might crack the sculpture, to escape out when the molten bronze displaces the wax. The wax is "lost" and replaced with the molten bronze, which then hardens while it is trapped between the two layers of clay. The result is a thin, hardened skin of bronze sandwiched between the two hard clay molds. Once the bronze cools and hardens, the mold is unburied and the outer layer of clay is cracked to reveal the bronze skin. A hole is made at the bottom of the sculpture so that the clay inner mold can be broken up and removed. Voilá: a hollow bronze sphere.

This method was used around the globe, and while Europe had to relearn it after the fall of the Roman Empire, it was alive and well in the Ife state of Nigeria in the eleventh century. Too often, English-language art history books have such a Eurocentric perspective on art that they overlook how far ahead of Europe other world cultures were when it comes to the arts.

This process can also be used to make more complicated shapes, like human limbs. Cast each arm and each leg separately, along with a head and torso, then each cast piece can be welded together to form an entire human body. The most skillful bronze sculptors, who were as much engineers as artists, attempted to make more complex figures in a single casting. Leonardo da Vinci wished to make the planned (but never executed) Sforza Horse (1482) in a single casting—the entire horse (24 feet or 7.3 meters long) poured at once into one mold. Leonardo's plan can be seen in his astonishing sketch of the mold that would have been used. He would likely have succeeded had not the French invasion of Milan in 1499 interrupted him. Sadly, the full-size terra-cotta model of the horse, which was on public display outside the Sforza Castle in Milan, was destroyed when the French decided to use it as a target for their training archers.

Art in Multiples: Printmaking and Photography

While today Leonardo da Vinci is probably the most famous of all artists (with Pablo Picasso coming in second place), during Leonardo's lifetime someone else held the crown: the German artist Albrecht Dürer. Dürer was a great painter, but his renown is thanks to a relatively new medium circa 1500: **printmaking**. Paintings and sculptures, which were almost always unique works of art, were hugely expensive and difficult to transport. Until the eighteenth century, such works were commissioned only by the superwealthy: kings, nobility, popes, and cardinals. But the upper middle class enjoyed owning art as well (remember those annoying Dutch genre paintings). The advent of the mechanical printing press, invented by the German goldsmith Johannes Gutenberg in 1440, made it possible to produce multiples of an image or a page of text without copying it all by hand, as had been the only option prior. The basic principle is to take a mold, cover it in ink, moisten paper, and use the pressure of the printing press to push the inked mold into the moist paper, transferring the ink onto the paper.

Dürer is still considered the greatest of all printmakers, but he was also a clever marketer. He recognized that prints, made in series and therefore far less expensive than paintings, were affordable ways for the middle class to own art. Since they were on paper, they were also portable. Dürer developed what was the first **artistic trademark**—a large uppercase *A* (for Albrecht) with a smaller uppercase *D* (for Dürer) between the legs of the *A*—which appeared on all his prints. This was at a time when it was not common for artists to sign their works—that would not be standard until the nineteenth century. This trademark helped spread his renown to wherever his prints were collected—which was throughout Europe.

Dürer used several printing techniques, the simplest of which was **woodcut**. If you've ever made potato prints in kindergarten, you'll be familiar with the principle. Dürer would begin with a smooth block of wood. Using a tool called a **burin** (similar to an awl) and other carving implements, he would carve away all the negative space—the parts that would be white in the print—and leave raised the parts that would be inked. He would then roll ink (the simplest form of which was just charcoal soaked in water) onto the raised parts and press this woodblock plate onto paper to transfer the ink. He could repeat the process, reinking the same woodblock, as often as he liked.

Dürer also used a more sophisticated and difficult technique called **engraving**. Engravings take precisely the reverse approach to a woodblock and use metal plates (usually copper) rather than wood. Using a burin, Dürer carved away the parts that should be inked, and the parts of the copper plate left raised

are the ones that will be white when transferred to paper. Instead of inking the raised parts, ink is instead poured into the grooves that were carved out of the copper. Then damp paper is placed over the plate and together they are run through a press. The damp paper dips into the carved-out grooves full of ink and soaks it up.

Using a metal burin to carve grooves in metal requires significant force. The level of detail that Dürer was able to coax with this technique is impressive. Consider his *Knight, Death and Devil*, which has the intricacy of a pen-and-ink drawing.

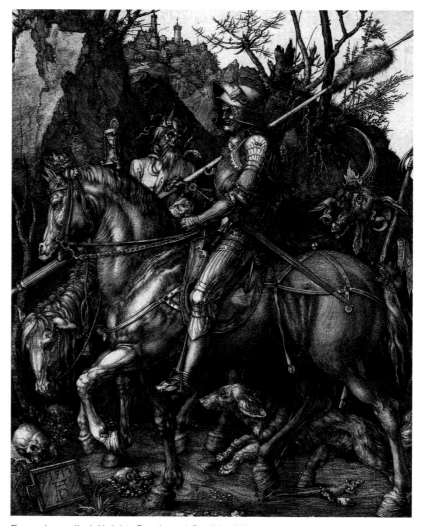

Engraving called *Knight, Death and Devil* by Albrecht Dürer (1513).
PHOTO COURTESY OF WIKICOMMONS BY THE NATIONAL GALLERY.

The greatest printmaker after Dürer was the painter Rembrandt van Rijn. His preferred technique was **etching**. Etching involves covering a metal plate in wax. The artist uses a needlelike tool to "draw" into the wax, scraping the wax away. Then the plate is bathed in acid, which eats away at the metal plate wherever there is no wax, while the wax protects the rest of the plate. This replicates the system of carving out grooves into the metal plate, but whereas the artist has to do the muscle work of carving metal with metal in engraving, etching allows for a far lighter hand and the acid does the heavy lifting. You can see the ease and levity of lines in Rembrandt's self-portrait etching: His expression always makes me think that he has just sat on a bee.

The last technique to mention is the first to allow for color prints: **lithography**. Invented in 1798, this technique allows the artist to draw with colors directly onto a stone or metal surface. The colors, which are intentionally greasy, are then locked into place with a chemical etch, which attaches the greasy parts to the surface. The greasy parts attract the special lithographic ink, while the blank spots repel it.

In printmaking, as with so many things, Asian cultures were far ahead of Europeans from a technological perspective. The first printed text in the world was the *Diamond Sutra*, the nickname for a scroll titled *The Diamond That Cuts Through Illusion*, written in Sanskrit and printed using hand-pressed wooden blocks around 868 CE on a 17.5-foot-long scroll. This was part of a secret library hidden in a cave, enticingly named the Cave of a Thousand Buddhas, near Dunhuang, China, when an advancing army threatened the region circa 1000 CE. It was one of forty thousand scrolls secreted there and discovered only in 1900 by a local monk.

While the earliest European color prints that were not colored by hand came in the nineteenth century, Chinese woodblock prints, in color, were created as early as 1346. This system did not employ a press. Wooden blocks carved into shapes and designs were inked with color and hand-pressed onto textiles or paper. European exposure to China led to the import of this technique in the fifteenth century. This system allowed the introduction of various colors into printing, but it would be decades before European color printing approached the complexity and skill exhibited in Japanese works of the sixteenth century, particularly those remarkably modern-looking prints by Hokusai (his iconic 1831 *The Great Wave Off Kanagawa* is probably the most famous color print of all time) or the totally badass, graphic-novel aesthetic of Kuniyoshi, for instance, in the key image of this chapter, the 1844 *Triptych of Takiyasha the Witch and the Skeleton Spectre* (which would also make a great name for a band). A **triptych**

is a painting consisting of three distinct sections, often linked or even hinged together so the two "wings" can be folded to close over the central section.

Photography involves capturing images using light-sensitive materials. The earliest known permanent photograph was taken by Nicéphore Niépce in 1827 and is called *View from the Window at Le Gras*, showing parts of his estate viewed, well, from a window. Niépce created the image using a **camera obscura**, a device that had been in use for centuries as a way to project an image onto a surface—the ancestor to the modern projector. He projected the image of the view out his window via camera obscura onto a plate made of pewter and coated with a naturally occurring asphalt called Bitumen of Judea. The bitumen hardened where it was exposed to bright light from the projection for long enough—probably a few days, in fact—but it remained soluble where the projected image was darker. He then washed away the still soluble bitumen.

Louis Daguerre was the first to create a permanent image—others before him had created images that faded away—and is credited as the inventor of the first photographic technique that was practical and lasting (his method is named after him, **Daguerreotype**). Daguerreotype photography, like this photograph of a young Abraham Lincoln by Nicholas Shepherd, was widely used in the 1840s and was far more practical than Niépce's approach in that it was quicker. A sheet of silver-plated copper was polished until it looked like a mirror, then it was treated with fumes (usually mercury vapor) that made its surface reactive to light. An image was projected onto the plate for a matter of minutes, then the reactivity of the surface was stopped by treating the plate with chemicals, then rinsing and drying it.

Photography is important to the history of art because it took over from painting and sculpture the need to act as a permanent visual record. Prior to photography,

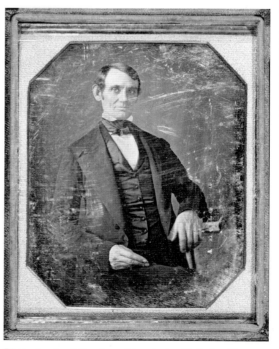

Photograph of Abraham Lincoln by Nicholas Shepherd (1846). PHOTO COURTESY OF LIBRARY OF CONGRESS PRINTS AND PHOTOGRAPHS DIVISION, LC-USZ6-2095

if someone wanted to remember what someone or something looked like, they had to commission a painting or sculpture, and there was a preference given to realistic renditions (or portraits "touched up" the way the sitter would like to be remembered—so a king might prefer that the portraitist not include the pimple on his nose). The famous 1474 portrait of Federico da Montefeltro, the Duke of Urbino, made by Piero della Francesca, is in profile for two reasons. First, it is meant to recall portraits of ancient emperors, who were shown in profile on coins. But second, Federico's face was badly disfigured on its right side, so Piero was doing him a favor by showing him for posterity from his "good" angle. Photography captures people and sights as they truly look, which set other art forms, particularly painting, free: painting no longer had to faithfully reproduce what the eye saw. Now it could do whatever the artist liked, including veering into abstraction and **minimalism**. Painting could get creative and weird and joyously unrealistic, thanks to photography taking over the role of archivist.

Other Fine Art Forms

Architecture was long considered a sibling of the fine arts of painting and sculpture, but because of its practical component—architecture involves creating buildings and structures for use, not just admiration and intellectual stimulation—and its expansiveness, we won't include it in this book. (It would surely push us past twelve hours.)

But while painting, drawing, printmaking, sculpture, and photography get the lion's share of attention and kudos among the fine arts, there are other art forms that deserve mention, even if we are just dipping into them in passing. The subtitle of this book, *Everything You Need to Know about Art*, is something we're taking literally: everything you *need* to know to get the ball rolling and to feel comfortable in museums and at dinner parties with artsy types. What you *need* to know is really the core basics, which is why I'm being selective. But I also do not want you to think that this admittedly European-painting-and-sculpture-focused book represents *everything* about art. So the focus of the subtitle should be on the word *need* rather than *everything*.

Throughout the history of art, painting and sculpture have been the most praised art forms, particularly from the Renaissance, at which point these forms were elevated on the arts-and-crafts social hierarchy far above others, like leatherwork and even goldsmithing (which you'd think would be at the top, considering the value of the materials involved, but it never enjoyed the same cachet as painting and sculpture). **Stained glass** was its own specialty, particularly important to the decoration of Gothic churches. By mixing dyes into

glass and piecing them together like mosaics, windows could be transformed into narratives, illustrations of stories from the Bible. Keep in mind that the vast majority of churchgoers until after the Reformation (so, until the mid-sixteenth century) would not have understood much of their Sunday Mass, which was held in Latin. Only the sermon would have been in the vernacular. The rest was a wash of incantations, songs, and sounds in a language that probably 95 percent of those attending any given service wouldn't understand (only the highly educated and the clergy were taught Latin). This meant that your expected duty was to go to church and participate, but without knowing what was happening until the priest, during the sermon, explained his interpretation of it to you. Naturally, this could get boring, and minds and eyes would drift around the church. The purpose of religious-themed decorations—from stained glass to frescoes to statues to rood screens and elaborately carved altars—was to capture these drifting eyes and refocus them on the subject at hand: the Bible. The decorations inside Catholic churches are really like a graphic novel for the largely illiterate assembly, unable to read words but able to "read" images, as in this detail from the Sainte-Chapelle in Paris of Jesus apparently eating a sword.

Speaking of **mosaics**, this art form of arranging stones or glass into patterns was one of the earliest and most enduring art forms. In places like Venice,

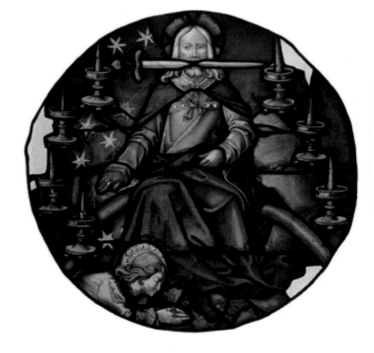

Jesus and the Vision of the Seven Candlesticks, detail from a stained glass window at the Sainte-Chapelle (fifteenth century). Ten out of ten dentists do not recommend doing this at home. PHOTO COURTESY OF WIKICOMMONS BY MAITRE D'ANNE DE BRETAGNE.

where the humidity of the lagoon and canals quickly ruined frescoes, mosaics were a perfect option to permanently decorate churches, as in the beautiful twelfth-century Madonna and Child called the *Teotaca Madonna.*

Prior to the advent of the printing press, to copy a book meant to copy it by hand, a task in which monks would specialize. In addition to copying the text, they would sometimes paint as well to decorate the text, creating what are called **illuminated manuscripts.** They require great patience and delicacy, using tiny brushes while hunched over vellum.

An equivalent of manuscript illumination appeared in other world cultures, like this *tughra* (a monogram made with calligraphy, like an official logo or signature) of Suleyman the Magnificent, circa 1520. In Islamic and Jewish art, naturalistic depictions of God were not permitted (the second of the Ten Commandments specifies "Thou shalt not make unto thee any graven images," which Jewish and Islamic theologians have always interpreted as a rule prohibiting images of humans or of God in religious art). For this reason, Islamic and Jewish decorations are abstract, geometric, or botanical. Protestants likewise followed this second commandment, whereas Catholics decided that pictures of God, Jesus, Mary, and the saints were acceptable and welcome.

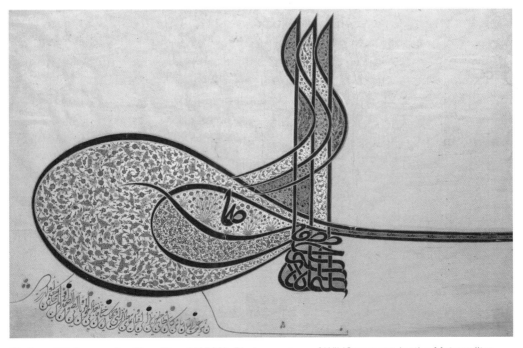

Tughra of Suleyman the Magnificent (1520). Photo courtesy of WikiCommons by the Metropolitan Museum of Art. THE METROPOLITAN MUSEUM OF ART, NEW YORK, ROGERS FUND, 1938

While we know the names of some master illuminators and stained glass makers, most are lost to history because, until the Renaissance, it was *what* they created that was important, not *who* they were. Works were not signed regularly until the nineteenth century, and the overall philosophy that predominated in the Middle Ages, **Scholasticism**, can be succinctly summarized as: God is great while people are worthless; or rather, people derive value only in their subservience to God. For this reason, the beautiful stained glass window produced by a master and his workshop was important because it glorified God, but the names of those who made it were not worth recording for posterity. This would shift in the Renaissance, at first largely thanks to Giorgio Vasari, whose *Lives* book, discussed in chapter 2, glorified individual master artists. This was a major shift away from a complete focus on the artwork to a focus on the artist as more important than any work he completed.

Unfortunately, we must use the pronoun "he" because, until the twentieth century, very few female artists are known—one of the few standouts to regularly appear in art history books is the Artemisia Gentileschi painting featured in chapter 5. This was in part due simply to old-fashioned traditions of women being excluded from professions and in part due to the nature of apprenticeships and bottegas—workshops peopled by a dozen or so men, most of them adolescents or teenagers who would be very much distracted by women in their midst. Because there were almost no female masters (local guilds restricted admission to men), there could be no all-female *bottegas*, so the only women artists were those with a father who ran a workshop, as was the case for Artemisia. (My next book for Rowman & Littlefield is on the role of women in art history, so I hope to rectify some of this imbalance.)

Cultures the world over decorated temples and religious ceremonial objects as well as masks, jewelry, textiles, terra-cotta urns and vases, and much more. These are all works of art. The idea that art is that which is made without a practical purpose is also a loosey-goosey definition. Benvenuto Cellini's masterpiece of **goldsmithing**, his 1543 *Saliera*, is a functional salt cellar, but its functionality is dwarfed by its artistic merit. It's a work of art that happens to be functional, not the other way around.

There's a joke among art historians, its origin unknown, that art history is "Jews teaching Protestants about Catholics." That's been largely true in the second half of the twentieth century in North America, the crucible from which I emerged. By percentage, the most significant art historians have been Jewish,

most of the art history texts are on Catholic art, and most of the students in the United States and Canada would self-identify as Protestants. This results in a narrow view of the world and its artistic creations, which is limited and not cool. It is also understandable, as art historians tend to write about and teach what they learned themselves, which is why we are "stuck" with a Western canon of a few hundred masterpieces that were most influential in the artistic traditions of Western Europe and North America.

I am ashamed at how little I know about non-European art. (I hesitate to use the term "Western," as it is also uncool, but that is the term I was raised with.) Fair or not (I'd side with not), an introduction to art written in English, published by an anglophone publisher, and purporting to be a one-stop starter kit for those interested in art should focus on the art that most of its readers will be familiar with and curious to learn more about. But while I plan to fulfill this service, it doesn't feel right to me to just line up the Western canon of iconic, famous paintings and sculptures as our only points of reference. This is why I've expanded the works we'll touch upon here to be as diverse and surprising as possible, while still keeping with the introductory level of the book and selecting reference works that best exemplify the point I hope to make. Suffice it to say that what we cover here is not *everything* but rather a strong point of departure for you to take your budding interest in myriad directions after our twelve hours together have passed. Our tour is too brief to touch upon an expansive list of art media and cultures, but for now, let this chapter act as a placeholder and point of departure.

CHAPTER 4

Find Crivelli's Pickle

Saint Spotting 101, Iconography, and the Covert Language of Art

Key Work: Carlo Crivelli, *Annunciation* (1486)

THE WORD *CRIVELLO* IN ITALIAN TRANSLATES AS "SIEVE" OR "RIDDLE." RIDDLE is cooler. The biggest riddle Carlo Crivelli left to us art historians is his passion for pickles. Yes, Crivelli placed a pickle (or a cucumber; it can be tough to differentiate) in almost all his paintings, sometimes more than once. The wall copy next to a Crivelli painting at the Metropolitan Museum of Art says that cucumbers were a symbol for redemption. The idea was that a gourd remains intact even when it is "dead," its innards desiccated, with the exterior of the gourd representing the soul, which transcends life on earth. A cucumber? Not so much. But if it's a pickle? Well, pickles tend to last. But I have a feeling we're trying too hard. It's okay to say that we just don't know why Crivelli was so into pickles. It may be an inside joke or an important symbolic device whose meaning is lost to time.

Why focus on this particular cucurbit fruit? (Fun fact: tomatoes and cucumbers are both categorized as fruit—see, I told you art history is a portal to all disciplines.) Because artists prior to the twentieth century did not throw random details into their works. Every element of a painting or sculpture was carefully considered, sometimes even dictated in the contract signed between the artist and the commissioner of the work. A patron, especially the clergy, would not have been cool with Crivelli randomly inserting a picture of a pickle into his religious paintings, destined for church altars, if there wasn't a good reason for it. What that reason is, though, is an enduring mystery.

Pickles aside (and who doesn't like a side of pickles?), Crivelli's 1486 *Annunciation* is a good work through which to introduce the concept of "reading" the

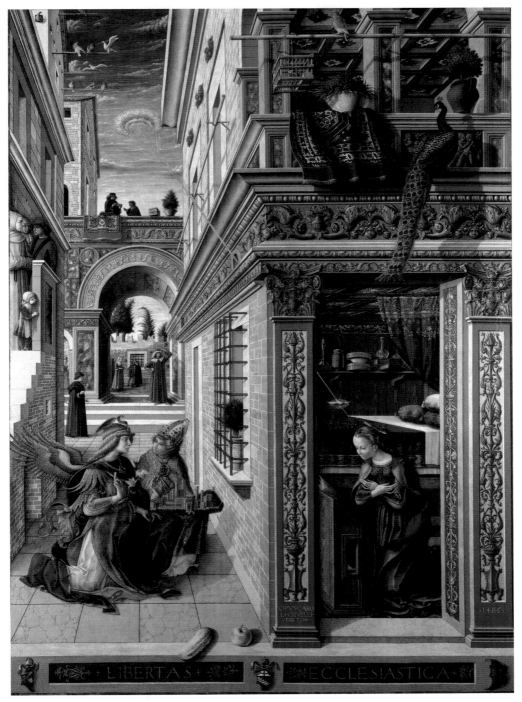

Annunciation by Carlo Crivelli (1486). Find the pickle. Find it, I say!

PHOTO COURTESY OF WIKICOMMONS FROM THE NATIONAL GALLERY.

symbolic elements in artworks. This is an intimidation point for many a potential art lover. Not being able to recognize and interpret symbols is like being thrown into a foreign country, surrounded by people speaking a language you do not yet know. Thankfully, there is a finite number of regularly recurring symbolic images in most Western art, making it easy to memorize this new visual vocabulary.

The **Annunciation** is the second-most-depictured scene in Western art history (the crucifixion is number one). It shows the moment when God sent the Archangel Gabriel to visit the Virgin Mary and tell her that she would give birth to the Son of God. There are dozens of Annunciations studied in art history classes, and tens of thousands scattered around Europe. How they differ, in terms of *disegno* and *invenzione*, keeps things interesting. But there are some consistent elements, particularly in Renaissance Italian Annunciations, that make it so that interpreting one can unlock interpretations to scores of others. Let's use Crivelli's as our template.

The staples of Annunciations are Mary and the Archangel Gabriel. Gabriel is often shown with multicolored wings, loosely resembling those of a parrot (or at least what a Renaissance painter who had never seen a parrot in his life *thought* a parrot's wings looked like). This is a reference to an obscure theological interpretation of Virgin Birth.

Virgin Birth refers to the Virgin Mary becoming pregnant with the Son of God without ever having intercourse. It's often confused with Immaculate Conception, a separate concept in which Saint Anne, Mary's mother, who conceived her the old-fashioned way, had that conception "cleaned" (immaculate comes from the Italian meaning "unstained") in order to purify Mary's existence.

Now, if a young woman was pregnant and gave birth to a son and people argued that she was a virgin, it might sound like a dubious claim. This was the case even in the Middle Ages, when the masses at Mass thought the idea that Mary was a virgin and yet gave birth to Jesus was suspect. In order to quell this consternation, theologians came up with a few interpretations. I'm not sure how convincing they sound now, but for our purposes, we only need to know them enough to recognize references to them in this painting.

Back to **parrots**. One explanation for the Virgin Birth was that if a parrot can be taught to say "Ave Maria," then Mary can be a pregnant virgin. (Makes perfect sense to me . . .) This is why you can find Gabriel with parrot-like wings, or even parrots, in Annunciation paintings.

But wait, there's more! Many such paintings show a **ray of light** shooting out from the sky, passing through a window, and touching Mary. Sometimes there's a white dove or even a miniature baby skiing down this ray of light. This

refers to another dismissal of concerns over the Virgin Birth: If a ray of light can pass through a pane of glass without breaking it, then Mary can be a pregnant virgin. The defense rests.

This is why there appears to be a *Close Encounters*–style beam of light shooting down from a rift in the clouds, along which a **white dove** (symbol of the Holy Spirit) zips down toward Mary. Mary is almost always shown **kneeling or seated on the floor**. This, too, has symbolic resonance: it conveys humility, a word derived from the Latin *humilitas*, which literally means "close to the earth." Her arms are crossed over her chest, a closed, defensive posture, emphasizing that this pregnancy was thrust upon her and was not something she was openly seeking. On a balcony ledge above her stands a **peacock**. In medieval bestiaries (catalogues of animals, real and imaginary, with stories related to them), it was recorded that peacock flesh did not decompose after their death. This scientifically inaccurate idea led to the linking of peacocks with Christ, who, the story goes, was resurrected after his death and eventually whisked directly up to Heaven, so his body, too, never decomposed. **Doves**, in addition to being a potential stand-in for the Holy Spirit, are more generally symbols of innocence and purity, and because of this, often accompany Mary to emphasize these qualities in her, as does the **halo** over her head, an attribute given to saints and holy figures.

Formally, the composition of the painting really emphasizes a technique called single vanishing point perspective. Can you spot the vanishing point? There's a trick. If you close your eyes while facing the artwork, then open them suddenly and allow them to gravitate where they will, your gaze will inevitably be drawn to the vanishing point. This is by design, with all the orthogonal lines (diagonal lines all emanating from a single point in the middle of the painting) from the buildings and the pavement drawing your eye to the vanishing point, the barred window in the wall at the back. Even that crenellated wall has symbolic value: Mary's virginity was described like a **walled garden**. The garden behind the wall might be Eden, from which humanity was cast out due to Original Sin. Sometimes a wall is just a wall, but not in the case of Renaissance art.

Numerology plays an important role in the Bible and in its art. Look for clusters of twelve, four, and three, sacred numbers meant to recall the tribes of Israel and the number of apostles (twelve), the gospels and evangelists (four), and the Holy Trinity (three).

Gabriel's **Annunciation** (a fancy word for saying something) was in the form of the words "*Ave Maria Gratia Plenum Dominus Tecum*" (Latin for "Hail Mary, full of grace, the Lord salutes you"). With these words, Mary is

impregnated. We can tell whether or not Mary is already pregnant. She's about to be in this painting but isn't quite. The Holy Spirit, that white dove zip-lining down a ray of light, is about to enter her body, but it's not there yet. In his left hand, Gabriel holds a **white lily**, a gift to Mary with loaded meaning. White lilies represent purity, but they are also traditional funerary flowers, a nod to the fact that Mary's son, Jesus, is being born but with the purpose of dying. His right hand is held palm forward, pointer, middle finger, and thumb straight up, a blessing that even the pope today makes when addressing a crowd.

Beside Gabriel is a local saint, Emidius, who is shown holding a model of the city for which this painting was commissioned: Ascoli Piceno. In 1482, the pope granted an advanced level of self-governance to this city ("*Libertas Ecclesiastica*," which can be seen written at the bottom of the painting), the news arriving on March 25, which is celebrated as the feast day of the Annunciation. To commemorate this, Crivelli was hired to paint an Annunciation including the patron saint of Ascoli Piceno for display in the local cathedral. This inclusion of Saint Emidius, who historically has nothing to do with the Annunciation (he wasn't born for another few centuries), makes this version of the Annunciation unique, local, and distinctive.

You can't help but spot Crivelli's pickle, as it appears to be sticking out of the plane of the painting, breaking the illusion that the painting is actually a window through which we see real life. Next to it sits an **apple**. Innocuous, you say? Well, by now you'll have noted that nothing is there by chance. The apple is linked to Original Sin, as it is traditionally shown as the Forbidden Fruit in the Garden of Eden. When Eve took a bite of the Forbidden Fruit, nothing happened. But when Adam did, having been offered the fruit by Eve, all heck broke loose. Adam and Eve were banished from Eden due to this Original Sin—the only rule God had set forth had been broken. Eve and all women, her descendants, were cursed with painful childbirth as punishment. And humanity was forced to live outside of idyllic Eden and deal with the horrors of the non-ideal world. Original Sin was a burden on all humanity from that point forth, until the moment Christ died, and it was reversed.

Theologically speaking, if you asked a Renaissance priest the reason why Christ was created by God, he would reply that it was in order to reverse Original Sin, which weighed upon humanity from the moment Adam took the Forbidden Fruit. This connection between Adam and Christ is shown visually by artists in myriad ways. The hill outside Jerusalem where Christ was crucified is called Golgotha, Aramaic for "place of the skull," because it is said to have been the very spot where Adam died, and where his skull could be

found. A skull at the foot of the cross is meant to be Adam's. In the *Merode Altarpiece* by Robert Campin, Joseph (Mary's husband and Jesus's stepfather, if we understand that his father was actually God), is in his carpentry workshop putting the finishing touches on a mousetrap. Christ was described as "a trap to catch the devil" laid by God to trick the devil into reversing Original Sin. The idea was that the devil thought he was promoting his own end by arranging for Christ to be killed, but in fact that is what God had wanted all along. In dying, Christ reversed Original Sin and the devil was defeated. Hence the mousetrap in the painting.

That's a lot of symbolic weight in a single apple, but there you have it. There's more, of course, even in this one painting, but let's stop before smoke starts coming out of your ears.

<div style="text-align:center">⸺ ⸺</div>

Welcome to the world of "disguised symbolism," as one of the great art historians, Irwin Panofsky, called it: objects in artworks that are present for their symbolic meaning, for some often obscure reference they make that helps to unlock our understanding of what an artwork "means."

Symbolism has been present in art for as long as art has been created, but the creators didn't always see it as such. Looking at one of the oldest sculptures ever found, the *Venus of Willendorf*, we see a statue of what appears to be a plump, pregnant woman with large breasts and a pronounced pubic triangle. This was likely meant to be symbolic—the figure represents the idea of fertility. That would have been self-evident to those who engaged with the statue, to the community in which it played a role. Other symbols were decipherable only to a select audience. There are works like Petrus Christus's *Our Lady of the Dry Tree* that still confound interpretation, but the best guess is that the symbolism within it is linked exclusively to a confraternity (a religious private club of sorts) to which Petrus Christus belonged, and no nonmembers were meant to understand what the painting "meant." Other symbols would have been immediately recognizable to educated contemporaries, but we in the postmodern era have forgotten, or ceased to learn, how to "read" these symbols because they are no longer relevant to our daily lives.

If we were in the sixteenth century, we would immediately recognize that a painting of an old man holding a pair of keys is meant to represent Saint Peter, or that a portrait that includes a dog does not necessarily mean that the person portrayed had that dog as a pet; rather the presence of the dog is meant to convey an idea that the dog embodies: loyalty. This visual dictionary must

be relearned in order to successfully interpret artworks in the Western tradition. The symbolic vocabulary is remarkably consistent and finite in European art and areas influenced by it (like North America). It is more like a series of equations than definitions: a pair of keys = Saint Peter. As such, it is easier to visualize and memorize.

We still employ disguised symbolism today, it's just less disguised and we absorb it unconsciously. If you see a building with a cross on top of it, you'll "read" that this is a church and the cross is a symbolic representation of Christ, linked to his story because a cross was the instrument of his execution. If you see a restaurant with a pair of golden arches atop it, you'll "read" that this is a branch of McDonald's—the "golden arches" letter *M* has been repeatedly presented to us in ads, so we have absorbed it into our unconscious and read it intuitively.

The decoding of art, **iconography**, can be divided into three sections. **Hagiography** is the study of saints. **Allegory** involves personifications of ideas: human figures who embody concepts, like a woman wearing a blindfold and carrying scales in one hand and a sword in the other represents justice and can be seen on many a courthouse even to this day. The third (and the one with the coolest name) is **disguised symbolism**, wherein objects take on symbolic meaning, like a dog representing loyalty.

SAINT-SPOTTING 101

The majority of artworks that you'll come across in visits to European museums and churches are religious—which is to say, Christian—in subject matter. This is because the Catholic Church was the main patron of the arts, responsible for commissioning the majority of artworks, until the eighteenth century. Most art prior to around 1700 was made only when someone ordered it. A cardinal might place an order for an Annunciation scene. The cardinal would pay for the painting and it would be made according to a contract, for a specific location, like the altar of a church. Members of the church commissioned most of the works of art in Europe through the Middle Ages and the Renaissance.

Wander the halls of just about any museum in the world and you will see a lot of dudes with beards, wearing what look like togas, looking unhappy (because many are being killed in dramatic and gruesome ways). The vast majority of the religious stories and images in the paintings around you come from the Bible, but we cannot know who is who, which saint is which, without some clues provided by the artists. Occasionally artists included the written names of those they represented, but not always—and art was meant to be appreciated even by people who couldn't read, so a written name was not always

useful. Instead, artists gave each person an attribute, usually an object they would carry, that would act in place of a name tag.

How were these objects chosen? Well, most of the objects, grisly as it may sound, are linked to the manner in which each saint was martyred or killed for their refusal to renounce their faith in Christianity. We know the stories of the lives of saints largely thanks to a sort of group biography of hundreds of saints called *The Golden Legend*, written by a bishop named Jacobus da Voragine in the twelfth century. The lives of these saints didn't differ dramatically (almost all of them were exemplary Christians, never sinned, refused to marry, performed at least one miracle, and so on).

But most saints can be distinguished by the creative ways in which they were executed. Jesus was crucified, so he is shown with a cross—that one just about everyone knows. But how about Saint Andrew? He was crucified too, but on an X-shaped cross. That one is a bit trickier. But there are lots of others. Bear with me a bit because the next part is slightly gruesome.

"Hagiographic icons" is the fancy term for objects carried by saints that help to identify who is who ("hagiography," as mentioned above, is the study of saints, and "icon" comes from the Greek word *ikon*, meaning "symbol"). By memorizing a finite number of hagiographic icons, objects carried by saints to identify them, we can suddenly recognize saints around the world, no matter who painted or sculpted them, where, and when. We just have to know how they were killed. A dude carrying a sword and who, for some reason, is always shown bald? That's Saint Paul, who was beheaded. A woman carrying a sword and a spiked wheel? Saint Catherine of Alexandria, who was supposed to be torn apart on a spiked wheel, but God sent a bolt of lightning to smash the wheel, so instead she was beheaded. A dude shot full of arrows? It's always going to be Saint Sebastian, who was used for target practice by archers but mysteriously did not die, and so was later clubbed to death—but the arrows are the more distinctive hagiographic icon, so that is how he is known. Want to get even creepier? Saint Lucy had her eyes gouged out, so she is usually shown carrying her eyes on a platter. Saint Bartholomew was skinned alive and is depicted carrying a knife and his skin! Some of the stories are more darkly funny than scary. Saint Lawrence was roasted alive on a grill. That probably doesn't sound that funny to you but, according to *The Golden Legend*, he was pretty cool with it. After a while, he told his executioners, "Turn me over, I'm done on this side." I always thought it would be funny to name a roadside restaurant the Saint Lawrence Grill. Only art history experts like us would understand the joke.

By linking these memorable stories with the icon used to illustrate them, it is pretty easy to memorize a few dozen saints and their identifiers. The good thing is that while there are hundreds and hundreds of saints, there are only a few dozen who appear regularly in European art. You don't need to memorize anything about Saint Polycarp—you could live to 102 and never run into a single painting of him. But if you visit Rome, you'll find yourself tripping over paintings of Saint Peter, Saint Paul, and Saint Sebastian. It'd be pretty cool if, as soon as you walk into a church, you can tell from across the room exactly which saints appear in each painting, right? Well, you can. Here's a handy chart to twenty saints and how to spot them.

Table 4.1. Field Guide to Saint Spotting (aka Hagiography)

Saint	How to Spot 'Em
Peter	Two keys, upside-down cross
Paul	Sword, for some reason always shown as balding
Sebastian	Shot full of arrows
Bartholomew	Holding a knife and/or his own skin
Lawrence	A grill
Catherine	A spiked wheel and sometimes a sword
Francis	Receiving the stigmata, preaching to birds
Stephen	A rock in his head
Anthony	Carrying a T-shaped walking stick
Lucy	Carrying her own eyes on a plate
Andrew	An X-shaped cross
Luke	Accompanied by, or embodied as, an ox
Mark	Accompanied by, or embodied as, a winged lion
Matthew	Accompanied by, or embodied as, an angel
John the Evangelist	No beard, carrying a goblet with a snake inside it, an eagle
John the Baptist	Hairy, wearing fur, carrying a cross made of reeds
Mary	Dressed in lapis lazuli blue
Jerome	A cardinal's red hat, with a lion at his feet, whacking himself with a rock
Mary Magdalene	Long blond hair, a jar of ointment, a veil
Nicholas	Anchor

ALLEGORY AND DISGUISED SYMBOLISM

In addition to hagiographic icons, art incorporates "disguised symbolism": inanimate objects that are inserted into works of art not because they have a narrative or descriptive function but because they convey an idea about the scene or person depicted. In Jan van Eyck's *Arnolfini Wedding Portrait*, we are not meant to assume that the Arnolfinis liked to store their oranges on the windowsill, or even that they were big fans of oranges. Rather, the oranges are there to convey the idea of fecundity and also the wealth that allowed the Arnolfinis to buy citrus fruits imported to Bruges, at great expense, from Spain. The dog at their feet may or may not have been an actual household pet, but it is there to convey the theme of loyalty, in this case loyalty of the couple to each other.

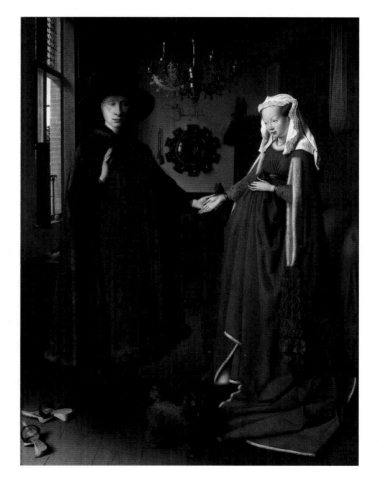

I learned to call this painting *The Arnolfini Wedding Portrait* by Jan van Eyck (though that title will get the knickers of some fellow art historians in a twist) (1434). She's not pregnant, people! PHOTO COURTESY OF WIKICOMMONS FROM THE NATIONAL GALLERY.

While inanimate objects can convey ideas, people can function likewise. Already in classical times, allegorical personifications were used to express abstract ideas visually: love, wealth, fortune, Rome, Egypt, prosperity. Most of these abstract concepts are feminine nouns in both Greek and Latin and are therefore represented as stately women. Love is a boisterous boy. Victory flies to the rescue of beleaguered armies, like the *Winged Victory of Samothrace* now in the Louvre, brandishing a palm branch, her symbol. Christian martyrs, at the moment of their death, are offered the same victor's palm by an angel.

And then there are the riddling pictures that no one will ever unravel, mysterious paintings like Botticelli's *Primavera*, a secret code to be understood only by the inner circle of Lorenzo di Pierfrancesco de' Medici, cousin and political opponent of the more famous Lorenzo the Magnificent, fifteenth-century ruler of Florence. We can guess about its meaning, but we will never really know. And sometimes it takes more work than usual to unravel a painted riddle. Raphael's suite of rooms for Pope Julius II can be picked out in its general outlines, as can Michelangelo's Sistine Chapel ceiling, but the wealth of ideas that went into the conception of these works is so great that scholars have been discussing them for centuries and will continue to do so.

Understanding iconography provides a few clues to unlock Bellini's *Sacred Allegory*, but most of it remains veiled to us. The debate over what these intentionally puzzling works mean provides the welcome excuse for a closer look at some of the world's transcendent works of art. *Sacred Allegory* was likely meant to be the subject of learned debate even for its contemporaries. Works of art that provoked thoughtful meditation, that required puzzling out, offered a pleasurable intellectual exercise for their viewers, prompted engagement with sacred themes, and provided thought-provoking entertainment as well as decoration.

In the Florentine monastery of San Marco, the monastic cells each contain a different painting (some by the great Fra Angelico, who lived there), and the paintings vary in their conceptual complexity. Younger monks would begin dwelling in the cells with the simpler subjects (a Crucifixion, for example) and move up to cells painted with more complicated scenes, like the Holy Trinity (which shows God, Jesus, and the Holy Spirit as both one combined being and three separate entities, often depicted as Masaccio did in his *Holy Trinity* painting at Santa Maria Novella—which Vasari would save by building a false wall over it when he was tasked with renovating the church around it—with the three figures painted one atop the other.

This hidden symbolism is not relegated to Old Masters (art made prior to the modern era, roughly pre-1850s). Ivana Kobilca's wonderful portrait *Kofetarica*

Holy Trinity by Masaccio (1426–1428) was walled up during a renovation by Giorgio Vasari and only rediscovered three centuries later. What else awaits excavation? PHOTO COURTESY OF WIKICOMMONS.

(the word in Slovenian might be translated as "female coffee enthusiast" or "cof-feecionado"), painted in 1888, is one of the great paintings of art history, period. Looking at it suggests that there is more to the portrait than meets the eye, and that the coffee, which we do not even see, might be laced with something stron-ger—either in the cup itself or in the message conveyed silently by the painter. With joy and welcome and a sly, layered look in her eye, a grandmotherly woman in black (indicating that she is a widow) raises a glazed terra-cotta coffee cup painted with flowers in a motion that at once suggests "cheers" and the intent to sip. She locks eyes with us, the viewer, her gaze and expression complex and difficult to read clearly—at *Mona Lisa* level of welcoming further analysis and discussion. One might read expectation, evaluation in her face. Is it all about the coffee that we, the viewer, were just served by her? Or is there something more? What social commentary is handed down by the woman who painted it? At the time this portrait was painted, coffee was a precious commodity in this corner of the Habsburg Empire, and the implication of being called a "coffee drinker" was that you had too much time and money. All that loaded information would have been clear to viewers circa 1888 but needs to be relearned by us, contemporary viewers, and so qualifies for us as crypto-symbolism.

Thus, there are two levels to the works we twenty-first-century viewers see as puzzles. First is that we must relearn the standard visual vocabulary of past eras, an act that very quickly peels away the mystery and allows us to identify saints and allegorical personifications with some ease. But there were also works, which we might call "mystery paintings," that were always intended to provide riddles to the viewers, even contemporaries, like Bronzino's *Allegory of Love and Lust*, which we'll tackle shortly.

To interpret that painting, art historians relied for centuries on a textual description of it included by Vasari in his *Lives*. His book has long been the default key to unlocking mysteries of Renaissance art, but his work is some-times misleading. Such was the case for this allegorical painting until someone realized that the long-standing overreliance on Vasari was leading scholars astray, as Vasari had accidentally misremembered or incorrectly described the painting's mysterious content.

WHEN THE KEY DOESN'T FIT THE LOCK: UNLOCKING BRONZINO'S *ALLEGORY*

Vasari has long been, and remains, the go-to primary source text for scholars researching Renaissance Italian art. But sometimes, despite Vasari's best inten-tions, he winds up leading scholars down false interpretative trails.

Bronzino's *Allegory of Love and Lust* is a case in point. (It's also my favorite painting, and I've tried to slip it into every one of my books—mission accomplished!) One of the most memorable and well-known works in London's National Gallery, it shows a shockingly erotic embrace of a marble-white-skinned nude Venus tonguing an adolescent Eros (her son, it must be said) while surrounded by gorgeously painted but mystifying allegorical personifications, including a girl monster with the face of a beautiful courtly lady, the tail of a snake, lion's legs, and hands affixed to the wrong arms, with which she offers sweet honeycomb while concealing a scorpion.

Vasari's *Lives* was used by centuries of art historians who tried to unravel the meaning of

Future reviewers of this book who inevitably ask me what my favorite painting is—the answer is this one! Bronzino's *Allegory of Love and Lust* (at least that's how I learned it, others call it *Allegory with Venus, Cupid, Folly and Time*, but what do they know, really?) (1545). PHOTO COURTESY OF WIKICOMMONS FROM THE NATIONAL GALLERY.

this striking, eroticized riddle of a painting. In this case, it was a mistake on Vasari's part that misled art historians. Only in 1986 did art historian Robert Gaston offer a plausible interpretation of the famous mystery painting that confounded four centuries of scholars—all because of their determination to use Vasari as their major source.

Translations of Vasari are rife with annotations and footnotes that correct or clarify his text, which, while remarkably accurate for the time, is still pocked with misinformation. This is understandable, as Vasari was inventing a type of book that had not previously existed, sewing together the lives of artists based on hearsay, anecdotes, found letters, and his own memory. But such is Vasari's enduring power that only in the last two decades have art historians realized they must not view his work as infallible, laced as it is with unintentional human error. But reliance on Vasari has inhibited the interpretation of some works, just as it has provided a key to interpret countless others.

Bronzino wished to make his *Allegory* difficult to decipher, inserting layers of interpretation and even toying with viewers physically, forcing them to approach a wildly erotic painting and view it as closely as possible: Without stepping right up to it, you cannot see a key detail, that a child personifying the joy of the first flush of a love affair has actually stepped on a thorn that has pierced his foot, with blood bubbling to the surface, but he does not care, because love has so distracted him that he will only later realize the pain it has caused.

In order to understand clearly how art historians employ Vasari's *Lives* to unlock the secret history of art—the history that has eluded interpretation, the blank spaces in the colossal jigsaw puzzle of historical knowledge—we turn to the story of *Allegory of Love and Lust*.

Vasari does not have a lot of time for Agnolo Bronzino in his *Lives*. This is likely a matter of professional rivalry (Vasari did not say much about him until Bronzino passed away, when he admitted how much he liked and admired him). Bronzino held the post of official court portraitist to the Medici family just prior of Vasari's succession to that role. Bronzino was a wildly talented painter, arguably the best of Vasari's era. His portraits are glassy, painted with such sheen and finish that brushstrokes are invisible. By contrast, Vasari's portraits are functional but ungainly, a good step below the work of Bronzino. It is perhaps unsurprising, then, that Bronzino is not awarded further praise by Vasari in the form of his own chapter, his own "Life," but rather is mentioned in passing, lumped inside a group chapter titled "On the Academy of Design." Within this chapter, even less is said of Bronzino's individual works, although Vasari is quietly praising. But for centuries, one small paragraph on an elaborate, complex allegorical painting was the only clue available to art historian detectives in their attempts to unravel the meaning of one of the world's most famous works.

The work is the most reproduced painting of the Mannerist style, the exemplar in countless art history textbooks. Yet for such a famous painting, its physical history is nearly as mysterious as its interpretation. It was painted around 1545 and was sent as a gift to King François I, who loved Italian art and naked ladies, making this work an ideal present. The extent of Vasari's text on a Bronzino allegorical painting reads:

And [Bronzino] painted a picture of singular beauty that was sent to King Francis in France, wherein was a nude Venus with Cupid who kissed her and Pleasure on one side, with Play and other cupids, and on the other side was Deceit, Jealousy and other passions of love.

It's not much to go on, but it was all scholars had that seemed to refer to the painting in question from the time that it was painted to the modern era. Vasari tells us only that (1) the painting was sent to François I, king of France (though he does not specify that it was painted for him) and (2) the names of the figures and allegorical personifications present in the painting: Venus and Cupid, as well as personifications of the concepts of Play (alternatively translated as Playful Love or even Folly), Deceit, and Jealousy, as well as other "cupids" or baby angels, and the rather enigmatic addition of "other passions of love."

It is from this short paragraph that centuries of scholars have departed, seeking to match up the personifications described by Vasari with the figures in the painting that hangs in the National Gallery. A quick look at Bronzino's painting makes Venus and Cupid easy to spot, although Cupid is in fact present in his adolescent form, usually called Eros. But what of Play, Deceit, Jealousy, "other cupids," and "other passions of love"? This is a game of mix-and-match, affixing the titles mentioned by Vasari to the figures painted by Bronzino. Jealousy might be the yellow-skinned figure on the far left, tearing its hair out and screaming with a mouth full of rotting teeth. Play could well be the naked child about to fling an armful of rose petals over the embracing Venus and Cupid (the one who doesn't notice he's got a thorn stuck in his foot). Deceit could be the girl monster, she of the swapped hands. So far so good. Other cupids and other passions of love? That's not so clear. There do not, in fact, appear to be any other "cupids" (*putti*, the Christianized equivalent of Cupid, in the form of plump baby angels). In terms of "other passions of love," we might likewise look but remain unsatisfied. There is a clear allegorical personification of Time, with his traditional wings and hourglass, of whom Vasari makes no mention, which is odd. There's a weird figure in the top left corner that appears to be working against Time and is missing the rear portion of its head. There are masks on the ground, bearing the faces of a satyr and a Maenad. Why no mention of these? They hardly qualify as "cupids" and "other passions of love."

Despite the difficulties in cleanly matching Vasari's description with the London *Allegory*, every scholar who examined the painting did so through the lens of Vasari's text, for lack of any other written reference to the work in question. Despite many theories, no one made convincing progress. Bronzino's *Allegory* remained one of art history's great mysteries. And then along came Robert Gaston, who recognized something no one else did, though it stood out in plain sight.

Vasari, Gaston suggested, was describing a *different painting*. His description simply does not jibe with the London *Allegory*. Perhaps Vasari misremembered

the content of the painting, since he had not seen it for several decades when he wrote about it (the relevant passage appears only in the 1568 edition of *Lives*). If he ever saw it in person (and we cannot be certain that he did), it would have been prior to 1545, when it was shipped off to France. Either Vasari misremembered the painting or—as seems more likely, since the description lacks the most obvious allegorical personification, that of Time—in this passage Vasari described an entirely different painting, a variation on the same theme.

Vasari's description had been a crutch for art historians, who lacked other clues beyond the work itself. But that crutch had been so leaned upon by generations of scholars that they had forgotten they could walk on their own. While *Lives* has been of critical use to countless researchers, in this particular case, four hundred years of research had made no progress because of an overreliance on the oft-inaccurate Vasari. It was only when Gaston cast Vasari aside that progress was made.

He came up with a reasonable and generally agreed upon interpretation that I expanded on in one of my master's theses, many moons ago. The painting was actually a warning against the dangers of being guided by lust and mistaking it for love, which was a popular theme in contemporary Tuscan poetry circa 1545. It seems to have been directed at Bronzino's best friend, a writer who was being courted by an infamous courtesan. The allegories collectively show the potential negative consequences of submitting to lust: jealousy and disease (the androgynous figure with gray skin, receding gums, and tearing at their hair), folly (foolish behavior, shown as the child throwing petals while stepping on a thorn), and betrayal (the hybrid serpent woman), while Time (the bearded man with wings, who looks strikingly like Bronzino's writer friend) struggles against Oblivion (the masklike face in the top left corner, which looks like the courtesan who was romancing him) to reveal the dangers of falling in lust (with the rather misogynistic implication that women will just break your heart and use you, so you should steer clear of them).

Through allegory, an entire philosophy and hidden message was conveyed in a way that required the proactive participation of the viewer to unpack and comprehend, with the intended audience able to understand it better than those without some specialized knowledge, who see its beauty and intrigue but not the direct message it contains.

CHAPTER 5

The *-isms* Cheat Sheet in Thirty Paintings

Key Work: Artemisia Gentileschi, *Judith and Holofernes* (1614–1620)

WHEN PEOPLE GET NERVOUS ABOUT ART, THE BLANKET UNDER WHICH THEY hide is often woven with *-isms*. By this I mean that the concern is not in understanding what the various classifications of art movements mean but rather that there are so many of them that we don't quite know where to begin: Surrealism, Fauvism, Futurism, Realism, Abstract Expressionism. Then there are other terms that can sound foreign: Archaic, Romanesque, International Gothic, Baroque, Plein Air (how do you even pronounce "plein"?).

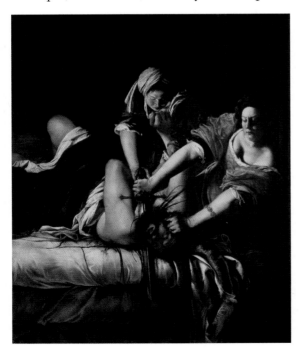

Don't mess with Judith, y'all. *Judith and Holofernes* by Artemisia Gentileschi (1614–1620). PHOTO COURTESY OF WIKICOMMONS FROM THE UFFIZI, FLORENCE.

It is frightening to admit that we don't understand something because we worry that others will judge us as dumb or uncultured. What a load of hooey. A sign of someone smart and cultured is the desire to learn what one does not know, and that begins with a willingness to admit that there is, in fact, little that we do know in any depth. Raising your hand (literally or metaphorically) and saying, "I don't know this, but I'd like to learn" is a sign of self-confidence. Then it's up to your instructor (in this case, me) to inform in a way that is clear and memorable. That means there's no pressure on you, it's all on me. Bring it on.

A foray into art requires braving the hailstones of terminology—and realizing that they aren't actually scary at all. One of the best ways to accomplish this is to speed through the hail in order to reach a destination and note that we survived the storm. The other way is reductionist: Boil down the definition of each period or style of art into the easiest-to-remember shorthand for it. That is likely all you'll need unless you plan to dig deeper and become a student of art history. We'll combine these two approaches and sprint twice through the hail of beautiful objects. The first time through, we'll focus on painting and the goal will be to use an image to help understand the *-ism* in question. The second time, we'll go into more depth on thirty-seven sculptures, attempting to tell a complete(ish) history of art in doing so, from prehistoric times to today. Two wind sprints, two approaches, two media, two ways to learn.

There will be some overlap in the lessons gleaned from both sprints, but that's intentional: I mean to show that the basics of art are finite and learning about one medium means you'll also learn about others, and that repetition yields effortless memorization. I like to tell my students that if they pay attention in my classes, they should never have to study for a test because I'll hammer home the key points often and from different angles so the information should be absorbed organically.

You heard it from a professor: There's nothing wrong with a cheat sheet, as long as you don't use it to actually, you know, *cheat* on an evaluation. If it helps you to learn something, then more power to you.

I always used to make cheat sheets as a student, but I wouldn't bring them to a test. The act of making them—of constantly trying to hone the knowledge I had to retain to the most concentrated, sharpest form, the easiest to summon up when called upon—helped me learn it. So, my doing the work for you somewhat defeats the purpose. The best would be if you read up and then make the cheat sheet yourself. But I'd feel remiss in writing you a book with too many blank spaces and telling you to go write it yourself. So, in the interest of fairness, here we go. These are the most concise ways that I can think of to reduce thirty

-*isms* (and a few -*ics*) important to the history of art (not all represented in our bottled history of sculpture—the subject of the next chapter—which is why we include some here and some there) to something maximally digestible.

<p style="text-align:center">～</p>

A SHORT HISTORY OF KEY ART MOVEMENTS, ERAS, AND STYLES
Cave Painting

The earliest paintings were made by our prehistoric ancestors on cave walls, for either commemorative or ritualistic purposes. They were not decorative because many could be seen only by torchlight. The earliest of all were handprints made by blowing pigment from one's mouth over one's hand as it was pressed to a cave wall, thereby coloring around it. Images of hunting are the earliest figurative paintings, as in this beautiful horse. It was sometimes thought that art was something people created only when all their basic needs were tended to, that it was an optional "extra." Cave paintings demonstrate that this is not the case. Our cave-dwelling Stone Age ancestors had no agricultural development and constantly fought to fulfill their basic needs, and yet they took the time to make art, indicating that this is a basic human drive and not a frivolity.

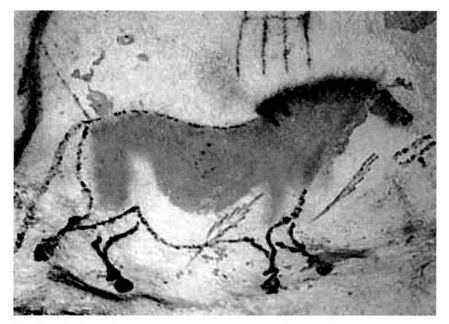

Painting of a horse from a cave at Lascaux. It was made by Cro-Magnon people some 20,000 years ago along their hunting route. PHOTO COURTESY OF WIKICOMMONS FROM THE FRENCH MINISTRY OF CULTURE.

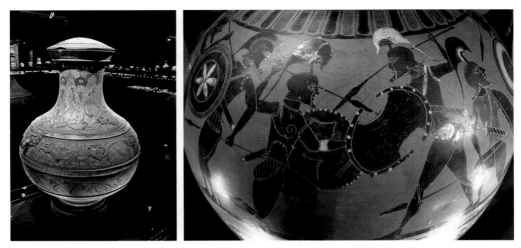

Here we see a Western Han–era Chinese vase (likely second century BC) and a black figure amphora of a battle scene from Athens (likely sixth century BC). Extra credit if you can guess which is which.
VASE PHOTO COURTESY OF WIKICOMMONS. AMPHORA PHOTO COURTESY OF WIKICOMMONS BY PROMETHEUS PAINTER.

Vase Painting

Decorating vases and terra-cotta vessels long predated painting on panel or canvas. Here are examples from the Western Han era in China and from ancient Greece, as in this **Black Figure** painting on an amphora. It is interesting to compare and see how relatively more advanced Chinese painting was compared to its European counterpart.

Roman Wall Painting

Paintings on walls are called murals. When the paint is applied to a fresh layer of plaster, so that as the plaster hardens it locks the colors into the wall, it is called a fresco. Ancient Roman frescoes, used to decorate private homes as well as public buildings and businesses, are divided into four styles. The first style, Incrustation, consists of colorful blocks of paint meant to replicate very expensive slabs of marble. The second style, Architectural, involves **trompe l'oeil**, which "tricks the eye" into thinking a two-dimensional painting is actually a three-dimensional architectural element. The third style, Ornamental, isn't about illusion but decoration. Painted columns, lines, blocks of color, or even details like a candelabra could be painted onto the wall simply for the pleasure of changing the feel of the space. The fourth style, Intricate, includes aspects of all the previous styles: architectural details, blocks of color, and ornamental aspects.

Romanesque

Literally the "Roman style" inspired by the architectural ruins of ancient Rome, this manifests in sculpture that decorated Romanesque churches, particularly reliefs. Figures tend to be chunkier and squatter, with generic features. There is little realistic about them, even in proportions.

Gothic

Linked to an advance in architecture that found that pointed arches could handle weight better than rounded ones (therefore permitting taller buildings with thinner walls and more windows), Gothic sculpture mirrors the churches for which they were made: elongated, thinner, sometimes painted. (The term for painted sculpture is **polychrome**.) Painting incorporated similar characteristics, putty-stretched bodies with needlelike fingers. See Lorenzo Monaco's *Coronation of the Virgin* in chapter 3 for a late example of this style, referred to as **International Gothic**, containing some of the subtleties and realism of the early Renaissance but in a largely medieval Gothic style.

Flemish Primitives

This is a very outdated and almost dismissive term that is still in use for **Early Netherlandish** painting. It refers to fifteenth-century painting from Flanders and Burgundy, which, at the time, was more advanced in realism and detail than Italian painting. See the *Ghent Altarpiece* in chapter 7 for an example of this style.

Early Renaissance

This was the start of a renewed interest in the Classical world, particularly Athens and Rome, led by Donatello in sculpture, seeking to relearn the art of the ancients, such as the lost-wax method. In painting this manifested in more three-dimensional, humanized figures. Developments in optics and mathematics meant that a realistic perspective and the illusion of depth could be added to paintings. **Foreshortening** replicated how our eye sees objects that are closer to us as larger, and objects farther away as smaller. Foreshortening is the artistic act of reproducing the illusion that what we see that is physically closer to us appears larger than what we see that is farther away from us. Imagine someone standing a few steps away from you, holding their arm extended toward you so their hand is a few inches from your face. The hand will appear very large, much larger proportionally than the person's face. We know, logically, that the human head is larger than the human hand, but whatever is closer appears larger. Foreshortening reproduces this three-dimensional illusion in art. **Single**

vanishing point perspective gives the appearance of three-dimensionality to a two-dimensional painting. A horizon line was drawn and a single point on it was chosen as the "vanishing point." From this vanishing point down to the edges of the canvas straight lines were drawn, called **orthogonal lines**. Then, from the bottom of the canvas up to the horizon, horizontal lines were added, drawn closer to each other as they got closer to the horizon. The result was that the bottom half of a painting looked like a chess board (or, if you're old enough, the original film *Tron*). Figures could be added to this grid, their proportions mathematically calculated so that those meant to appear nearer to the viewer were painted larger and those meant to be in the distance in the painting were shown smaller. This was the primary technical advance of the Early Renaissance in Europe and allowed for an unprecedented level of illusionism. Alongside this, faces become less generic and more like portraits, drapery appears to have mass and form, feet appear to be standing on surfaces rather than floating above them. See Masaccio's *Holy Trinity* as an example in chapter 4: This work combines early use of foreshortening and single vanishing point perspective, as well as geometric compositions. The Trinity—the Father (God), Son (Christ), and the Holy Spirit (in the form of a dove)—was theologically both three separate entities and one combined unit. Masaccio chose to paint them as such, layered together with a white dove in the foreground overlapping (and looking a bit like a necklace) with Christ and with God looming in the background, all set against the illusion of depth in the barrel vault arch above them.

High Renaissance

This movement was led by a philosophy called **Neoplatonism** (inspired by both Plato, and his Allegory of the Cave, and Plotinus), which posited that artists, in their work, were capable of showing a vision of the perfection that must surely exist in Heaven. The focus was on that perfect harmony, particularly in religious art, where everyone looked ideal and are posed like a tableau vivant, a stage set with actors frozen in position, with grace, elegance, and solid, immobile basic geometric forms (particularly triangles) that can be superimposed onto the compositions. See Crivelli's *Annunciation* from chapter 4.

Mannerism

This movement was inspired by Michelangelo, featuring intentionally unnatural, contorted, antigravitational bodies for dramatic effect, often posed in a *figura serpentinata*, a serpentine, s-shaped pose. Pontormo's *Deposition* is a magical vision of a biblical scene, not meant to actually look as it would have

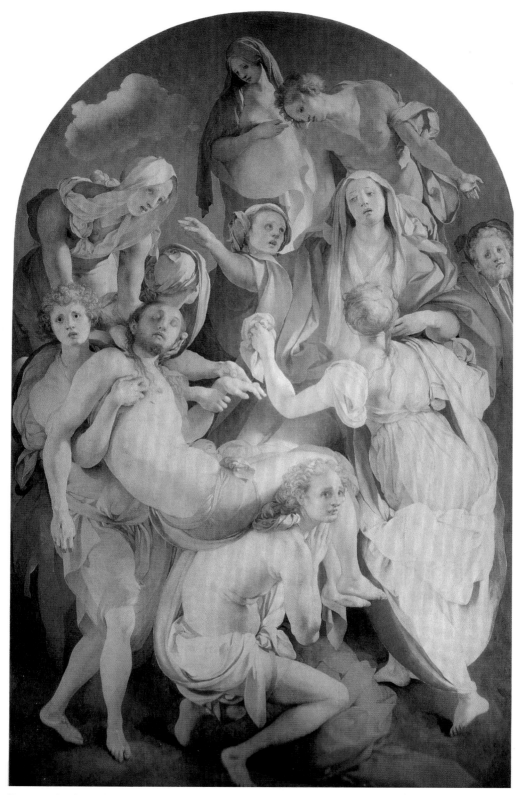

Pontormo's otherworldly *Deposition*, which places the Biblical scene in a zero gravity chamber, all floating, weightless, elegantly twisted bodies. Man, do I love this! PHOTO COURTESY OF WIKICOMMONS.

historically, but as a vision of it packed with emotional faces and an intentional absence of the laws of anatomy and physics.

Baroque

This movement seeks moments of highest drama, after an action has begun but before it has ended, often using ***gesamtkunstwerk*** approaches and theatricality as well as an awareness that viewers are participants in the artwork and their experience can be controlled in terms of what they see and how. This mouthful of a German word that we use in English, *gesamtkunstwerk*, means a complete work of art. The artist took into consideration and designed many artistic elements around the work. Bernini—its best-known exemplar, whose sculpture we'll see in the next chapter—sculpted, designed architectural elements, controlled lighting, designed paintings, and even inlaid floors in chapels featuring his statues. In Baroque painting, the focus is on the dramatic play of spotlighting emerging from darkness called chiaroscuro, figures and action filling all aspects of a painting. (It is the opposite of minimalism; let's call it maximalism.) Caravaggio was the revolutionary we most associate with Baroque painting (see his *Judith and Holofernes* in chapter 11, contrasted to the same subject painted by Artemisia Gentileschi). But the majority of painters in the first half of the seventeenth century followed the **Academic Baroque**, the most prominent of which were the members of the Carracci family (Annibale, Ludovico, and Agostino), who ran a painting academy in Bologna. This was less melodramatically posed and lit, more in the tradition of Raphael and the High Renaissance, just with added shadow and drama.

Tenebrism

This is the movement of followers of Caravaggio. Let it be said that Caravaggio was not amused. He wanted to be unique and threatened or even beat up artists who imitated his revolutionary style. Artemisia Gentileschi's *Judith and Holofernes*, the image that opens this chapter, is a fine example. One of unfortunately few female artists prior to the modern era, Artemisia learned art thanks to her painter father, but she far outdid him. This subject is a loaded one for Artemisia, as she was the victim of rape and this gruesome decapitation, **in medias res**, right in the middle of the action—head half-severed, blood everywhere—might be analyzed as painted revenge. Freud would say that male heads are representative of the phallus and Judith's action is a castration fantasy.

Rococo

This style is ornate, feminine, highly decorative, and frilly with themes of playful love. Artists like Fragonard and Watteau painted scenes of aristocrats behaving badly as entertainment for badly behaved aristocrats.

Romanticism

Linked to the Enlightenment, this movement highlights both the power of human reason and the weakness of the human body and existence in the face of nature's sublime grandeur. It also includes melodramatic subjects of love, sacrifice, and poverty, all meant to tug at the heartstrings. It is also inspired by the awesomeness (as in the capability to transmit awe) of the natural world. Anyone who has climbed a mountain and stood looking out over the precipice will recognize the vibe. Nature is infinite and glorious while we humans are modest in comparison. This feeling is called the **sublime** and it is part of the Romanticist tradition, which deals with high passions of the heart and what makes humans feel small and insignificant, whether the source of that feeling comes from nature or from the behavior of other people.

Neoclassicism

This is a return to the Renaissance interest in balance and harmony, with references to the Classical world as a source of morally elevating subject matter. The Renaissance was a "rebirth" of interest in the Classical world, as was Neoclassicism three centuries later, coinciding with the Napoleonic era. Paintings were often large-scale and didactic, taking Classical stories as a way to teach moral lessons of how to behave.

Realism

Realist art seeks to present its subject both realistically and truthfully, without artifice, stylization, or excess, and often with social commentary. This expansive movement found a home, well, everywhere. It focused on realistic paintings of aspects of everyday life, sometimes laced with hidden commentary.

Impressionism

Impressionist paintings are studies of light, almost always painted *en plein air* (French for "outdoors"), overtly painterly, using daubs of paint that, when looked at from a distance, take form that is difficult to see when looking up close. The work that gave this movement its name was Monet's 1872 *Impression Sunrise*. Rather than a realistic image, it gives the impression of its subject, a sunrise over

water, using daubs of paint that render a dreamy, blurry projection of a scene rather than a precisely realistic one, with a focus on how light falls on landscapes.

Post-Impressionism

This style was favored by artists who admired the Impressionist aesthetic but weren't interested in a style that was about little more than beauty, light, and color. Post-Impressionists willfully distorted for dramatic effect. This meant choosing nonrealistic colors and bending perspective, like Cezanne liked to do, distorting and foreshortening, painting a single table, for instance, that looks "correct" from multiple angles that shouldn't coexist in the same table the way we viewers are seeing it. Post-Impressionist works often don't "work" according to the laws of physics and optics but are beautiful all the same.

Fauvism

This style favors strong, unrealistic, garish colors applied directly from tubes of purchased paint, rather than carefully mixed from various pigments. Fauvism is a giddy romp in a box of pigments, with the "wrong" colors chosen, avoiding realism in favor of joy and games with color, part of the newfound freedom of painting liberated from the accurate chores now taken over by photography, as discussed in chapter 3.

Futurism

This movement features a rejection of art history and a focus on mechanization and the future of art, finding geometries in forms and deconstructing what is realistic. Its most iconic sculpture is Umberto Boccioni's 1913 *Unique Forms of Continuity in Space* (see chapter 6). The Futurists theorized that all museums and libraries should be destroyed to stop looking at the past and idealizing it and to turn forcibly toward the future. They sought new forms of expression in art that echoed what they admired around them, especially the mechanical revolution of factories and industry—Boccioni's bronze sculpture looks like what would happen if wind ripped into molten metal as a melting car transformed into a robot and took flight, in a good way.

Cubism

Cubism breaks down realistic images into geometric shapes, like a photograph chopped into irregular pieces and rearranged haphazardly. Georges Braque and Pablo Picasso founded Cubism, breaking down realistic images into geometric elements and then shifting them around.

Modernism

This movement featured artists using techniques and images that reflected modern advances like industrialization. Modernism is a big, broad, multidisciplinary movement, so picking one exemplary work is a tough call, but Picasso's 1907 *Les Demoiselles d'Avignon* is considered the first Modernist painting. Picasso created an abstract group portrait of naked prostitutes, covering their faces with designs inspired by African and ancient Iberian masks and statues—one of which he stole from the Louvre. This is both a comment on contemporary values, the objectification of women, and rampant prostitution and also an artistic statement, "shattering" realism in favor of something more visually arresting.

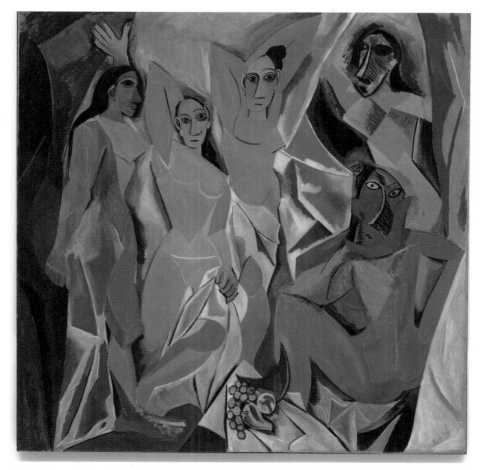

Pablo Picasso's *Les Demoiselles d'Avignon* (1907) has been described as the first Modernist artwork. It incorporates aspects of Cubism with Abstraction and a sociopolitical theme. Fancy.

Minimalism

Minimalism reduces a concept or image to its simplest, cleanest, most basic form. The ultimate extension of the freedom of painting when it no longer had to record history, now that photography did so, was to strip it down to the bare minimum, as in blocks of color. Mondrian made this style famous, creating a painting titled *Broadway Boogie Woogie* (1942–1943) that was meant to give the vibe of Broadway in New York, but by rendering it as a series of colored squares and lines only.

Suprematism

This Russian movement was focused on geometric and minimalist forms that went against traditional, formal art. Its most famous figure was Kazimir Malevich, who made works as simple as a black square on a white background or an all-white painting. Russian art at the turn of the century involved either Orthodox religious icons or realism. Malevich did the opposite, throwing away anything recognizable and realistic in favor of geometries and blocks of color, in an act of rebellion through art.

Dadaism

A precursor to Surrealism during World War I, this movement focused on the weird and mundane as a protest against the horrors of war. Duchamp's 1907 *Fountain* is one such example, a "found object" sculpture, making an everyday item strange and new, looked upon with fresh eyes, when it is shifted out of its quotidian context. Dadaism was about embracing the weird.

Surrealism

Inspired by Freud, Jung, and de Sade, Surrealist art tries to record the revelatory weirdness of dreams and the subconscious. If Dadaism was about daily life turned odd, Surrealism took it deeper, into the recesses of the mind, with a heavy influence of psychology.

Abstract Expressionism

This movement pushed back against realist, formal art and moved toward abstraction that was highly expressive, emotional, and created with movement and passion rather than deliberation. Pollock's *Lavender Mist* is one of his signature "drip" paintings, which he made by dancing around the canvas and flicking, dripping, and spattering paint, letting it land where it would. As the name

of the movement suggests, this was about abstraction and the expression of the act of creating art, keeping it fluid and not overworked. While Renaissance artists might take four years to complete a painting, an Abstract Expressionist might do it in one sitting.

Pop Art

Elements of popular culture that seem mundane are made into high art, both holding them up for closer analysis and aggrandizing them. Roy Lichtenstein painted Mickey Mouse and comic book scenes in large format, making high-end work out of what we're used to seeing in poor-quality, mass-produced comic books.

Photorealism

Photorealistic paintings take back the precise replication of the world around us from photography. The movement to show that painting, once supplanted by photography, can now imitate it is a bit of a parlor trick, but it requires tremendous skill, and often mathematical calculation, to make viewers mistake a painting for a photograph.

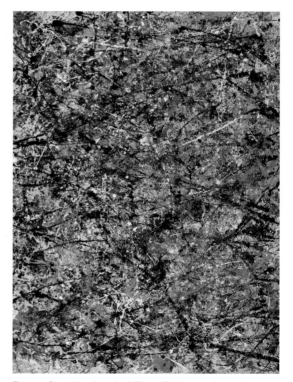

Postmodernism

This is art made in the last decades of the twentieth century that is self-referential, "aware" of itself as art, and acknowledges the viewer. It's a catchall category, not easy to pigeonhole and covering all manner of styles and media. The giveaway is the attitude of the work, in your face and "winking" at you, as if to say, "Yes, I'm a work of art, you know it, I know it," throwing away centuries of attempts at illusionism.

Do not fear the dreaded "isms!" Here we've got Abstract Expressionism, represented by Jackson Pollock's *Lavender Mist*. © 2021 THE POLLOCK-KRASNER FOUNDATION / ARTISTS RIGHTS SOCIETY (ARS), NEW YORK. NATIONAL GALLERY OF ART, WASHINGTON.

You did it! (You're still there, right?) Was that an exhaustive list? Of course not. Are you exhausted by it? Hopefully not. It may feel like a barrage at the moment, requiring some digestion, but I'll be helping you memorize without making an effort by circling back to these terms and concepts when they are relevant throughout the rest of the book.

The "Complete"(ish) History of Sculpture

Key Work: Bernini, *Tomb of the Blessed Ludovica Albertoni* (1671–1674)

MANY YEARS AGO, I ENJOYED TEACHING A SUMMER SCHOOL AT CAMBRIDGE University for advanced high school students. One of their favorite lectures was my attempt to teach them "The 'Complete' History of European Sculpture in One Hour." The goal was to keep an eye on a stopwatch and dash through as

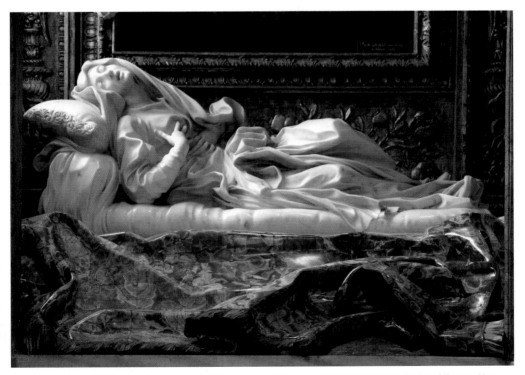

The key image of this chapter is the multidimensional *Tomb of the Blessed Ludovica Albertoni* by Gian Lorenzo Bernini (1671–1674). PHOTO COURTESY OF WIKICOMMONS.

many key sculptures—each carefully chosen to represent a movement, period, or key lesson—as I could with the clock thundering down. It was art history on adrenaline. You might think the speed would be fun for the students to watch but would result in them learning very little. But in practice, they were hyper-focused and retained more than I think they would have had we drifted, like leaves in the autumn wind, through the lecture, as is the case in most classrooms.

How long it takes you to read this chapter is up to you, but I've adapted the principle of the complete history in one hour into a wind sprint through European sculpture. It's the swiftest, most concise way to convey a great deal of information. The focus is on maximum useful, memorable material that can be applied to other artworks you'll encounter elsewhere, in a minimum number of artworks and a tight word count and including a finite number of "big ideas" that are useful everywhere you find art. I couldn't fit an image of every work in here, so you may want to have internet access as you read to summon up the works referenced.

Ready . . . steady . . .

VENUS OF WILLENDORF (CIRCA 25,000 BCE)

This rather Rubenesque-looking fertility statue we encountered in chapter 1 was carved of stone some twenty-five thousand years ago. There, you already have a new art vocabulary word that you've probably heard in casual banter: **Rubenesque.** The ideal of beauty in the era of the seventeenth-century Dutch painter Peter Paul Rubens was similar to that of 28,000 BCE: maternal, zaftig, suggesting fecundity, the ability to bear many children. Ideals of beauty change, but this is the most frequent through history. This statuette, with its highlighted breasts, engorged belly, and pubic triangle, was likely used in some fertility rite by women in hopes of getting pregnant or of a healthy birth. This is the work that most art history books begin with. It is a work of art, but it was also made with a purpose, as is much art. (Think of any religious artwork and it is likely meant to be both beautiful and used as an object of devotion or to stimulate meditation.) The face is abstracted in a way that looks quite modern. One narrative has the goal of art to become increasingly more realistic until the advent of photography made this no longer necessary, and then art was free to shift to abstraction. But in truth there are periods of abstraction throughout the history of art, and not always because the artist in question was incapable of realism, as we will see.

EGYPTIAN FUNERARY STATUE (CIRCA 2000 BCE)

Skipping ahead about twenty thousand years (I did say this would only be complete-ish), we arrive in ancient Egypt. Why overleaping this little slice of our human history? Well, our focus in such a condensed tour of art has to be turning points, revolutions. While much art was made between 23,000 BCE and 2000 BCE, for our purposes we can pass over it to join the trajectory of European art and its chain of influence to the present. Egyptian funerary statues saw a sea change in their level of realism. This statue is made of terra-cotta (baked clay, like you used to make in your third-grade art class). It's beautifully painted, and it's very well preserved because this is the sort of sculpture that would have been found in a tomb inside a pyramid. We have a sense that the body proportions are more like a real person would look, whereas the *Venus of Willendorf* was an exaggeration of a pregnant woman. The painted aspects heighten the realism, as does the left foot, which is just a little bit in front of the right. It doesn't look realistic, really, but that is meant to give the impression that the statue is capable of movement, that it is stepping forward. The hands are actually very good. Traditionally in art history, hands and faces are considered the most difficult to pull off. The face here is quite generic: There's no danger that, if the person who was portrayed in the statue walked into the room, we would recognize them straightaway by their face alone—that would come later. (And it probably isn't actually modeled on a real person at all but is just meant to look like "a person.") The face also conveys no emotion. But in terms of the body and the way it's sculpted this is a step forward.

KOUROS OF PAROS (MID-SIXTH CENTURY BCE)

A **kouros** (plural *kouroi*) is an **Archaic Hellenistic** sculpture of athletic nude young men. Hellenistic is the term for art from what is now Greece (Greece, as a country, is a modern concept; Hellenistic art was created by people who associated themselves with city-states, like Athens or Corinth). Archaic is a term for the oldest version of something, so this type of statue is the earliest sort that we consider in the Hellenistic tradition. And since what the classical Greeks did was considered of the highest cultural level by the classical Romans and then Renaissance Europeans, it was foundationally influential.

Such sculptures were likely meant as an ornament for a tomb. The hair is braided in a special way that athletes would wear for competing in sport, as in the earliest Olympic Games. It also features what's called the **archaic smile,** a smile that is meant to give a sense of liveliness to the sculpture. In contrast to the straight-faced Egyptian one, it does look a step more vivacious, though

71

maybe like one of those frozen smiles that form when Aunt Gertrude asks you to hold a smile too long for a photo and a minute later you're still smiling and wondering when you can stop. The illusion of movement, with the left leg a little bit in front of the right, is a technique borrowed from ancient Egyptian sculpture. This may seem like a tiny detail, but art history is self-referential. Hellenistic artists admired Egyptian artists of centuries past and were, in turn, admired by artists who came after them. Art is full of references to previous works, which art historians (who, it might be argued, should get a hobby), love to hunt and point out.

Myron, *Diskobolos* (450 BCE)

Shifting from this rather static *kouros* statue, this is the first work on our list by a sculptor we can name. What we're looking at here is actually a Roman copy in marble of a lost ancient Hellenistic bronze. Most ancient Hellenistic sculpture was made in bronze, the preferred medium. But the vast majority of these ancient bronzes were lost; sadly, many of them were melted down to make other things, sometimes as mundane as cannonballs. Our record of Hellenistic sculpture comes largely through ancient Roman copies made in white marble, Rome's preferred medium for sculpture.

Like the *kouroi*, this work shows an athlete, but this is a discus thrower. This is clearly a big jump forward in terms of realism. We are now in the heart of what's called the **Classical Period**, which is the zenith of the ancient Athenian democracy, when Athens was the center of art and culture in the classical world. This is a very naturalistic rendition of a male nude athlete, anatomically correct. The hands are especially good; you can actually see veins in them. Muscles are tensed, and specific muscles in the human body are replicated here, as opposed to the *kouros*, which is sort of a generic idea of musculature but without this precision.

This sculpture also includes what we might call **potential energy**, borrowing the term from physics. In physics, we have potential and kinetic energy. Potential energy is the energy an object has before it's in motion. So if I take my coffee cup and hold it up, it has potential energy, meaning that if I released it, it would move—drop—thanks to gravity. On the other hand, if I actually released it—and I'm not going to do that because there's coffee in it and I have to finish writing this chapter and computers are expensive—and dropped it, we would see kinetic energy in action.

Here we have the torqued body of a discus thrower, an athlete twisting backward, and we have a sense that the motion is paused. If you imagine you're

holding a magical remote control (how cool would *that* be?) and this is on pause, if we unpause it, the discus thrower would suddenly spin forward and release the discus. We can sense the energy, like a pulled-back rubber band, ready to be shot across your third-grade art classroom, twanging little Billy on the ear. The ability to take a big block of stone and give it not only this realistic, anatomically accurate look but also the sense that the figure has the potential for movement, is a long stride ahead of the half-hearted potential of movement in the *kouros* or the ancient Egyptian statue.

NIKE OF SAMOTHRACE (SECOND CENTURY BCE)

You may recognize this as *Winged Victory*, which is displayed at the Louvre Museum. This is carved out of marble and is meant to look like the decorative figurehead on a warship depicting the goddess of victory, Nike (pronounced *nee-kay*; I've always wondered why the shoe company willfully mispronounces its own name). The **plinth**, or platform, on which the sculpture stands is meant to resemble the prow of a ship. It has a level of naturalism that goes even

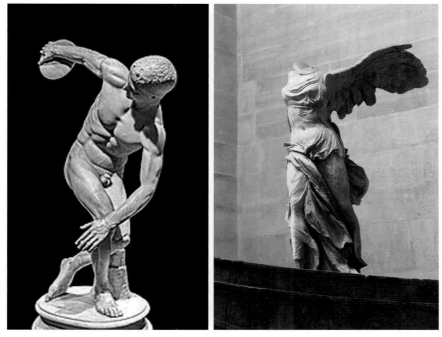

A duet of Hellenistic (meaning ancient Greek) sculptures, the torqued *Diskobolos* by Myron (circa 450 BC) and the later "wet drapery style" *Nike of Samothrace* (circa 200 BC), aka *Winged Victory* (it's pronounced "nee-kay" not "nye-key," by the way).
PHOTOS COURTESY OF WIKICOMMONS.

beyond *Diskobolos*, thanks to the drapery clinging to the sculpted body. It's easy to forget that this began as a block of stone. (The process of marble carving was described in chapter 3.)

A nude figure alone would be complicated enough to make look realistic, but here we add the illusion of not only drapery but **wet drapery**, which is actually the name of this style of sculpture—not so original, but easy to remember. Consider Nike's stomach in this statue: it looks so real, the muscles clenched in movement with cloth wet from the sea spray of the warship plowing through the brine, making the cloth cling to the skin.

The statue would originally have had a head and arms, and perhaps a hand holding forth a sword. These often simply broke off over time, though some works were mutilated intentionally when they were deemed inappropriate, for example, for religious reasons. Pope Gregory the Great (circa 590 CE)—who wasn't all that great, at least in this respect—ordered the smashing of heads and arms of ancient statues in the Vatican collection for fear that they would inspire a reversion to paganism. This was in the early days of Christianity, its grip in danger of slipping, and the pagan statues were of identifiable gods and goddesses—but only if you could see their faces and the symbolic identifiers they held in their hands. Obliterating the faces and hands rendered the statues anonymous. You could still admire the beauty of their carved bodies, but they were no longer a threat to receive pagan prayer because you couldn't tell which member of the pantheon they represented.

That wet drapery was modeled using a special technique. Before sculpting in stone, the artist would make a terra-cotta miniature model and bake it, so it hardened, or even make a model entirely out of wax. Then he would take cloth and soak it in water mixed with pulverized clay. This cloth would be modeled around the wax or clay figure and would harden slightly when it dried, replicating sculpted drapery. This would then act as the mock-up for the full-size sculpture.

Apollo Belvedere (circa 120 CE)

The *Apollo Belvedere* is an example of a statue that gives much more of an illusion of the capability of life and movement through levity. It feels like it's lighter, and this is in part thanks to a fancy Italian term, **contrapposto**. You probably stand contrapposto without realizing it, when you stand still in line waiting to get a mocha Frappuccino at Starbucks: Your weight is not equally distributed between both of your legs, but instead you have most of your weight on one leg, while the other rests. If the person behind you in line got frisky and lifted up that resting leg, you wouldn't fall over (but you might call security).

We see this in the sun god Apollo's right leg. The left leg is just sort of hanging there as Apollo stands in contrapposto. This is a trick that artists would use for centuries to come to give the illusion that a figure is in the process of moving forward, that it is not rooted to the spot. This statue also has beautifully handled drapery, which is really hard to do. The head and the hair are deeply carved out, which is one of the shorthand tricks to determine how difficult a sculpture was to do; the more shadow you see, the deeper a statue is carved, so those shadows in Apollo's hair attest to the ability of the sculptor.

You don't need to learn many Greek words (unless you're Greek), but this one is useful for the study of art: **kalon**. It refers to beauty, elegance, grace, and poise but it can be both aesthetic or moral. So a crucifixion painting could convey *kalon* in the sense that the scene is morally elevating, demonstrating beautiful, exemplary behavior. But the term can also describe the physical pose of an elegant figure, like Apollo here.

AGESANDER, ATHENODOROS, AND POLYDORUS OF RHODES, *LAOCOÖN* (ORIGINAL CIRCA 200 BCE, MARBLE VERSION CIRCA 70 CE, EXCAVATED IN 1506)

Pronounced "lah-ah-koh-own," this **sculpture group** (since it consists of multiple figures) was originally made around 200 BCE in a now-lost bronze version. The version you see here was made by a Roman sculptor, in marble, around 70 CE. This sculpture epitomizes a movement called the **Hellenistic Baroque**. We'll get to Baroque sculpture later on, around 1600, and it has some of the same characteristics of its ancient precursor. One is horror vacui, Latin for fear of empty spaces. It's typified as being the opposite of minimalist: The work has as much as possible going on, with little empty space around the main figures.

Baroque art circa 1600 and Hellenistic Baroque both try to show the moment of highest drama, emotion, pain, and movement in

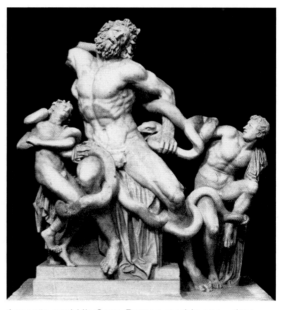

Laocoön and His Sons, Roman marble copy circa 70 CE based on lost bronze original circa 200 BC by Agesander, Athenodoros, and Polydorus of Rhodes. PHOTO COURTESY OF WIKICOMMONS.

75

any story they depict: the most melodramatic, action-packed, emotional moment they can choose to tell the story. Here, the story comes from Homer's *Iliad*, which tells the story of the Greek army laying siege to the impregnable city of Troy and eventually conquering through trickery: The Greeks built what appeared to be a giant wooden horse as a gift before abandoning their siege. The Trojans brought the horse into the city, not realizing that Greek soldiers were hidden inside it. The Greeks snuck out at night and opened the gates, and the Greek army surged in, sacking the city. Before this happened, according to the story, Laocoön, a Trojan priest, had a vision that the wooden horse was a trick of the Greeks. He wanted to warn the Trojans but Poseidon, the god of the sea, who was cheering for the Greeks, stopped him from doing so by sending a sea serpent to kill him and his two sons.

That's the moment we're seeing here. We have a realistic serpent that's about to bite Laocoön, with his beautifully handled physicality and anatomically precise body. We have the contrast of his aged musculature next to the delicacy of his adolescent sons. Laocoön's face is in anguish, since he knows he can't possibly fend off this magical sea serpent. The depth of his beard is carved out dramatically, the drapery wound around him. His bending, twisted body is very unnatural. I'm not sure this would happen even if one were attacked by a magical sea serpent, but it's very beautiful and dramatic.

This sculpture is so important because it was excavated during the Renaissance, in 1506. It had been a centerpiece of Emperor Nero's palace, the Domus Aurea, in Rome. Michelangelo supervised the excavation. This was a time when interest in the Classical world was at its peak. Renaissance scholars, thinkers, and artists thought that the ancient world, particularly Athens and Rome, was the epitome of what culture was capable of, and they were trying to revive and continue those traditions after a very long period from the fall of Rome through the Middle Ages, which was something of an artistic and cultural wasteland in comparison. This sculpture group was hugely influential for Michelangelo—it embodies the *figura serpentinata* he so admired: that snakelike *S* form, like a flickering candle flame. This basic geometric composition of the sculpture is one Michelangelo loved and integrated into his paintings and sculptures, including into his figures on the Sistine Chapel's ceiling. It showed him the beauty of the athletic male nude form, encouraged him to overaccentuate poses for dramatic effect, even encouraged his detailing of deeply carved beards. Because it was influential for him, it was influential for everyone who admired him and for his followers who, in the second half of the sixteenth century, were the most influential movement of European art—the **Mannerists**.

BOXER OF THE QUIRINAL (CIRCA 100 BCE)

This life-size bronze statue of a veteran boxer shows a face packed with—or perhaps pummeled by—real, humanizing emotion. You can read a life story into this face and the positioning of the body. Clearly, he's an athlete. He has the ancient equivalent of boxing gloves on, called *cestus*. We can see that he has endured many fights: His nose has clearly been broken. He wears a look of resignation, of aging, of an understanding that his time has passed coupled with the necessity to continue as a fighter, even if his body and mind are exhausted. There's a lot you can read into his face, and the artist's ability to convey sympathetic emotions by pouring bronze into a mold is really quite remarkable—the lost-wax method, described in chapter 3.

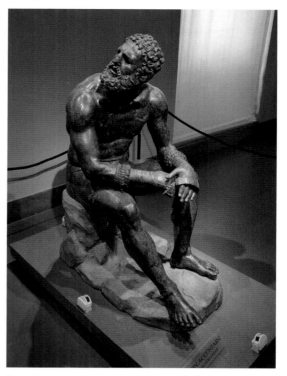

Boxer by an unknown sculptor, made in bronze sometime around 100 BCE. PHOTO COURTESY OF WIKICOMMONS.

GARLAND SARCOPHAGUS (CIRCA 150 CE)

When we think of sculptures, we tend to think of three-dimensional art that can be seen from all angles, but another type of sculpture is called a relief—a carving meant to be affixed to a wall and therefore viewed from only one side, discussed in chapter 3. A series of relief sculptures that wrap around a building are called a **frieze**. The example I mention here is a side panel of an ancient Roman sarcophagus. This was meant for an immensely wealthy citizen, and it is an extremely well executed example. Relief sculpture that is carved shallow is called **bas relief** (French for "low relief"). But high relief steals the show. In addition to garlands, the relief is decorated with cupids, called *putti* (pronounced "pootee"; the singular is *putto*). The face and open mouth of a gorgon (a creature with snakes for hair; Medusa was a gorgon) is in the middle, while portraits, likely of the couple buried in the sarcophagus, are on either side.

EQUESTRIAN MARCUS AURELIUS (CIRCA 175 CE)

This is the only surviving **equestrian**, or horse riding, sculpture from antiquity. It is fourteen feet tall and shows the Roman emperor Marcus Aurelius, life-size on a life-size horse, both cast in bronze using the lost-wax method. Ancient bronzes are relatively rare, as many were melted down to reuse the metal. This statue was the centerpiece of the Capitoline Hill in Rome. The proportions were carefully planned. If we look at the sculpture standing at eye level with it, the proportions appear off, but that's because it was designed to be looked at from below as it stood on a plinth. It is also remarkably realistic, as we can see wrinkles in the skin of the horse's neck as well as well-defined muscles and hooves. It is well balanced, even though only three of the four legs of the horse touch the ground. With one leg lifted, the statue gives the illusion that it is capable of movement. The bronze used here was gilded: gold powder was mixed into it and gold leaf could be applied to the exterior, both techniques to make it appear that it was made of gold.

ARNOLFO DI CAMBIO, *SAINT PETER* (THIRTEENTH CENTURY)

You may have noticed that we just skipped about a thousand years. How much can happen in a millennium, right? Well, a lot, but the reason it's okay to skip it in this whirlwind tour of ours is that art did not move forward. Art was made, but new techniques were not developed (at least, not in Europe and not important to trends in art to include here). And we skipped about twenty thousand years when we leaped from the *Venus of Willendorf* to ancient Egyptian sculpture, but who's counting?

When Rome fell (after a series of invasions in the fifth century CE), much of its art was destroyed and its techniques lost and forgotten, since the conquering nomadic tribes did not value or produce art in the same way. Many of its treasures were melted down for the raw material, while others (like *Laocoön*) were buried in the rubble of defeated Rome. Some of Rome's conquerors wound up settling down, like the Visigoths in Ravenna, and creating their own beautiful artworks (particularly **mosaics**, designs made of colored stones or glass glued into place). Other tribes created textiles, ceramics, jewelry, and weapons of great beauty, but the tradition of creating lasting monuments was lost, and many of the tribes did not keep writen records. This meant that the advances made by Roman artists were largely forgotten. Some, like the lost-wax method, were relearned during the Renaissance. This loss of advances in art and culture is why this period is often called the Dark Ages.

In the Middle Ages, we find examples like this statue of Saint Peter by Arnolfo di Cambio, who is best known for having designed the cathedral of Florence, which included a drum for the world's biggest dome, but he never figured out how to build the dome itself—that wouldn't come for centuries, when Brunelleschi, having examined the ruins of Rome, relearned an ancient technique and successfully built it. This statue is displayed in Saint Peter's Basilica in Rome and it has a very shiny foot, as traditionally pilgrims would rub it for good luck.

If this statue looks like a step backward from what the ancients were doing, that's a fair statement. It is quite clunky, sedentary, immobile. The figure holds two keys, a symbol of Saint Peter (meant to be the keys to heaven) and holds up two extended fingers, the blessing we mentioned that is still used by the pope today. The keys are an example of a **hagiographic icon**, discussed in chapter 4.

Ghiberti versus Brunelleschi, *Sacrifice of Isaac* (1401)

These are two relief sculptures in bronze, meant to be one of twelve panels displayed on the so-called Gates of Paradise, the doorway to the baptistery in front of the cathedral in Florence. The two sculptures were submitted as part of a competition to win this lucrative, prestigious commission in 1401. Each participant was asked to create a single panel depicting the Old Testament subject of the Sacrifice of Isaac, in which Abraham is told by God to kill his son, Isaac, as a test of faith. He is about to do so when God sends an angel to stop him; he has proven his faith and his son is spared. This was a big competition, with all the famous sculptors of Florence

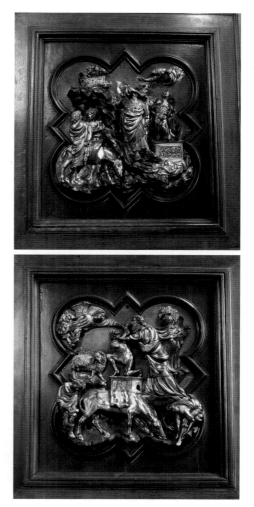

Juxtaposition of the two finalists for the Florence baptistery doors competition, one by Lorenzo Ghiberti, the other by Filippo Brunelleschi, both titled *Sacrifice of Isaac* and both from 1401. Which would you vote for to win? PHOTOS COURTESY OF WIKICOMMONS.

participating, including Donatello. The finalists were Lorenzo Ghiberti and Filippo Brunelleschi (the man who would later design the dome for the cathedral). Which do you think won?

Ghiberti's sculpture was the winner. It has more depth to it and there's more going on than in Brunelleschi's submission, which is a bit flatter. Such competitions were an important part of how commissions were determined, and many stories of rivalry and competition shaped the story of art. (My first book with Rowman & Littlefield, *The Devil in the Gallery*, is about this subject.)

DONATELLO, *SAINT GEORGE* (1417)

We've discussed Donatello quite a bit, and he is really the one to thank for the revitalization of sculpture in the Renaissance. This statue of Saint George shows something that we haven't really seen before. If we look at its face, we can read into it multiple conflicting emotions. That is very hard to do if you're an actor using your face and body to express emotion, much less a sculptor using a block of stone. If we were to showcase someone who is happy, to take a simplistic example, we might just show them smiling. Somebody sad might be shown frowning. But imagine you're an actor asked to show fear of failure, of death, yet also knowledge that you'll muster the courage to do what you need to do and win the day. That's a good deal more complicated, and that's what we see on the face of Donatello's *Saint George*. He shows us the moment before Saint George fights a dragon. He is afraid—he fingers his shield nervously—but steels himself to the challenge ahead.

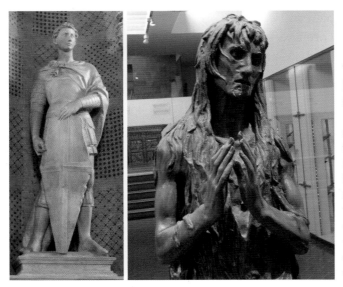

This pair of sculptures by Donatello really demonstrates the breadth of his abilities. His *Saint George* (1417), in marble, shows multiple conflicting emotions prior to throwin' it down with a dragon. His Mary Magdalene (1455) is made of wood and shows a super-creepy, haggard hermit, far from the beautiful prostitute she once was. (I wrote a Young Adult novel for fun once in which this statue is the bad guy!) PHOTOS COURTESY OF WIKICOMMONS.

This is a step toward humanization. That might sound funny, since Saint George is supposed to be a human, but the prevailing philosophy of the Middle Ages, Scholasticism, can be simplified as the idea that individual human life (unless you're royalty or the pope) is worthless. Humans are just pawns whose only value is in their subservience to their ruler or to God. Because of this, there is no record of which artists created buildings or artworks during this period—only the art or building was important, not the master who created it. Because the Classical world valued individual human life and records of its accomplishments, Renaissance thinkers did likewise, and so a movement called **Humanism** arose, investing importance in each individual. (Although it wasn't all that democratic; it focused on the importance of wealthy, creative, pious, intellectual, or warlike European men.) In art, this manifested as no longer painting and sculpting generic faces but rather recognizable, distinctive ones, packing them with emotion and recognizing that the viewer was requisite to the successful completion of a work of art. If the world's greatest sculpture is stored in a black, lightless room and no one can ever see it, then it has not fulfilled any purpose. The viewer is part of the equation, and so provoking sympathy in the viewer and making the viewer feel elevated by the beauty of the artwork were advances of the early Renaissance.

DONATELLO, *MARY MAGDALENE* (1455)

This later work by Donatello, in wood, depicts Mary Magdalene after she became a hermit in the desert. The story goes that after Christ's death, Mary Magdalene traveled from the Holy Land by boat and landed in the south of France, near Marseille. (Fun fact: the shape of the madeleine cookie, the sort that Proust dipped into his tea and ate to prompt the sense memory of his childhood that begins *In Search of Lost Time*, is meant to look like Mary Magdalene's boat.) There, she retreated into the desert and lived out the rest of her days as a hermit, clothed only in her extensive hair. This is a kind of creepy sculpture—if I see it out of the corner of my eye, I think it's about to jump off its plinth and start crawling up the wall of the museum—and it is probably the most realistic sculpture ever made to that date. The figure really looks like a haggard old woman whose skin has baked into leather from the desert sun. There is humanity to it. Saints were usually idealized, perfectly beautiful and generic, but not here. If we believe the biblical story and consider it to be a historical document, this is a good depiction of how this old woman, living alone in the wilderness, probably would have looked. It is creepy, but also has a beauty to it, and it is certainly impressive that it is carved from polychromed wood.

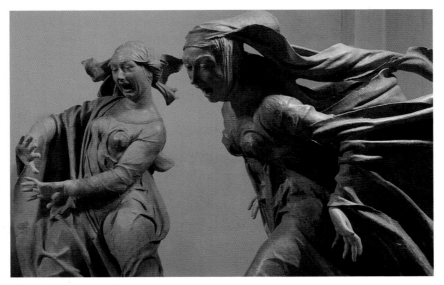

Emotional, melodramatic, and totally striking, I love this collection of terracotta statues, each reacting to the death of Christ in this work called *Compianto* by Niccoló dell'Arca (circa 1470). PHOTO COURTESY OF WIKICOMMONS.

NICCOLÓ DELL'ARCA, *COMPIANTO* (CIRCA 1470)

We've seen terra-cotta used to make mock-ups for bronze sculptures, but it can also be the final medium. Relatively few clay sculptures survive because it is such a fragile medium. This example is not just one statue, but a sculpture group, called *Compianto*, which might be translated as "crying together." This group is meant to be a pageant of emotions and possible reactions to a traumatic event, in this case, the death of Christ. So here we have the Virgin Mary, Mary Magdalene, Saint John the Evangelist, and Nicodemus. Each shows a different, very much over-the-top reaction. They are not subtle, like Donatello's *Saint George*; each of the figures is showing one emotion, but they are powerful. It's easy to cry along with someone who's crying, even if that someone is made of clay. The focus is on maximum melodrama. There are other figures in the group that show more stoic emotions, like Joseph. The idea is that this is a frozen moment of a variety of high emotions. As the viewer, you can decide what your reaction would be and find the figure with whom you sympathize at this dramatic moment.

VERROCCHIO, *EQUESTRIAN STATUE OF BARTOLOMEO COLLEONI* (1480–1488)

We have already seen the *Equestrian Marcus Aurelius*, created more than one thousand years earlier. This example refers to another equestrian statue, this one

by Andrea del Verrocchio. The subject is an Italian military leader, or **condottiere**. Italian city-states preferred not to fight themselves but instead used their wealth to hire mercenary generals and armies to fight for them. The mercenary generals were called *condottieri*, and this was one of the most famous. Depending on how you translate his surname, it could mean "with lions" or "testicles." (A story goes that he was so manly that he had three of them.) It is interesting to compare this statue to the *Marcus Aurelius*, which would have been the direct point of inspiration for this Renaissance version.

DONATELLO, *DAVID* (1440); VERROCCHIO, *DAVID* (1473); MICHELANGELO, *DAVID* (1504); BERNINI, *DAVID* (1624)

David was the symbol of the city of Florence. Florence is and was basically a small Tuscan hilltop town that happened to be the center of a small empire that was so wealthy it attracted the greatest artists of Europe during the fifteenth

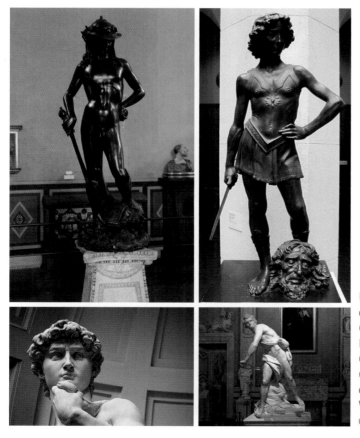

Four artists take on the theme of David. Bronzes by Donatello (1440) and Verrocchio (1473). Marbles by Michelangelo (1501–1504) and Bernini (1624). Each new *David* is in dialogue with previous ones. Which is your favorite? PHOTOS COURTESY OF WIKICOMMONS.

and early sixteenth centuries. And so we have all of the artists interested in getting commissions for Florence and turning to the subject of David. The idea is that the biblical David was a little guy, a youth, who volunteered to fight the champion of the Philistine army, a giant named Goliath, when none of the Israelite soldiers dared to do so. But even though he was small, he shouldn't be underestimated, because he kicked Goliath's butt. By extension, the message is that Florence may be small, but don't underestimate us, because we're going to beat you in battle.

It's interesting to compare what various artists did with the theme of David, sometimes alone and sometimes accompanied by the beheaded head of Goliath. Comparing the same subject handled by various artists is where Vasari's terms *invenzione* and *disegno* come into play. Consider the concept of each and its execution. Of course, here we're only looking at some of the very best sculptors in history, so the *disegno* is masterful across the board. Still, you can have a personal favorite. It's when it comes to the concept of what the sculpture should entail, before the sculpting began, that fun distinctions can be made, and it's good to compare them.

Two different Davids, both by Donatello, showcase how the same artist can approach a theme in varying ways. One is in bronze and one (not pictured here) is in marble. The bronze *David* is still a child, wearing a helmet and carrying a scimitar, the head of Goliath at his feet. He is naked other than greaves (leg armor) and a helmet, which is illogical and ahistorical. The sword is what we see most vividly, and he holds the stone that killed Goliath, but the sling has been discarded beside the severed head. The marble *David* is a young teenager, elegant, maybe even haughty. Goliath's head is there, as is the sling David used to cast the stone that struck him between the eyes. He has elongated, graceful hands that steal the show. He is dressed like a contemporary—that is to say, fifteenth-century Florentine—youth.

Verrocchio's bronze *David* splits the age difference between Donatello's two versions. Here David is perhaps twelve or so: prepubescent but not a child, waifish, and effeminate, wearing a tight, form-fitting suit instead of armor, as if he's out for a day at the beach. The sword has become a child-size dagger, and Goliath's head is far smaller than it should be in comparison to David's. David's expression is cocky: "Of course I defeated this giant champion," he seems to say, despite his physique suggesting that it would be impossible. The sling has been flung away and the stone it threw is still embedded in Goliath's forehead.

The most famous *David* statue is by Michelangelo. It shows David as a young adult, much older than he is in the biblical version. His nudity is not

historically logical but a nod to the beauty of ancient sculptures of athletic young men in the *kouroi*. Michelangelo felt that the most beautiful form was the athletic nude male, and so it is showcased. If his hands look overly large, that's on purpose. This statue was meant to be displayed high on the roofline of Florence cathedral and therefore seen from far below, in which case the hands, which appear oversized when we stand close to them, would have looked perfectly foreshortened.

Michelangelo's *David* also shows a moment in the story we've not yet seen. David has not yet thrown the stone with his sling. The sling hangs over his shoulder, the stone is in his hand. His body reads as nonchalant, but there is concern in his facial expression. This is the moment before the action has begun, whereas Donatello and Verrocchio chose to show a moment after the action has ended, with Goliath defeated and decapitated.

A century later, Bernini's Baroque-era *David* shows yet another moment: after the action has begun but before it has ended. It shows David in medias res, Latin for "in the middle of things." David is biting his lip with concentration as he torques his body back, the sling taut, about to spin forward and unleash the deadly stone. The tension, the potential energy, recalls *Diskobolos*, but it is even more coiled and powerful. This is the moment preferred by Baroque artists, particularly Bernini in sculpture and Caravaggio in painting: the moment of highest tension, drama, movement, as if the artwork were an action on pause.

MICHELANGELO, *SLAVES* (1520–1523)

An illustration of how stone was carved comes in a series of statues by Michelangelo that were unfinished, though Michelangelo may have preferred them this way. These were originally meant to decorate a tomb Michelangelo had been commissioned to build, but then the commission was abandoned. He began to carve huge blocks of stone in which he described "seeing" the forms of the final sculpture, so he would carve away all the excess stone to "release" the figure from within the block. Particularly since the theme of the series is slaves, the idea that they are imprisoned in stone and the sculptor sets them free is nicely resonant.

GIAMBOLOGNA, *RAPE OF A SABINE WOMAN* (1580)

Vasari thought his friend Michelangelo was the greatest artist to ever live or who would ever live. Many would still agree. His mastery of painting, sculpture, drawing, and architecture is unsurpassed; there are different options but no one whom you could argue is objectively better at any one of them.

Still, such GOAT (greatest of all time) debates are fun but not so useful. What is important to know is that he was the inspiration for artists throughout Europe in the second half of the sixteenth century, and those who admired his work and sought to emulate it came to be known as Mannerists, for they worked in the *maniera* (manner) of Michelangelo. One of them was the French sculptor Jean de Bologne, who went by the Italianized version of his name, Giambologna (many artists were known by nicknames, a bit like Brazilian soccer players). As an unrelated note, when I say "Giambologna" into my phone, its dictation software renders it as "jumbo lasagna." Just saying.

Mannerism involves the intentional distortion and hyperextension of bodies for dramatic effect. Michelangelo and Leonardo were among the first and few artists to dissect human cadavers—it was illegal to do so, but they snuck into the hospital of Santo Spirito in Florence by night. So they

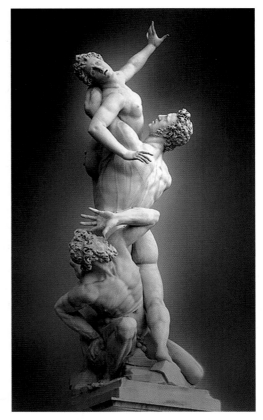

Mannerism in sculpture: this is a true three-dimensional work, meant to be walked around, seen from all sides. Giambologna, *Rape of a Sabine Woman* (1574–1582). PHOTO COURTESY OF WIKICOMMONS BY RICARDO ANDRE FRANTZ.

knew exactly which muscles the human body possessed. But Michelangelo liked to add to or alter what he knew about the body, bending or pulling it like putty, in order to make forms that he found more beautiful. He also wasn't particular—nor were the Mannerists—about the laws of physics and things like gravity. If they wanted a body to appear weightless, they would make it so. This sculpture group is one such example. Its shape recalls a DNA double helix. It shows a scene from ancient Roman history when the Romans, in need of women to expand their lineage, kidnapped women from the Sabine tribe. The title, *Rape of a Sabine Woman*, uses the word "rape" in the archaic sense of the word, meaning "kidnapping." The Sabine tribesman is helpless to save the woman from being carried off by a Roman. But what is most striking is how

the sculpture appears to move—or rather encourages you, the viewer, to circle around it, never taking your eyes off it, as it seems to pull up into the air, ever higher, defying gravity.

MADERNO, *SAINT CECILIA* (1600)

The story goes that at the church of Saint Cecilia in Rome, the body of the original saint, a young Christian girl killed for refusing to marry a pagan Roman man, was found in nearby catacombs and exhumed. It was brought out of the catacombs and displayed before a crowd of hundreds, including the sculptor Stefano Maderno. And supposedly, though more than a millennium had passed, Cecilia's body had not decomposed at all. Maderno sculpted what he and those eyewitnesses claimed to have seen that day, and the milk-white marble statue, intentionally displayed in a reflective black stone niche that recalls the **loculi**, or burial niches carved into catacombs, is his historical record of that event.

The statue is heartbreakingly empathetic. Sympathy and empathy are two emotions an artist can seek to elicit. Empathy is when you share the feelings of another because you've felt them, too, or perhaps even experienced exactly what the other has experienced that led to those feelings. Sympathy is your ability to put yourself in someone else's shoes, so to speak, and imagine what it would be like to experience what they have, to feel what they feel, even if you haven't. This sculpture provokes empathy for both the subject, a young girl killed for her refusal to marry, and the undepicted family of the girl. Hopefully none of you have experienced exactly this, but any of us can project and imagine what it must have been like. One approach is the over-the-top, sledgehammer of emotions we saw in Niccoló dell'Arca's *Compianto*. Here, Maderno has taken an altogether subtler, softer tack. His sculpture is very realistic: delicate, light, and airy. It looks like the ghost of a young girl. Her face is covered in a veil, her throat slit, but her head is twisted away from us, facing the back of the loculus. Her hands are bound—perhaps that is the most pathetic element (keeping with the true meaning of the word *pathos*: "arousing feelings of pity, sympathy, bitterness or sorrow"). Maderno is also aware of where this sculpture will be displayed and how viewers will see it. This was a big advance of the Baroque era, circa 1600. He has planned out what viewers can see from which angles. The viewer wishes to see the statue's face, but has to approach it, getting uncomfortably close, and look at the reflection in the polished black stone at the back of the loculus in order to see it, as it's covered in a veil and barely visible, twisted the wrong way around.

BERNINI, *APOLLO AND DAPHNE* (1625)

The king of Baroque sculpture was Gian Lorenzo Bernini. He was a very nasty, violent man, a fruitarian (maybe all that fiber didn't agree with him), but an absolute genius. This sculpture group illustrates a story from the ancient Roman poet Ovid, whose book *Metamorphoses* was a hugely popular well of subject matter for Renaissance artists. During the height of Catholic dominance over southern Europe, classical mythological themes were considered acceptable subjects for art, even when they included nudity and sexual innuendo. Many a shameless picture of a naked lady was forgiven by calling the naked lady Venus and painting nudity more like a statue of a naked person than the real thing; this is one of the reasons why nude bodies were idealized and any overly realistic body hair removed. The theme of *Metamorphoses* is stories of pagan gods falling in love with human mortals and pursuing them with amorous intent. Either the god or the mortal would change—metamorphose—in order to woo or escape being wooed. In this case, the god in question is Apollo, who falls in love with Daphne, a half-mortal whose father is a river god. Daphne flees from Apollo and calls out to her father to save her from him. To do so, her father transforms her into a tree. Bernini has chosen to show the most Baroque moment possible: after an action has begun, but before it is completed—the moment of maximum drama, when Daphne has begun to change into a tree, but isn't yet a tree. Her fingers morph into leaves, her toes into roots, her skin into bark, but just barely. This is surely one of the most beautiful, delicate sculptures ever made.

BERNINI, *TOMB OF THE BLESSED LUDOVICA ALBERTONI* (1674))

I would be remiss if I didn't include at least one of Bernini's two ecstasy sculptures, the subject of my master's thesis. (There you go, Sheila!) This is the key image of this chapter. Bernini was devoutly religious and interested in the writings of a Jesuit named Saint Ignatius of Loyola. This former soldier developed a handbook for prayer, a series of exercises and advancing skill levels similar to military rank and training, called *Spiritual Exercises*. This was hugely influential in seventeenth-century Europe. The basic concept was that you could train and develop your prayer, advancing levels until you reached the highest, a sort of black belt in prayer, at which point miraculous things could occur. Another wildly popular author, the second most read in the history of Spanish-language literature (after Cervantes), was Saint Teresa of Ávila. She wrote memoirs of

her spiritual experiences at this highest level of prayer, at which point eyewitnesses affirm that she would begin to levitate, fire would engulf her body but not harm her, her heart would swell to many times its normal size, and other miraculous goings-on. This was called an *ex stasis*, or out of body experience, from which we get the word "ecstasy." Bernini depicted this moment in his *Ecstasy of Saint Teresa*, but my personal favorite is in a church on the other side of Rome from Saint Teresa, called *Tomb of the Blessed Ludovica Albertoni*.

Not only did Bernini design and sculpt the main figures, but he also designed and supervised paintings, frescoes, architecture elements in the space, and an element of theatricality in that he wished to control, as Maderno had before him, what viewers saw, where they would stand, and how they would move around the space in order to experience the artwork. If this were made today, we might call it an "installation," since it brings together so many elements.

Let's be honest: Ludovica Albertoni (and Saint Teresa) both look like they're having orgasms. Although they are shown having a spiritual ecstasy, Bernini recognized that if you've not achieved the level of prayer that these ladies did, then the closest approximation you will have felt is a corporeal ecstasy. This was not considered objectionable at the time, but the sexuality is striking.

Albertoni was one step below a saint, deemed "blessed" by church authorities, and she is shown in the throes of an ecstasy brought on by prayer. Since she is wearing shoes, we know that she is not dying in her bed—even back in the seventeenth century, people didn't go to bed with their shoes on (if she were shoeless, this would be another reasonable interpretation of her expression, somewhere between pleasure and pain). Bernini is showing us a religious vision she is having, which is made vivid for us in the form of the painting above her. There are architectural tricks at play in that Bernini has hidden a **clerestory window** (a window fitted with clear glass) in a niche, out of sight behind Albertoni's head, so all we see is the light shining through it, as if by magic. The daybed onto which she has fallen looks soft and plump to the touch, and a different stone was used to carve the undulating fabric beneath it. (It is remarkable that all of this began as stone.) There's also a lot going on here. As discussed earlier in this chapter, Baroque art is about maximalism: Any empty spaces should be filled with something decorative. For my money, sculptures don't get any more well made, beautiful, and interesting than this.

CELLINI, *PERSEUS WITH THE HEAD OF MEDUSA* (1550); CANOVA, *PERSEUS WITH THE HEAD OF MEDUSA* (1790)

These two statues bracket the Baroque period, Cellini's in the Mannerist style and Canova's Neoclassical. I've selected them together because they are on the same theme. Perseus, the hero of Greek myth, has slain the gorgon Medusa, whose stare can turn enemies to stone. He defeats her thanks to some helpful magical items gifted by the gods, including winged sandals that allowed him to fly and a shield from Athena that was so shiny it functioned like a mirror. To defeat Medusa, he used his shield so he could see where she was based on her reflection, allowing him to approach her as she slept and cut off her head without looking directly at her. These two statues show the moment after his triumph.

Cellini was a Mannerist sculptor, a contemporary of Vasari who admired Michelangelo. His bronze *Perseus* has more muscles than are actually present in the human body, to emphasize the muscularity by hyperextending it, giving Perseus a Marvel superhero body. Medusa's headless corpse is torqued and twisted beneath his feet—an interesting parallel to the other Mannerist sculpture that is displayed a few steps away from this one in Florence, Giambologna's *Rape of a Sabine Woman*. We viewers are meant to be metaphorically

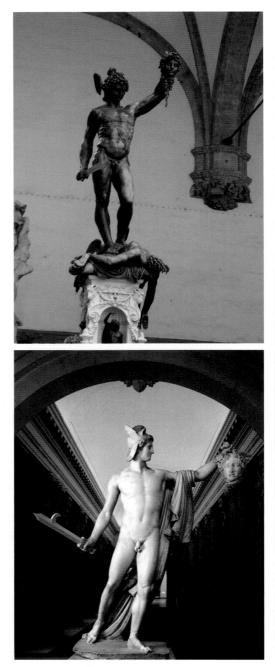

Two versions of Perseus carrying the recently severed head of the gorgon Medusa. The bronze is by Benvenuto Cellini (1545–1554), the marble statue is by Antonio Canova (1804). PHOTOS COURTESY OF WIKICOMMONS.

90

"petrified," turned to stone, through awe at the grandeur of this sculpture, and it's a clever play since Perseus is holding up Medusa's severed head, the sight of which could literally petrify. (There's also a fun addition to the sculpture: a portrait of the artist hidden in the back of Perseus's helmet that is visible only when you walk around behind the statue.)

Canova was Napoleon's favorite sculptor and is exemplary of the Neoclassical period, which could be described as a renaissance of the Renaissance. The Renaissance was a rebirth of interest in the classical world, and Neoclassicism, three centuries later, similarly looked back to the antique world but also to the Renaissance, bringing back its harmonious, elegant aesthetic and its stories that were morally elevating and taught contemporaries how to live and act, with classical figures as paragons of proper behavior. You'd be correct to see a resonance with the *Apollo Belvedere*. The body type is athletic and idealized, but not at Cellini's Mannerist impossible fitness level. While Cellini's *Perseus* is in bronze, Canova's work is in **Carrara marble**, a particularly white and veinless marble quarried near Pisa and preferred by Renaissance sculptors. (Some marble is mottled or so full of blue veins that it looks like gorgonzola, which isn't the look for this gorgon that Canova was after.) Canova is really showing off with the afunctional cloak draped over Perseus's left arm and with the hair of both Perseus and Medusa, speckled with shadows because it is so deeply carved out. You can even see the bulging knuckles on Perseus's fisted left hand as it tightly grips Medusa's snake-filled hair.

Art history is self-referential, and earlier styles cycle back to the fore. Later artists will visually or stylistically "quote" their predecessors and aspects of movements, like the High Renaissance, will return to style in later eras, like Neoclassicism. Spotting these internal references, almost like inside jokes to those who recognize them, scores you extra points on art history exams.

UMBERTO BOCCIONI, *UNIQUE FORMS OF CONTINUITY IN SPACE* (1913); BRANCUSI, *BIRD IN FLIGHT* (1923)

Now let's leap forward stylistically. We've blown past numerous -*isms* (there are so many of them and this chapter is long enough already). We've seen ideal perfection, balance, and harmony. We've seen over-the-top, in terms of contortions and body shapes and in everything-but-the-kitchen-sink maximalism.

A few technological steps forward in the nineteenth century led to art shifting in a different direction. One was the industrialization, followed by the mechanization, of the world. The Industrial Revolution of the eighteenth and early nineteenth centuries saw a shift from an agriculture-based economy to

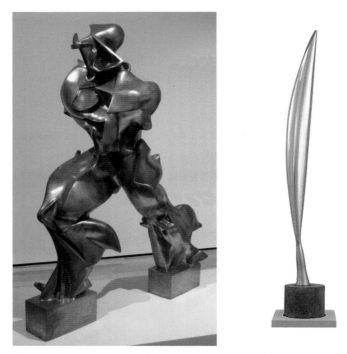

Umberto Boccioni's muscular, forward-thrusting *Unique Forms of Continuity in Space* (1913). *Bird in Flight* by Constantin Brancusi (1923). See the bird? (Me neither.) PHOTOS COURTESY OF WIKICOMMONS.

one of industry in cities. Production lines meant that unskilled workers could specialize in a single, repeated action and mass-produce what was once, start to finish, the handiwork of a master craftsman. Quantity and reproducibility were most valued. Art responded to this and began to comment on it. Then came a shift toward mechanization in the early twentieth century. Many of those unskilled workers could be replaced by machines. This was both exciting and depressing. What would happen to the art of craft when anonymous factories churned out cheap multiples that sold more readily than unique objects?

The other advance was the advent of photography. We've discussed this in more detail in chapter 3, but photography took over the job of reproducing exact likenesses of people, places, and events for posterity. Rather than "beating" sculpture and painting—since photography could be more realistic than either other art form—it set them free to do things other than seek maximum realism. Art could go back to abstraction—which was where it began.

These two works are good showpieces for commenting on mechanization and the move toward abstraction. Umberto Boccioni was a **Futurist**, part of

an Italian movement that had a radical theoretical manifesto, which included destroying all past art, museums, and libraries—an idea they didn't actually think should happen, but it was a point they wished to make that art was *too* backward-facing, in their opinion. *Unique Forms of Continuity in Space* is an artistic, abstracted ode to excitement at the mechanical world. While it looks basically humanoid, it embraces the fact that it is made of metal—bronze—and there's a sense of powerful, irresistible movement forward at such speed that wind whips the garment (or is it molten metal?) back. This could be the world's snazziest hood ornament on a Rolls-Royce. It is a muscular robot created before humanlike robots were conceived. It is not Cubist, but rather undulates, wave-like. I'd bet that Michelangelo, with his admiration for the shape of a candle flickering in a breeze, would've loved this.

While Boccioni's is an abstracted human form with an identifiable head, torso, and legs, Constantin Brancusi took abstraction to the most dramatic possible level. You'd win a free bag of Cheetos of you could look at this sculpture and name what it is meant to represent without looking at its title. Brancusi began with the concept—a flying bird—and sought to strip away as much of the literal realism of the image as he could while still conveying what he felt was the core of it. So he ended up with a beautiful, graceful bronze, well, *something*, that suggested to him the subject. I suppose it looks like a wing slicing through the air. I love it, but I would not have won that bag of Cheetos.

This is **minimalism**, trying to present the minimum possible proactive artistry required to convey a concept. I like to explain it with the analogy of my favorite dish my father would make when I was growing up: chicken with apples and apple cider cream sauce. This dish involved boiling down apple cider in an open saucepan, removing the excess water in the form of steam, until two cups of apple cider were reduced to half a cup of intense apple-ness. Yum. That's what Brancusi was trying to do. He began with the idea of a bird in flight (two cups of apple cider) and conceptually boiled away all that he thought was not necessary to the core of what he wished to convey. And in the end, he was left with this puffed curve that is vaguely winglike (half a cup of intense apple-ness).

In fact, this analogy is actually the approach I am taking in this book. Of course, a single, reasonably sized book will not teach you "everything" about art, but, taking a reductionistic approach, my goal is to teach you everything I think you'd need to get started. To do so, I've boiled down the big ideas in art to the briefest still-useful bites I can manage, in order to make it all feel more approachable and easier to remember. If this book were a work of art, it would be by Brancusi (writes the author, rather optimistically).

Now, whether you prefer Baroque maximalism or Brancusian minimalism—or something in between—is your choice. I love them all and I enjoy the differences. You're entirely welcome to like or not care for any work you encounter.

LUCIO FONTANA, *SPATIAL INTERVENTION* (1948)

We've already seen how art forms can mix, as in Bernini's *gesamtkunstwerk Tomb of the Blessed Ludovica Albertoni*. But when can a painting actually be a sculpture? Many artists seek to expand your mind and make you look at situations, or objects, in new ways. This is nowhere more evident than in Lucio Fontana's *Spatial Intervention*, which is a canvas for a painting that the artist has slashed, turning it into a sculpture. It is beautiful and couldn't be more minimalist (a contrarian might argue that there's actually nothing there). But it's interesting, too—and recall Aristotle's three criteria from the chapter 2. Since painting, for centuries, sought to trick the eye by making viewers think that some pigment daubed on a flat canvas was actually a three-dimensional image, it is a clever twist to actually take a flat canvas and cut into it. At first glance, this work might look like a minimalist painting of a slash into the canvas, rather than the slash itself that turns the work into a sculpture, a trompe l'oeil. (Pop quiz: remember that term?) Here we have a painting/sculpture hybrid that likewise makes the viewer think about categories of art.

DUCHAMP, *FOUNTAIN* (1917); EMIN, *MY BED* (1999)

We looked at length in chapter 1 at Duchamp's *Fountain*, which certainly must appear on any list of important sculptures, and it launched a conceptual tradition continued famously in Tracey Emin's *My Bed*. Part found art, part sculpture, part conceptual work, the entire installation consists of Emin's actual unkempt bed. The artist looked at it after a self-destructive, multiweek bender of booze, drugs, and promiscuous sex, and decided to leave just as it was. For her, it was a snapshot of her behavior, memento of a raucous period in her life. Featuring used condoms and pregnancy tests, bottles of liquor, drug paraphernalia, and assorted suspicious stains, it is the definition of the Duchampian vein of conceptual art: it exhibits no skill and it is no one's idea of beautiful. It is, however, interesting. And sometimes that is enough.

HIRST, *THE PHYSICAL IMPOSSIBILITY OF DEATH IN THE MIND OF A LIVING PERSON* (1991)

If *Fountain* and *My Bed* are both essentially found objects that were framed as sculptures, the work that made Damien Hirst famous (he and Jeff Koons are

by far the highest-grossing artists of all time) is part found, part made, and all conceptual. Hirst hired someone to catch him a tiger shark. He hired a firm to build him a steel-and-glass aquarium. He hired workers to fill the tank with formaldehyde and to suspend the dead, embalmed shark within it. He did not "make"—in the hands-on sense—anything about this sculpture as **installation**. But it is wonderful. While it exhibits no skill, for me it does fulfill the other two of Aristotle's Big Three in a way that *Fountain* and *My Bed* do not: I find it beautiful in a certain way, invoking a concept called the **sublime**. This was particularly at the fore during a late eighteenth-century movement called Romanticism, in paintings of the awe-inspiring beauty and power of nature, in contrast to the weakness and tininess of humans. The feeling of fear and majesty when we are confronted with a wild storm or an avalanche or are suddenly brought face-to-snout with a predator is triggered by this work. Stand in front of the glass and look at the shark. You know, logically, that it is long dead and cannot harm you. But our innate instinct when faced with a predator, the fight-or-flight reflex, is still triggered. It is clear that this is what the work is about when we consider the title: *The Physical Impossibility of Death in the Mind of a Living Person*. It messes with your head, in a good way.

When this work was making headlines, some public outrage was stoked by the fact that Hirst hadn't actually *made* any part of this sculpture. But as we have seen, that is simply in keeping with a long tradition of *bottegas*, in which the master designs and oversees the creation of works that will be known as "by" the master but are largely carried out by assistants and apprentices.

Marc Quinn, *Self* (1991)

Marc Quinn spent months drawing his own blood until he had ten pints of it. From this he created a self-portrait bust. There is a long tradition of busts, usually sculpted in marble, as commemoration. But never before had a work been made out of the artist's own blood. Quinn established a new sculptural medium. It maintains its shape through immersion in frozen silicone and it has to be refrigerated constantly, otherwise it starts to melt, blood dripping onto a black plinth that has raised edges to catch any such drippings. Many artists would say that they "put themselves" into their art, but here it is taken literally. It's also an interesting element that the bust must be plugged in, refrigerated, to "survive"—an analogy to the contemporary human condition, very much "plugged in" at all times. This could be considered an extension of a movement called **Body Art**, in which interventions, including violent ones, to the artist's own body were an aspect of the artistic performance. It is also linked to some

edgy works featuring the artist's own bodily effluvia as the main medium, like Piero Manzoni's *Artist's Shit* (a series of ninety cans of—you guessed it!).

RICHARD SERRA, *ARCS* (CIRCA **1980**)

Great slices of Cor-Ten steel, burnished to a rust-flecked chocolate brown, are Richard Serra's hallmark, and they are all about imposition into space. They are **Brutalist**: intentionally oppressive, heavy, and almost ugly (though I find them beautiful). They are raw and minimalist and are meant to provoke a similar sense of the sublime, but now not in relation to nature but in relation to industry, the capability of human beings to create and manipulate dwarfing colossi of unnatural material. There is beauty in the surface of the steel, and you are meant to feel small in relation to it. This is the sort of sculpture that doesn't really register as anything special when you look at a photo of it. You have to feel its presence in person. Architecture is not about walls and facades—it's about what it feels like to be in a space that is defined by walls. This is sculpture as architecture. It's not about what it looks like; it's about how it makes you feel when confronted by it. That's an important thing to keep in mind whenever you are underwhelmed by a photograph of an artwork, particularly something in three dimensions, like sculpture or architecture. You can't really dismiss it or claim that it doesn't work until you see it in person.

REFIK ANADOL, *QUANTUM MEMORIES* (2020)

We'll end our constellation of the history of sculpture with an ultramodern work that consists of a 10-by-10-square-meter high-resolution screen on which a series of undulating, colorful patterns swirl, churn, and splatter, as if gummy bears mixed with sand were being pumped and ricocheted around a glass box. (This is the key work of our final chapter, so flip there to see it.) The result is mesmerizing, thoroughly beautiful, interesting, and demonstrative of skill from both a computer science and a tech perspective (though not from a traditional artistic one). This is the epitome of computer-generated art. The idea of drawing or painting by computer might feel like it's cheating, but here, since Anadol does things one could never do without a computer, it feels just right.

───◆───

Art repeats and is self-referential. Artists tip their hats to past works in their new creations, sometimes "sampling" the way musicians do (like the bass from Rick James's "Superfreak" in MC Hammer's "U Can't Touch This"). Art historians love to play "spot the reference" when exploring museums. Let's conclude with one

such example. In the next two groups we can see a continuity of influence from the so-called *Belvedere Torso*, the remnants of a statue by Apollonios from the first century BCE. It was excavated in Rome in the 1430s and was a sensation because of its powerful realism. Michelangelo loved it and visually referenced it in his *Last Judgment* fresco in the Sistine Chapel (painted between 1536 and 1541), most evidently in the body of Saint Bartholomew, as we can see in the picture. Michelangelo was present when the aforementioned *Laocoön* statue was excavated, and it was an immediate influence on him. This can be seen in his sculptures, but also in his painting the *Doni Tondo*, where the position of the Virgin Mary is in a *figura serpentinata*, a form metaphorically found in the contortions of Laocoön and his sons as they are attacked by a literal serpent.

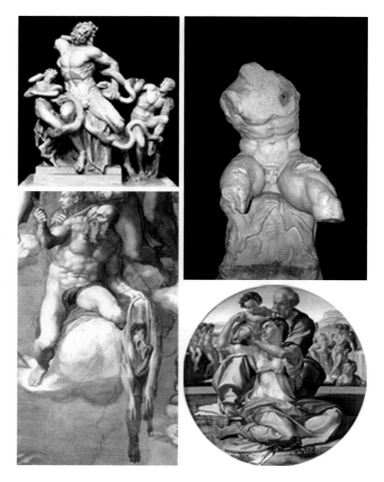

An example of the sort of chains of influence that go over very well on art history exams. *Laocoön* (a Roman marble copy circa 70 CE based on a lost bronze original circa 200 BCE by Agesander, Athenodoros, and Polydorus of Rhodes), *Belvedere Torso* (first century CE), a detail of Saint Bartholomew in Michelangelo's fresco *Last Judgment* (1536–1541), and Michelangelo's *Doni Tondo* (1507). PHOTOS COURTESY OF WIKICOMMONS.

What Michelangelo did was taken up by his followers, later called the Mannerists, including Pontormo, whose *Deposition* (1526–1528, a term here not referring to a legal document but rather the removal of Christ's body from the cross) clearly echoes the *Doni Tondo*. Mannerism expanded and can be seen in the work of El Greco, a Greek painter working in Spain, as in his *Assumption of the Virgin* (1577). And there are Mannerist echoes even today in the wonderfully twisted paintings of John Currin, whose *Thanksgiving* (2003) includes elongated limbs and necks posed in a *figura serpentinata*. From the *Belvedere Torso* to *Thanksgiving* is the sort of chain of influence and visual reference that just got you an A on my test. Welcome to the club!

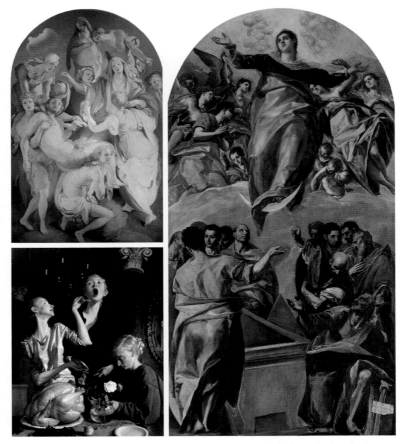

The chain of influence continues looking at three Michelangelo-inspired paintings in a Mannerist vein. *Deposition* by Pontormo (1526–1528), *Assumption of the Virgin* by El Greco (1577) and *Thanksgiving* by John Currin (2003). PONTORMO AND EL GRECO PHOTOS COURTESY OF ID WIKICOMMONS. JOHN CURRIN PHOTO © JOHN CURRIN. COURTESY OF GAGOSIAN.

CHAPTER 7

When Bad Things Happen to Good Art

Conservation and Loss

Key Work: Jan van Eyck, *Adoration of the Mystic Lamb*

UP TO NOW, WE'VE PRIMARILY DISCUSSED WHAT MAKES UP A WORK OF ART: medium, content, how it is made, what its appearance symbolizes, and how to "read" it. In this chapter, we'll shift focus and consider art as an object: an object that may be fragile and valuable and the survival of which, over centuries or even millennia, is really quite miraculous. How and why do bad things happen to good art, and what can be done to save it?

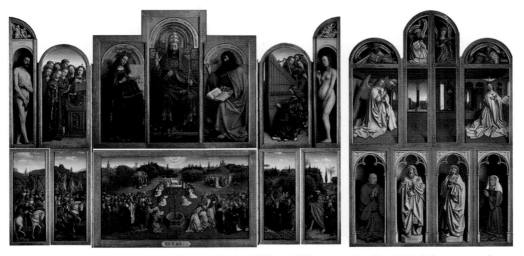

Adoration of the Mystic Lamb by Jan van Eyck (1426–1432), view when the triptych is open and closed. Look, I've got a whole book on this. It makes a great Christmas and/or Hanukkah present. Maybe you should buy two? PHOTO COURTESY OF WIKICOMMONS FROM THE WEB GALLERY OF ART.

Conservation versus Restoration

In 1994, when the Sistine Chapel reopened to visitors after a decade of restoration, the world drew a collective gasp. Michelangelo's painting, the most famous fresco in the world, looked *nothing* like it had for the past few centuries. The figures appeared clad in Day-Glo spandex, skin blazed an uproarious pink, and the background shone as if backlit. Was this some awful mistake, an explosion of colors perhaps engineered by the sponsor, Kodak? Of course not. This was how it originally looked, this work that launched the Mannerist movement of passionate followers of Michelangelo's revolutionary painting style, before centuries of dirt, smog, and candle and lantern smoke coated the ceiling with a skin of dark shadow. This restoration required a reexamination on the part of everyone who had ever written about the Sistine Chapel and Michelangelo.

After four years of restoration by the Royal Institute of Cultural Heritage in Brussels, an equally important work of art was revealed, newly restored, with similarly reverberant consequences. The painting looks gorgeous, with centuries of dirt and varnish peeled away to expose the electric radiance of the work as it was originally seen some six centuries ago. But this restoration not only reveals new facts about what has been called "the most influential painting ever made"; it also solves several lasting mysteries about its physical history, for it has also been called "the most coveted masterpiece in history"—and it is certainly the most frequently stolen.

The *Ghent Altarpiece* is the perfect artwork through which to tell the story of bad things happening to good art, because just about anything bad you can think of that could befall a painting has happened to it. But it has always been conserved and survives in a remarkably strong state, the colors fresh, the surface undamaged. Yet conservators continue to discover new things within it.

—◦—

Bart Devolder tries not to breathe—not too heavily, anyway, because a mislaid breath, let alone a sneeze, could wreak all manner of havoc given the delicacy of his work. He and his colleagues have just completed a four-year project to clean and restore what is arguably the most influential painting ever made: *Adoration of the Mystic Lamb* by Hubert and Jan van Eyck, often referred to as the *Ghent Altarpiece*.

The *Adoration of the Mystic Lamb* is an elaborate triptych consisting of twelve panels painted in oils, displayed in the cathedral of Saint Bavo, in Ghent, Belgium. It was probably begun by Hubert van Eyck around 1426, but he died that year, so early in the painting process that it is unlikely any of his work is

visible. It was completed by his younger brother, Jan van Eyck, likely in 1432. It is among the most famous artworks in the world, a point of pilgrimage for educated tourists and artists from its completion to the present day. It is a hugely complex work of Catholic iconography, featuring an Annunciation scene on the exterior wing panels (viewed when the altarpiece is closed, as it would be on all but holidays), as well as portraits of the donors, grisaille (grayscale) representations of Saints John the Baptist and John the Evangelist, and Old Testament prophets and sibyls. (Now that you're familiar with many of these terms, I hope the previous sentences feel empowering to you, showing just how much you've learned.) These exterior panels on the wings of the altarpiece were restored first, followed by the central panels. Both restoration efforts have yielded rich discoveries.

Completed in 1432, it was the first true masterpiece in oil paint, which, thanks to its popularity, became the preferred medium from that point until the mid-twentieth century. It has a wildly complex iconographic scheme, with more than one hundred figures showing a variety of biblical scenes, including highly realistic nudes of Adam and Eve, an Annunciation, Christ enthroned in Heaven and flanked by John the Baptist and the Virgin Mary, and a field of scores of worshipers making their way toward an altar at the center, on which stands a lamb (a stand-in for Christ) bleeding into the Holy Grail—from this, the title of the work is derived.

The complex iconography is something of an A-to-Z of Catholic symbolism. Adam and Eve represent the start, and Adam's Original Sin is what required the creation of Christ in the Annunciation, as his ultimate sacrifice is what reversed Original Sin (the symbolism of which we touched upon in chapter 4). But the visual puzzle of the painting is just one of its enigmas. For the physical painting itself and its component panels have had adventures of their own. The painting—all or in part—has been stolen six times and was the object of some thirteen crimes and mysteries, several of which are as yet unsolved. But the discoveries made by conservators have peeled away not just old varnish but the veils on several of those mysteries, as well.

In 2010, conservators studied the painting and determined that the altarpiece needed treatment and the removal of several layers of synthetic varnishes, as well as thinning down of the older varnishes added by past conservators, while adjusting the colors of older retouches. Devolder, the young, dynamic on-site coordinator of the conservation work, explains, "Once we began the project, and the extent of overpainting became clear, the breadth of the work increased, as a committee of international experts decided that the conservators

should peel away later additions and resuscitate, therefore, as much of the original work of van Eyck as possible." Past conservators meant well but sometimes made decisions that were either acceptable at the time but problematic in retrospect or did long-term damage because of insufficient understanding of the science. Works have been mauled by bad conservation. They have been overpainted too heavily, so that we see more of the conservator's hand than that of the original artist. In other cases, cleansing chemicals or varnishes were applied that were state-of-the-art at the time but caused problems down the road. The term "restoration" has in fact been replaced by "conservation," the idea being to intervene as little as possible in the artwork but to help it survive in a state as close as possible to the original.

Stripping away centuries of touch-ups by past conservators led to surprise discoveries, including silver leaf painted onto the frames themselves to produce a three-dimensional effect and make the overall painting look very different. It also found that many different "hands"—not only Jan's—were involved in the painting.

Computer analysis of the paint carried out by a team from the University of Ghent clearly demonstrates that different hands were involved—just as linguistic analysis programs can spot authorial styles and so claim that at least five different people "wrote" the **Pentateuch** of the Old Testament (the first five books, once all attributed to Moses), computers can also differentiate painterly techniques, even subtle ones (one man's crosshatching differs enough from another's from the same studio, just like handwriting differs from person to person even though we've all learned to write). That there are different hands involved is not a surprise, as van Eyck, like most artists of his time, ran a studio and works "by" him were, in fact, collaborative products of his studio.

"Damage was apparent in X-rays of the two painted donor figures," explains Devolder, "and we assumed that, in cleaning away overpainting and varnish layers, they would expose the damaged layer." **Varnish** was used as a final layer on oil paintings, to seal the paint and protect it from dirt, but it also helps bring out the pigment colors by helping to refract more light, a process called **saturation**. It was first thought that the damage had taken place during the initial painting phase—perhaps in Hubert's studio—and Jan then "fixed" it by painting over it, thereby also repairing his brother's legacy, but it later proved to be a sixteenth- or early seventeenth-century overpaint.

The conventional dating of the painting was likewise confirmed through **dendrochronology** (the panels in it came from the same tree), likely disproving a recent theory that the work may have been finished many years after the 1432

date most scholars believe to be accurate. "During the recent conservation campaign, two additional panels, one from the painting of Eve and the one plank from the panel of the hermits, were dendrochronologically tested and shown to have come from the same tree trunk," Devolder notes. Dendrochronology can tell the origin and age of wood, in this case, from the planks on which the altarpiece was painted. "In an earlier study, a different pair of panels likewise matched," says Devolder. It is unlikely that different panels would come from the same tree and remain in van Eyck's studio for a decade before being used in different sections of the same painting, so it is safe to conclude that it was indeed completed in 1432 and installed as a backdrop for the baptism of the son of Duke Philip the Good of Burgundy (van Eyck's patron; the painter also acted as godfather). It also suggests that Jan immediately took up the project of his late brother, aware of its importance to his brother's legacy and to his burgeoning career, rather than setting it aside and only getting to it later on.

The biggest discovery is that for portions of the painting, up to 70 percent of what is visible today was found to contain overpainting, with later painters adding their own touch to the original, whether for restoration or editorial reasons. If, for centuries, scholars have based their interpretation on a careful analysis of every detail, and it now turns out that some of those details were never part of the original conception of the work, then the reading of the work must be reexamined.

This led to some major changes to the appearance of the altarpiece. For instance, in a skyline in the background of one panel, a cluster of buildings were found that had been painted out, and details of other buildings have been revealed through cleaning away surface grime and overpainting, making them easier to identify with real historical structures. But the headline-grabbing detail was the face of the Mystic Lamb in the central panel: It used to have four ears, the result of a restoration after it was damaged in a fire in 1822, which led to the painting of a second face of the lamb over the original. The recent restoration removed the 1823 overpainting (including the extra set of ears) and revealed a lamb's face, as painted by Van Eyck, that is shockingly humanoid. Each restoration requires the rewriting of art history books.

Now, post restoration, the work looks strikingly different: the colors more vibrant, painting on the framework (which proved to be original) unleashed to provide a glow, and a three-dimensionality to the work that had been lost after centuries of interventions to the monumental painting, a twelve-panel triptych that weighs around fifteen hundred pounds and has the dubious distinction of being the most frequently stolen artwork in history.

Since its completion, this twelve-panel oil painting has been looted in three different wars, burned, dismembered, forged, smuggled, illegally sold, censored, hidden, attacked by iconoclasts, used as a diplomatic tool, ransomed, hunted by the Nazis and Napoleon, rescued by Austrian double agents, and stolen a total of twelve times.

Jan van Eyck was the most famous artist in Europe, thanks to the fame of the *Ghent Altarpiece*. But there was a mystery surrounding the painting even before the paint had dried, for after a series of thefts and sales, the wing panels of the altarpiece ended up in Berlin in 1823, where they were cleaned—and suddenly a new inscription was discovered suggesting that the altarpiece had been painted by one Hubert van Eyck, the brother of Jan, who was a better painter. This was the first anyone had ever heard of Hubert van Eyck, and it rocked the art world. Suddenly there was mention of a new painter, ostensibly more skillful than the world-famous Jan van Eyck, yet not a single definitively attributed work by Hubert van Eyck exists to this day. Some believe that the inscription was a forgery—art history books are divided to this day as to whether the *Ghent Altarpiece* is the masterpiece of Jan van Eyck or if it is by the van Eyck brothers.

In 1566, the altarpiece narrowly avoided destruction at the hands of rioting Calvinists who broke into the cathedral, intent on burning it. But thanks to the ingenuity of a brave group of Catholic knights who were determined to guard this symbol of Catholicism with their lives, the altarpiece was saved.

In 1794, the four central panels of the altarpiece were stolen from the cathedral by French Republican soldiers who formed part of the world's first official military division dedicated to art theft, established by Napoleon.

In 1816, while the bishop was in exile due to anti-Napoleonic sentiment, the vicar of Saint Bavo sold the wing panels of the altarpiece to a crooked art dealer in Brussels who had already profited from a purported stolen van Eyck—he sold a sixteenth-century copy of the *Ghent Altarpiece* panel by panel, convincing each buyer that they were acquiring a part of the stolen original. The dealer sold the real wing panels to the British collector Edward Solly, who in turn sold them to the king of Prussia, who was building an art collection to outdo the Louvre's. This collection would eventually become the Kaiser Friedrich Museum in Berlin, where the mysterious inscription regarding Hubert van Eyck was revealed in 1823.

During World War I, the Germans were determined to steal the central panels of the altarpiece, which had been returned to Ghent by the French king Louis XVIII. Their plan was to reunite them with the wing panels, already in

Berlin. A series of officers and civilians came to cajole and threaten the bishopric into handing over the altarpiece. But it had already been spirited away in a dramatic nocturnal escape by a brave clergyman, Canon Gabriel van den Gheyn. He and his friends dismantled the panels and hid them at the bottom of a junk cart to sneak them out of the cathedral and secret them under the floorboards of a number of local houses. The Germans threatened to blow up the entire city of Ghent if the altarpiece was not handed to them, but the armistice came before they could act, and the panels were saved.

In 1934, a single two-sided panel, referred to as the Righteous Judges, was stolen in the night. Police were baffled and their investigation smacked to many of conspiracy. A series of bizarre ransom demands came in to the bishop, and the back of the Judges panel, which had been split vertically for display in Berlin, was returned as a gesture of goodwill. But the ransom would not be paid, and the police got nowhere. Then suddenly, a portly stockbroker collapsed at a political rally, and on his deathbed, he whispered to his lawyer that he was the last man on earth to know the hiding place of the Judges panel. And then, with operatic timing, he died before he could reveal any more. Was he the thief? The police, who had no leads of their own, believed so. But the investigation that followed was marred by the suggestion of coverup. A group of four local lawyers investigated privately for one month before even informing the police of the deathbed confession. An unsent ransom letter was found in the dead man's study, which suggested that the missing panel was somehow hiding in plain sight and could not be recovered without "attracting public attention." Some thought it had been hidden on the cathedral premises and not removed at all. It was later found that he had indeed planned the theft but must have had help carrying it out. And his plan was based on the plot of his favorite novel, *The Hollow Needle* by Maurice LeBlanc, part of a series featuring Arsene Lupin, the gentleman jewel and art thief who was a famous literary figure in the francophone world the way Sherlock Holmes was to anglophones.

The Judges panel is still missing, a case very much alive in the minds of Belgians. After interviews with a number of weekend detectives who have taken up the investigation as a hobby, there is very good evidence that explains both where the panel was originally hidden as well as where it was moved to and remains today.

Perhaps the most dramatic story is that during World War II, the *Ghent Altarpiece* was the most wanted artwork by both Hitler and Göring—the two raced each other to steal it first, Hitler for his planned supermuseum at Linz

and Göring for his private collection. Göring got there first, ordering the altarpiece to be stolen from its hiding place in the south of France. But Hitler commandeered the altarpiece, and it was moved for storage to a secret salt mine that had been converted into a high-tech stolen art warehouse in the mountains near Salzburg, at Altaussee (where I've hosted several documentaries for television). There, seven thousand masterpieces from across Nazi-occupied Europe waited for the war's end, when they would form the core of the Linz citywide museum. But the local Nazi gauleiter, against Hitler's direct orders, was determined to destroy the entire contents of the mine if he failed to defend it against the Allies as the war drew to a close. It was thanks to the incredible efforts of a secret OSS operation, in which Austrian double agents were parachuted over the Alps in order to stall the destruction of the Altaussee mine, as well as the bravery of local miners working for the Resistance, coupled with a fortuitous toothache that led the Allied Monuments Men to learn of the Altaussee hoard, that the thousands of masterpieces, including the *Ghent Altarpiece*, were saved.

Thus it is a minor miracle that the altarpiece is as intact as it is. Having been so thoroughly studied for centuries, it is also remarkable that it still has secrets to reveal. But this recent restoration sent shock waves across the art world, for the marvelous details it uncovered, including the solutions to some centuries-old mysteries. But it also highlights two important points: first, that the major discoveries of recent years are down to digital technologies seeing things (often seeing *through* things) that mechanical or manual intervention could not without irrevocably damaging the art itself; and second, that the role of the conservators who explore and treat these treasures has changed dramatically over the years.

Of late, when art history makes headlines, it does so because something lost has been found. Everyone loves a good treasure hunt (and everyone has a little Indiana Jones in them), so we thrill to learn, for example, that "space archaeologist" Sarah Parcak used satellite photographs to help locate unexcavated archaeological sites, including her discovery of the real lost ancient Egyptian city of Tanis, made famous because it was what Indy was searching for in *Raiders of the Lost Ark*. But that is on a hugely macroscopic scale. Most revelations are down to the size of a single picture, or a detail of it.

In 2012, the Museo del Prado in Madrid announced the discovery that a copy of Leonardo's *Mona Lisa* that was in its collection (it was a frequently copied work, even back in the sixteenth century) turned out to have the exact same underdrawings as the original. This meant that it must have been painted alongside the original, in Leonardo's studio (and likely by one of

his assistants or apprentices), because the shifts in design and drawing in the development of the final picture matched the original, meaning that the painter was present throughout the painting of the original. That same year, at the Galleria Borghese in Rome, Raphael's famous *Lady with a Unicorn* was found to contain a layer cake of surprises. The unicorn in the lap of the lovely courtly lady portrayed turns out not to have been a unicorn at all, but a lapdog that a later artist "converted" into a unicorn. But that's not all: the lapdog was also a later addition, not painted by Raphael at all. *Lady with a Unicorn* was actually just a lady, with nothing apparently cuddled in her lap, when Raphael laid down his brushes.

These discoveries were made thanks to noninvasive investigations by conservators who used special technology such as infrared spectroscopy, allowing them to see *through* the surface paint and glimpse what lies beneath without having to actually remove or damage the surface. This is how a stone crucifix was discovered in the upper left corner of Hans Holbein's *The Ambassadors*—someone had painted over it at some point, but conservators at the National Gallery in London were able to find it, using technology to harmlessly reach their hands through the murky waters of overpainting. It was then decided to peel away the later intervention, so that viewers could see the work as Holbein had originally made it, not as later painters or restorers had determined it *should* look.

THE TOOLS OF CONSERVATION

Conservators can use special cameras with varying light spectra—**infrared** (analyzing pigments used in paints), **ultraviolet** (analyzing the varnish and retouchings or underpaintings), and **X-ray** (to see beneath the visible paint layers)—to look beneath the surface of a painting and determine what was original, by the hand of Van Eyck and his studio when the altarpiece was made back in 1426–1432, and what was added later. They analyze the different chemical compositions of paints and technical elements, like brushstrokes, to figure out what was original, and what was a later addition that should be removed. The work of conservators ranges from using the most advanced technology to slow, surprisingly simple work like rolling a moist cotton swab over the surface to remove grime.

In the slapstick comedy film *Bean*, Rowan Atkinson's character, a museum guard, accidentally sneezes on *Whistler's Mother*. Frantic, he tries to daub off the mess, and manages to smudge the painting, making it far worse than it was before. Panic escalating as the museum directors and media approach for the

grand opening, he takes matters into his own hands to restore the painting to its original glory—with comically disastrous results.

Art conservators can work miracles. They are tasked with maintaining the often-fragile state of works of art in museum and private collections. Some of this art is worth millions and may be millennia old and made of such delicate material as paper, cloth, or terra-cotta. It is something of a miracle that so many artworks have survived in a well-preserved state at all. Age, changes in humidity, smoke, fire and water damage, overexposure to light that can make colors fade, mishandling—the list of things that can endanger a work of art is immense. Conservators use a variety of high-tech analytical tools to help scholars learn more about art as a physical object. Laboratory tests can reveal underpaintings or hidden drawings beneath the surface, as well as approximate the age of the artwork, analyze the materials used, and reveal any hidden secrets. Thus, conservators today are art's CSI detectives, combining forensic laboratory analysis with the hands-on task of touching up damaged portions of works and ensuring that they deteriorate as little as possible.

The vast majority of conservators are art's medical staff, paralleling the Hippocratic oath: First, do no harm. But every once in a while, a blooper comes to media attention, causing much hand-wringing (and eye-rolling). A nineteenth-century fresco of Jesus called *Ecce Homo* in Borja, Spain, had deteriorated when the plaster onto which it was painted began to flake off, taking the paint along with it. An amateur conservator tried to restore the painting and did such a laughably horrific job that it became an internet sensation and a tourist attraction for all the wrong reasons. (It actually looks astonishingly like Mr. Bean's restoration attempt from the movie.)

Today, conservators seek to intervene as little as possible. They make any additions (like touching up a damaged part of a painting) chemically distinct from the original paint so that it can be easily removed without affecting the original. They try to prevent deterioration but never force their own artistic interests on the original.

But restoration need not have only the negative connotation of interfering. There have been innumerable, very hands-on restorations that have resurrected art thought lost forever. On July 27, 1944, a bomb fragment from an Allied air raid started a fire on a timber-and-lead roof of the Field of Miracles in Pisa, adjacent to the Leaning Tower. Unique, priceless frescoes, sculptures, and sarcophagi were burned and covered in molten lead. After World War II, a painstaking restoration process began that was completed only in 2005. When the Arno River in Florence flooded its banks on November 4, 1966, causing

not only water damage but mudslides, some fourteen thousand artworks, from paintings to sculptures to frescoes, were soaked and stained, damaged, or altogether destroyed. Hundreds of volunteers, whom the locals dubbed "mud angels," flocked to Florence to help teams of conservators. We have their dramatic and timely intervention to thank for the fact that Florence is still home to so many masterpieces.

In an effort never to mislead viewers (and scholars), restoration (which implies a more proactive hand in touching up damaged aspects of an artwork) now follows the guidelines that require conservators to carefully photograph and chart all interventions and make them reversible. New additions to paintings should look similar to, but not exactly like, the original so there can be no confusion. And minimal intervention is preferred, which is why the term "conservation" is considered more appropriate, to result in as few Mr. Bean–style incidents as possible.

Until the second half of the twentieth century, works of art were restored, not just conserved. This meant that an active intervention on the part of the restorer was considered not just appropriate but often desirable. This took two main forms: erasure and addition. When Bronzino's extremely sexy *Allegory of Love and Lust* was acquired by the National Gallery in London, it was deemed too hot for the Victorian public. A museum restorer painted away a rogue tongue, erect nipples, and a protruding buttocks (the latter disguised by the addition of a plant). These attempts at erasure by way of painting over the original were removed only a few decades ago. Hundreds of thousands of viewers of the painting, including scholars and students, studied it without its original inclusions, thinking that the prurient plant was part of Bronzino's conceit (a particularly problematic factor for a painting that is considered a visual puzzle, with each detail offering a clue to its interpretation, as discussed in chapter 4).

Overzealous additions by restorers can mask the original—or worse. There was once a **predella** (a painted strip that ran across the base of the altarpiece, a bit like a comic strip of scenes related to the main theme) to *Adoration of the Mystic Lamb*. This was irrevocably damaged when the altarpiece was badly cleaned sometime before 1550. The bad cleaning resulted in the predella being discarded and lost.

Today's conservators intervene more deeply not in adding their own brush to the canvas, but in peeling away the work of earlier restorers or overpaint intruders to reveal what the original artist intended, as was the case in the *Ghent Altarpiece* conservation, which was more of a restoration than most. For centuries, no one had seen the altarpiece as it was intended—until now.

The work of the *Ghent Altarpiece* conservation team combined high-tech gadgetry, like the use of infrared spectroscopy, dendrochronology, and even computer analysis to determine how many painters had been at work on the original. But for all the digital glamour, the CSI: Art History machines can clue us in, but it is a human conservator, working with painstaking delicacy, who actually completes the reveal.

There's a certain poetry in this. Discoveries that could hardly have been possible without high-tech equipment cannot be completed without flesh-and-blood intervention, whether on the scale of satellite photos notifying an archaeologist like Parcak of likely unexcavated sites, which must be dug up and sifted clear and analyzed by hand, or the minutiae of conservators like Devolder rolling a cotton swab over a 4-by-4-centimeter square of *Adoration of the Mystic Lamb* to dissolve clotted yellow varnish and allow original brushstrokes, centuries buried, to breathe again. It will always be by human hands that art discoveries are made and the long-lost unburied.

ART AND LOSS

Off Rozel Point on the shore of the Great Salt Lake in Utah, a masterpiece by sculptor Robert Smithson is slowly vanishing. *Spiral Jetty* was built in 1970 of earth, water, the salt crystals that dust the lake like snowfall, and 6,650 tons of local basalt rock. From the sky, it resembles the tendril of a fern or a bishop's miter. Some fifteen hundred feet long and fifteen feet wide, it was never meant to last forever. When wind, rain, and erosion have completed their work on his piece of land art, it will disappear. Regular intervention could maintain it, but that was not Smithson's wish. By 1999, when *Spiral Jetty* was donated by Smithson's estate to the Dia Art Foundation, this work of art was lost. The waters of the lake had risen and the rock and earth from which it was built had eroded to the point that it was submerged. A few years later the waters receded, and it reemerged after almost thirty years. Lost art, found—only to be lost again. Smithson wanted nature to run its course. When it was ready to swallow or disperse his sculpture, so it should be.

My book *Museum of Lost Art* focuses on the works that were lost but which, when they were extant, were as important or more so than the works that happen to have survived the centuries and which we tend to focus—or even over-focus—on. I call this "survivor bias": Our view of art history is heavily skewed toward works we can still visit (called **extant**) as opposed to those whose location is unknown or which are known to have been destroyed (called **lost**). This is understandable, but it means that one can study art history through the

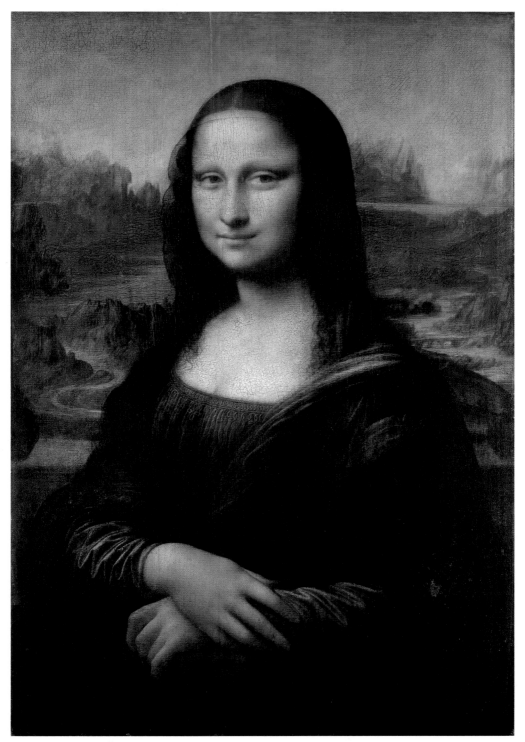

The world's most famous painting. Oh wait, should I label it? Why not, right? Leonardo da Vinci's *Mona Lisa* (1503–1506). PHOTO COURTESY OF WIKICOMMONS.

doctorate level and not know much, if anything, about the millions of works that are no longer extant.

Art can be lost for myriad reasons: natural disaster (earthquake, flood), accident (fire, breakage), atmospheric deterioration (overly humid storage), theft, misplacement (a work hidden and then its location forgotten), intentional destruction (by the artist or the owner or an outraged **iconoclast**—someone who attacks art because of what it symbolizes)—the list goes on. The role of museums is to preserve art and educate through it. But there are times when art can be stolen or looted, even from museums themselves.

There are tens of thousands of art thefts reported each year (some twenty thousand a year in Italy alone), and many more go unreported. Art crime may be linked to organized crime and the drug and arms trades and is even a funding source for some terrorist groups. It is far more serious than most people imagine, and it has been relatively understudied. When I began my career, still as a postgraduate student, I was described in a *New York Times Magazine* article (December 2006) as having effectively founded the field of the study of art crime. It has since blossomed, thanks in part the Association for Research into Crimes against Art (ARCA), which was the first research group in the field and established both the first academic journal, the *Journal of Art Crime*, and the first academic program, the ARCA Postgraduate Program in Art Crime and Cultural Heritage Protection. My other books detail many of the fascinating, filmic stories of art theft and forgery, from the most famous heist of all time, the 1911 theft of the *Mona Lisa*, to the most frequently stolen artwork in history, the *Ghent Altarpiece*.

EIGHT LOST TREASURES

Imagine a museum of lost art. The gallery would be larger, and contain more objects, than all the world's museums combined, for only a modest percentage of the works created through history survive intact and are accounted for today. For many premodern artists, not to mention the countless artists of the ancient world, many more works are known of (thanks to references to them in texts or other sources) than are extant.

Some of these vanished masterpieces are permanently gone, their destruction documented: most (but not all) of the Seven Wonders of the Ancient World, for example; Leonardo's *Sforza Horse* statue (used as target practice by French archers after they took over Milan in 1499); and Rogier van der Weyden's *Justice Cycle* (consumed by fire, along with the rest of the so-called Golden Chamber in Brussels). But what really stirs the imagination are not the

definitive tragedies of monuments and artefacts known to have been ruined, but the stories of artworks that are lost—stolen, mislaid, hidden, and forgotten—and might be found.

In art terms, "lost" could mean lost forever, but it could also mean simply that current whereabouts are unknown. This leaves hope that lost art may be found, and important works resurface with just enough regularity to inspire. A case in point is Leonardo's *Salvator Mundi*, missing for centuries, covered in dirt, misattributed, thought all but worthless—and now the world's most expensive artwork.

The following "gallery" of lost works is meant for optimistic treasure hunters, festooned with works that are lost but for which there is reasonable hope that they remain intact and can be found again. Today we focus on what you should keep an eye out for, should your inner Indiana Jones inspire the hunt.

Masamune's Honjo Samurai Sword

Japan's most famous swordsmith, Goro Nyudo Masamune, made this quasi-legendary katana, said to be perhaps the finest sword ever made, in the early fourteenth century. It was wielded in combat over the course of centuries, getting its name from a seventeenth-century owner, General Honjo Shigenaga. The story goes that another samurai attacked Honjo with this sword and split his helmet in two with a single blow, but Honjo won the fight and took the sword as his prize. It was worn by the Tokugawa shoguns and declared a National Treasure of Japan in 1939. It disappeared, along with a collection of fifteen prized swords, in January 1946, when these blades were taken by someone who appeared to be an American Allied officer. None have been recovered.

The Gardner Loot

On Saint Patrick's Day 1990, thirteen objects—including paintings by Manet and Vermeer—worth a combined estimated $500 million were taken from Boston's Isabella Stewart Gardner Museum. It has been called the highest-value peacetime property theft in history. The works are still missing, despite the reward for their recovery having been recently raised from $5 million to $10 million. Word is that those who know where the art is stashed have all died, so it is a matter of luck whether they will be stumbled upon.

Caravaggio, *Nativity*

Number 1 on the FBI's "Most Wanted Stolen Works of Art" list is a Caravaggio altarpiece (1609) swiped in 1969 from the church of San Lorenzo in

Palermo. It was taken by members of Cosa Nostra and nearly found by British journalist Peter Watson. Later, a Mafia informer claimed that the painting had been damaged in an earthquake and fed to pigs. Let's hope not.

Carl Spitzweg, *The Poor Poet*

In 1976, performance artist Ulay stole from the New National Gallery in Berlin what was known as Hitler's favorite painting, *The Poor Poet* (1839), and brought it to the home of a poor immigrant Turkish family to hang it on the wall. He then phoned the gallery and turned himself in. This theft-as-performance-art resulted in the painting being returned to the gallery. So how is it still missing? It was stolen again in 1989—that time for real—and has never been found.

Giorgio Vasari, *Libri dei Disegni*

Of all the lost artworks that could fill a "museum of lost art," the "books of drawings" (circa 1574) collected by the first art historian, Renaissance painter and architect Giorgio Vasari, is perhaps the most apt. It was, in many ways, a portable protomuseum, before the term "museum" (*museo*) was in regular use. It was a collection of twelve large folio blank books, into which Vasari pasted drawings he had collected by the most famous artists of the fourteenth through sixteenth centuries, from Giotto to Michelangelo. Around each drawing, Vasari added his own illustrations and motifs based on the style of the artist featured. Today, only a handful of individual pages from the *Libri* are extant, but what a treasure the whole collection would be, were it found.

The Hanging Gardens of Babylon

Of the Seven Wonders of the Ancient World, only the Great Pyramid at Giza is known to have survived, but the Hanging Gardens (built circa 600 BCE) may have as well. Archaeologists have recently considered that the elaborate terraced gardens of the Assyrian kings may not have been in Babylon at all, but at Nineveh. In fact, when ISIS iconoclastically blew up parts of Mosul, they may have inadvertently revealed previously buried and unknown structures from ancient Nineveh that some scholars believe were part of a terraced garden better matching the descriptions of the Hanging Gardens than anything that is known in Babylon.

Animal Heads from the Zodiac Water Clock

The 2009 auction of the estate of Yves Saint Laurent made headlines when included in the sale were two of the twelve bronze animal heads that had once

decorated a great fountain in the Old Summer Palace in Beijing. The palace complex had been looted by British and French soldiers in 1860, during the Opium Wars, and the rat and rabbit heads had been considered lost since then. They were eventually acquired by China, and seven of the twelve heads are now displayed at Chinese museums. A snake, sheep, rooster, dog, and dragon remain lost—at least for now.

Marcantonio Raimondi, *The Sixteen Pleasures*
Considered the first work of printed pornography (1524), this collection of sixteen erotic engravings by Renaissance master Marcantonio Raimondi (based on a lost painting cycle by Giulio Romano) are all likely lost, despite the fact that they were considered great works of art. Pope Clement VII was unimpressed and sought to acquire and burn all copies of the first edition and the second (in which the engravings were accompanied by sonnets penned by famous wit Pietro Aretino). But hope springs that some of the prints survived, and pirated versions certainly do, including one published by two seventeenth-century fellows at All Souls College, Oxford, who shepherded the first English edition, titled *Aretino's Postures*, as an early publication of Oxford University Press (before the fuddy-duddy dean confiscated the copper plates and shut down the operation).

—⁓—

Through these works and many more, it is important to recognize that the art blessed with survival is not necessarily the art that was most important or influential when it was first displayed. Just because an object had the bad luck to have been lost or destroyed, by man or by nature, does not mean its place in history was insignificant. Many lost works were more important and celebrated than those that have survived, but our understanding of art is skewed, inevitably, toward works that can be seen, that have outlived the numberless dangers that can befall a work of art that is often as brittle as a piece of paper.

Still, keep an eye out for those lost works. You never know when fortune might lead you to them.

A Digital Light in the Forest

High-Tech Art History Reveals Secrets

Key Work: Bosch, *The Wayfarer Triptych: Death and the Miser*

EVERYONE LOVES A GOOD TREASURE HUNT. FROM INDIANA JONES TO *THE DA VINCI CODE*, the search for lost artworks, solving puzzles and cyphers along the way, captures the popular imagination. Before I turned to art history as my field, I was certain that I wanted to *be* Indiana Jones. I recall the first line of my university application essay, which was on just this subject: "It's not just the whips and leather that are appealing." I later learned that, for each of the occasional eureka moments that cap the careers of researchers into art and antiquities, there is a whole lot of digging—in dirt for archaeologists and in musty archives for art historians. While fascinating, these careers are less glamorous and dynamic than I had originally imagined.

For most, that is. There are indeed art historians, equipped not with fedoras, leather jackets. and whips but—these days—with innovative digital technology that augments more traditional research methods, who are making swashbuckling, cinematic discoveries.

CODE BREAKING

As the world of mathematics bristles with beckoning, unsolved theorems, art history includes its share of coded manuscripts: beautifully illustrated books that are unintelligible, written in an invented language or carrying a clue that hides behind the superficial text and images. These include the Copiale cipher, a 105-page manuscript dated to around 1760 and written entirely in code. The code was cracked in 2011 by a team led by UCLA professor Kevin Knight. He is no art historian but rather a specialist in computer science and its application

to linguistics. He develops computer translation software of the sort that can be applied to unknown languages, tracing, for instance, the frequency of certain sounds and linking them to the frequency of words in known languages. Using a language analysis approach, Knight "translated" the Copiale cipher, which turned out to have been written in a complex substitution code (a simplified example would be 1 = a, 2 = b, and so on) that used a combination of abstract symbols along with Greek and Roman letters. Traditional code-breaking approaches had made no headway, but Knight approached the problem from an oblique angle—the sort of outside-the-box thinking that saw such success at Bletchley among World War II code breakers from a wide variety of fields. If linguistics computer software could unlock unknown languages, he thought, then maybe it could unpuzzle coded texts. Knight is now tackling a far more complicated project: the Voynich manuscript. This is a good deal trickier, because the bizarrely illustrated Voynich is written entirely in an unknown symbolic language, and its images may be linked to its overall code. Knight's approach is to view this as an elaborate translation project, assigning each symbol a digital equivalent—a total of 170,000 of them. The task is still underway, but Knight's progress has been remarkable, merging machine translation, computation, and cryptography.

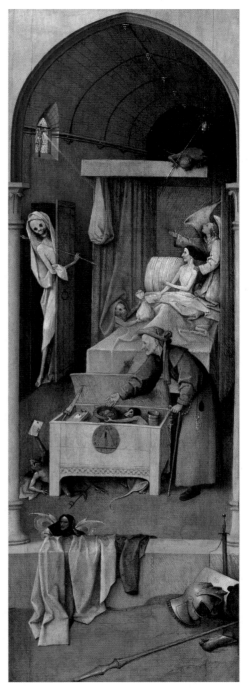

Death and the Miser panel from Hieronymus Bosch's *Wayfarer Triptych* (1485–1490).
PHOTO COURTESY OF WIKICOMMONS FROM THE GOOGLE ART PROJECT.

117

DA VINCI CODE BREAKING

Martin Kemp is perhaps the world's leading expert on Leonardo da Vinci and a former professor at Oxford. He is the go-to man for all things Leonardo and was responsible for authenticating several lost Leonardos—one that convinces (almost) everyone and one that still divides scholars. *Salvator Mundi* came to light just prior to the blockbuster Leonardo exhibition at London's National Gallery and featured in it, as its authenticity is universally acknowledged. It then sold for $450 million, the highest price of any artwork in history. While its authenticity as a Leonardo original has been questioned (some think it is by a member of Leonardo's studio or circle of colleagues, but not by his hand), most remain convinced that it is the master's own handiwork. A parallel discovery that was not included in the exhibit was *La Bella Principessa*. This painting on vellum was long thought to have been an eighteenth-century pastiche after Leonardo. But a battery of high-tech tests suggested that it was from Leonardo's lifetime. This was supplemented by Kemp's fieldwork, in which he successfully hunted down the very book from which the painting was cut, convincing most scholars that it is, indeed, a lost original.

"High-tech is totally reforming what we know about what is happening beneath the surface of paintings by Leonardo da Vinci," Kemp told me. "Multispectral scanning is not only displaying extensive underdrawings, but it is also revealing how he changed his mind incessantly during the actual process of painting." Kemp went on to mention two original paintings by Leonardo, one of which was stolen in 2004 from a castle in Scotland and only recently recovered: "In the two versions of the *Madonna of the Yarnwinder*, we can witness an alternating series of changes as they developed side-by-side in his workshop. Science meets the history of artistic production!" These underdrawings, often revealed by infrared reflectography, which allows us to see beneath layers of paint, have proven invaluable for art historical research.

Another lost Leonardo that has received a lot of press is *Battle of Anghiari*, which once adorned a wall in Florence's Palazzo Vecchio but has not been seen for centuries. Mauricio Seracini, an engineer turned art historian who appears briefly in *The Da Vinci Code*, has spent decades searching for it (and dodging bullets of bureaucratic red tape along the way). His interest began with a novelistic moment—in the enormous Salone dei Cinquecento of the palazzo, the size of a soccer field and covered in frescoes by Giorgio Vasari, there is exactly one piece of text painted onto the wall. It reads "*Cerca trova*": Seek and you shall find. Vasari painted it in such a high, remote corner that you cannot see it without binoculars or access via scaffolding. And the text is precisely

where most scholars believe Leonardo's *Battle of Anghiari* once adorned the wall. Vasari was a great admirer of Leonardo's and would not have knowingly destroyed one of his works if he could have avoided doing so. But he was commissioned to renovate and paint the palazzo and so had to fulfill his commission, which included a new fresco where Leonardo's once was. It seems likely that he borrowed a trick from another renovation project of his, at the church of Santa Maria Novella, in which he preserved a Masaccio fresco, *The Holy Trinity*, by building a false wall over it. Seracini thinks Vasari built a wall over the Leonardo, burying it without destroying it, and painted on this new wall.

Research with a wide variety of high-tech gadgetry permitted him to see behind the Vasari fresco without having to destroy it. Seracini discovered a gap of only a few centimeters just beneath Vasari's text. By shooting neutron-gamma rays through the outer wall and bouncing them off pigment beneath it, Seracini confirmed that there is a painting on the hidden inner wall. Drilling carefully through the outer fresco, the Italian Ministry of Culture, with Seracini's assistance, gathered paint pigment that is similar to pigment used by Leonardo. Signs point to *Battle of Anghiari* being back there, waiting to be uncovered. But a group of art historians signed a petition to stop Seracini's work, arguing that it is not worth ruining a Vasari fresco in hopes of finding what is likely a very badly deteriorated Leonardo, perhaps only a few unrecognizable clumps of pigment, after five centuries trapped in the crawl space. There is also a decidedly Italian soap opera of power plays among politicians and gatekeepers going on behind the scenes that has knotted up the project. It remains to be seen how this treasure hunt will conclude, but it was thanks to Seracini's comfort in the world of engineering and advanced technology that he was able to follow Vasari's centuries-old clue and determine that there is, indeed, something buried beneath it.

CSI ART INVESTIGATION

While advances in art research have come from seeing *through* paintings to find what lies beneath, a Dutch conservator and his team have come up with a way to examine art at such a microscopic level that his method has a good chance of not only revealing secrets about painting techniques and chemistry but also eliminating forgery altogether. Dr. Bill Wei is the man behind what has been called "art fingerprinting." The principle is to use a high-powered camera with a zoom lens that functions like a microscope to take an extreme close-up of a portion of an artwork or other object, as small as one square millimeter. Software then maps the topography of that square millimeter, turning

the photograph into what looks like a heart rate monitor, showing the peaks and crevices in the surfaces of even smooth objects that we don't imagine as textured: It has been used on paper and porcelain and was even used by the Dutch police to uniquely identify bullets. The idea is that only the owner of an artwork will know the location of the square millimeter thus "fingerprinted," so a work can be identified as your own by matching the topography of that portion of the object in question with the "fingerprint" photograph the owner keeps on file. For example, when a rare Ptolemaic world map was stolen in 2009 from the Biblioteca Nacional in Madrid, the library had a difficult time overtly proving that a Ptolemaic map that was recovered by the police in Australia was, indeed, *their* map, and not another version of the work. A normal photograph of the map, of which a number of authentic copies exist around the world (and possibly more that are lost and therefore not catalogued), was insufficient to prove that this recovered map was theirs. Had they "fingerprinted" the map, then they could have proven beyond a doubt that the map was their own. One can see how this technology could be likewise used to foil forgers: No forgery technique is sufficiently detailed to reproduce the microscopic topography of an individual millimeter of surface area.

Kemp, Seracini, Knight, and Wei are trailblazers in the field of digital art history. All four come from scientific backgrounds and have applied advanced technology to puzzles and mysteries in art history. They have made progress where hundreds of more traditional researchers have failed, because they have stepped outside the box and approached problems from new angles, embracing innovative technology in a field that is traditionally conservative. Like an economist studying human behavior or a mathematician searching for proof of the existence of God, crossing into new disciplines often results in great strides forward. There will always be a place for traditional, archive-trawling, connoisseur art historians. But when such methods hit a wall, the digital discoverers have the best chance to break through it.

PISHPOSH, IS IT HIERONYMUS BOSCH?

Art historical breakthroughs are supposed to come after months spent thumbing through brittle-paged archives in obscure libraries that smell of moldy carpets under the insect hum of fluorescent lighting. That has traditionally been the way: look closely with the naked eye, perhaps a magnifying glass, and flesh out the story behind the artwork with scraps of information culled from old documents. But since the late 1990s—when inexpensive, ubiquitous digital photography and the internet combined to allow unprecedented access

to scholars the world over, who could suddenly see and study works they could not see in person, in more detail than is usually found in books, and allowing them to sometime even see *through* works, using X-rays, infrared, ultraviolet cameras, and more—the most exciting discoveries have come through advanced technological investigations.

As we saw, a copy of the *Mona Lisa* was found to contain identical alterations to the underdrawing as in the original, demonstrating that it had been painted alongside the original, with the composition of both shifting simultaneously before the final was painted into being. An archaeologist uses satellite photographs to identify unexcavated archaeological sites, having spotted hundreds throughout Egypt, mapped terrorist looting in the Middle East, and even located a previously unknown Viking settlement in North America. The list goes on, each discovery thanks to digital investigative techniques complementing traditional close reading and archival research. Each story is a dramatic quest with a "big reveal" at its climax. Each story has required that art history as we know it be rewritten.

Such is the case with the artist of the year, the much-discussed Hieronymus Bosch (circa 1450–1516). The five hundredth anniversary of the death of the Flemish artist, best known for his imaginative depictions of hell as populated with playfully grotesque monsters, has seen a sold-out exhibition at the Noordbrabants Museum in the artist's hometown, s'Hertogenbosch, and at the Museo del Prado in Madrid. Both exhibitions can claim to be definitive, featuring almost all of the very few extant works by Bosch (there are twenty-four works, or perhaps twenty-seven; we'll return to that in a moment). But they have also become rival exhibits, thanks to digital discoveries first revealed at the Noordbrabants show, discoveries that have divided scholars and rankled storied institutions.

The Noordbrabants Museum exhibited seventeen of Bosch's extant paintings, recognizing that there were twenty-four in total. The Prado now exhibits twenty-four extant Bosch paintings, recognizing a total of twenty-seven. How can there be twenty-four, or perhaps twenty-seven, works? One of several prominent new conclusions about Bosch's oeuvre to come from the research leading up to these two exhibits is that the Dutch research team used infrared spectroscopy (photographs taken with infrared light that passes through the paint and bounces back off underdrawings) and found that three works previously thought to have been independently painted—*The Wayfarer*, *Ship of Fools*, and *Death and the Miser*, the key work in this chapter—were actually part of a single work, now called the *Wayfarer Triptych*, which had at some point been

dismembered and its constituent panels sold separately. Dutch scholars consider these three panels to actually be three parts of a single work and count it as such. Spanish scholars continue to list the works as separate, though the opinions of many have been swayed by the convincing papers published by the Dutch researchers on the reunification of this altarpiece.

Attributing an artwork to a specific artist's hand has always been difficult (we tackle this in depth in chapter 11). It was not until the nineteenth century that artists regularly signed their works, and attribution based on a work's style—the way it looks to the trained eye—leaves much room for error, inadvertent and otherwise. Part of what makes Bosch precious is how limited an oeuvre of his survived. There may be more works by his hand that have been mislaid or misattributed to someone else. Artists have always worked in studios or workshops, so students and apprentices developed styles very similar to that of their masters. Later artists learned by copying past masters, sometimes so well that it's hard to tell the difference. Art historians do their best to match up written records of the production of paintings with the paintings themselves, but often the matches are imperfect. And attributions can change, especially when new forensic discoveries come to light.

For all the excitement of piecing together a once-lost artwork, there has also been rancor. For the Dutch researchers found evidence that led them to downgrade the attribution of certain works, including *Extracting the Stone of Madness*, which was originally going to be loaned by the Prado to the Noordbrabants. On the loan agreement, the painting is listed as "by Bosch" and considered to have been painted between 1501 and 1505. But the view of the Dutch changed between the loan request and the exhibition. They informed the Prado that they would be listing the painting as "by the workshop or a follower of Bosch," dating it between 1500 and 1520. (Bosch died in 1516.) Needless to say, the Prado was unimpressed. As the museum's deputy director, Miguel Falomir, told the *Art Newspaper*, "It is unacceptable to request a painting as a Bosch and then show it as something different." Downgrading the work strips it of its cachet and value. While it is still of aesthetic and historical interest, it is no longer a draw—and in financial terms, it converts a seven-to-eight-figure value into a six-figure one. This was not the only problem. The Dutch also downgraded another Bosch from the Prado, *The Temptation of Saint Anthony*, describing it as having been painted several decades after Bosch's death.

These reattributions were largely due to examination of the underdrawing via infrared spectroscopy. Most artists would draw on their panel or canvas prior to painting, sometimes changing their mind about positioning or number

of figures, and only painting the final version. Thus the underdrawing can reveal the thought process and conceptual development of the artist. As discussed earlier, this is what happened with the Prado's copy after *Mona Lisa*; when the underdrawing was examined, it was found to be *identical* to the original. Had the painting been a copy, the copyist would have just painted the finished version and could not have known of the changes in composition Leonardo made prior to painting. Thus it can be concluded that the Prado version was made, step by step, alongside the original, likely by one of Leonardo's workshop assistants. But the Dutch researchers didn't like what they saw in the underdrawings to *The Temptation of Saint Anthony* and *Extracting the Stone of Madness*. Neither looked to them like the underdrawings in confirmed Bosch paintings. In *The Temptation of Saint Anthony*, for instance, in which the saint is beset by monsters, the underdrawing appears to show a monster uncharacteristically smiling. The Spanish team have reasonable counterarguments for the different underdrawings, citing one as in a different style because Bosch was painting for a new patron, and rebutting the smiling monster issue by suggesting that the monster is just licking its lips with glee before taking a bite out of the saint.

One of the beautiful but potentially frustrating things about art history is that it has never been, nor can ever be, an exact science. Whatever forensic evidence becomes available must be interpreted by human beings. Just as the introduction of DNA evidence has allowed huge strides forward in criminal investigations but has not proven definitive in courtrooms, so too have digital art historical discoveries offered the most eureka moments of late. But any evidence can be seen from a number of angles, and in the case of Bosch, new evidence has come to light—but how it is interpreted remains a game of dueling opinions, sometimes with millions in value at stake.

CHAPTER 9

What Would Freud Say?

Art, Psychoanalysis, and Neuroscience

Key Work: Magritte, *Son of Man*

THE GREATEST DISCOVERIES IN ART HISTORY, AS IN SO MANY FIELDS, TEND TO come from those working outside the box. Interdisciplinary studies break new ground because those steadfastly lashed to a specific field or way of thinking tend to dig deeper into well-trodden earth, whereas a fresh set of eyes, coming from a different school of thought, looks at old problems in new ways. Dr. Eric Kandel, winner of the 2000 Nobel Prize for Physiology or Medicine, underscores this point in his book *Reductionism in Art and Brain Science*, which offers one of the freshest insights into art history in many years. (It's interesting that it should come not from an art historian but a neuroscientist specializing in human memory, most famous for his experiments involving giant sea snails. You can't make this stuff up.)

I've spent my life looking at art and analyzing it, and I've even brought a new discipline's approach to art history. Because my academic work as a specialist in art crime bridges art history and criminology, my own outside-the-box contribution is treating artworks like crime scenes, whodunits, and police procedurals. I analyze Caravaggio's *Saint Matthew Cycle* as if the three paintings in it are photographs of a crime scene, which we must analyze with as little a priori prejudice and as much clear logic as possible. Such was the case for one of the most famous puzzle paintings, Bronzino's *Allegory of Love and Lust*, in which Vasari's description of what centuries of scholars have assumed was this painting had to be cast aside in order for progress to be made. Ernst Gombrich made waves when he dipped into optics in his book *Art and Illusion*. Sigmund Freud offered a new analysis of Leonardo. It takes an outsider to start

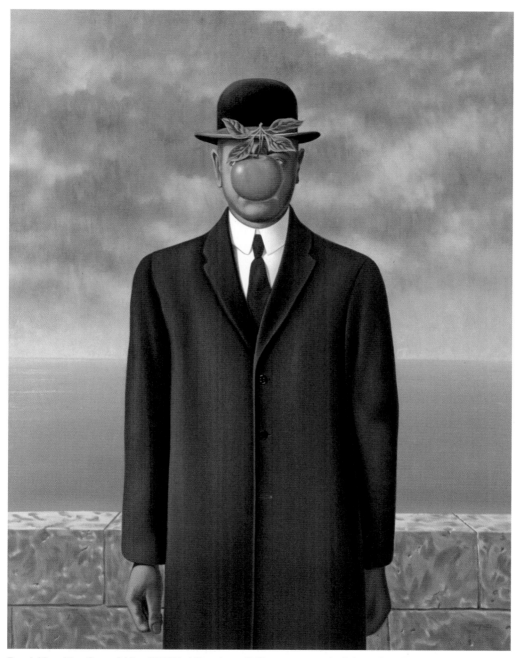

René Magritte, *Son of Man* (1964). Who doesn't like green apples? And *The Thomas Crown Affair*, right? © 2021 C. HERSCOVICI / ARTISTS RIGHTS SOCIETY (ARS), NEW YORK. PHOTO CREDIT BANQUE D'IMAGES, ADAGP / ART RESOURCE, NY

a revolution. So it is not entirely surprising that a neuroscientist would open this art historian's eyes.

Ask average people walking down the street what sort of art they find more intimidating, or like less, or don't know what to make of, and they'll usually point to abstract or minimalist art. Show them traditional, formal, naturalistic art, like Bellini's *Sacred Allegory*, art that draws from traditional core Western texts (the Bible, apocrypha, mythology) alongside a Rothko or a Pollock or a Malevich, and they'll retreat to the Bellini, even though it is one of the most puzzling unsolved mysteries of the art world, a riddle of a picture for which not one reasonable solution has ever been put forward. The Pollock, on the other hand, is just a tangle of dripped paint; the Rothko, just a color with a bar of another color on top of it; the Malevich, all white.

Kandel's work explains this in a simple way in *Reductionism in Art and Brain Science*:

> In abstract painting, elements are included not as visual reproductions of objects, but as references or clues to how we conceptualize objects. In describing the world they see, abstract artists not only dismantle many of the building blocks of bottom-up visual processing by eliminating perspective and holistic depiction, they also nullify some of the premises on which bottom-up processing is based. We scan an abstract painting for links between line segments, for recognizable contours and objects, but in the most fragmented works, such as those by Mark Rothko . . . our efforts are thwarted.
>
> Thus, the reason abstract art poses such an enormous challenge to the beholder is that it teaches us to look at art—and, in a sense, at the world—in a new way. Abstract art dares our visual system to interpret an image that is fundamentally different from the kind of images our brain has evolved to reconstruct.

Kandel describes the difference between bottom-up and top-down thinking. This is basic stuff for neuroscience students, but brand-new for art historians. Bottom-up thinking includes mental processes that are ingrained over centuries: unconsciously making sense of phenomena, like guessing that a light source coming from above us is the sun (since for thousands of years that was the primary light source, and this information is programmed into our very being) or that someone who appears larger must be standing closer to us than someone who appears much smaller and is therefore in the distance. Top-down

thinking, on the other hand, is based on our personal experience and knowledge, not ingrained in us as humans with millennia of experiences that have programmed us. Top-down thinking is needed to interpret formal, symbolic, or story-rich art, whereas abstraction taps bottom-up thinking, requiring little to no a priori knowledge.

Kandel is not the first to make this point. The great painter Henri Matisse said, "We are closer to attaining cheerful serenity by simplifying thoughts and figures. Simplifying the idea to achieve an expression of joy. That is our only deed [as artists]." But it helps to have a renowned scientist (who is also a clear writer and passionate art lover) convert the ideas of one field into the understanding of another. The shock for me is that abstraction should really be *less* intimidating, as it requires no master's or PhD degree, no reading of hundreds of pages of source material, to understand and enjoy. And yet the general public, at least, finds abstraction and minimalism intimidating, quick to dismiss it with "Oh, I could do that" or "That's not art." We are simply used to formal art, expecting it, and also not necessarily expecting to understand it in an interpretive sense. Our reactions are aesthetic, evaluating just two of the three Aristotelian prerequisites for art to be great: it demonstrates skill and it may be beautiful, but we will often skip the question of whether it is interesting, as that question requires knowledge we might not possess.

We might think that formal paintings—particularly those packed with symbols or showing esoteric mythological scenes—require active problem-solving to "read." At an advanced academic level, they certainly do. (I racked my brain for years over that Bronzino painting.) But at any less scholarly level, for most museumgoers, this is not the case. Looking at formal art is actually a form of passive narrative reading, because the artist has given us everything our brain expects and knows automatically how to handle. It looks like real life. But the mind-bending point Kandel makes is that abstract art—which strips away the narrative, the expected real-life visuals—requires active problem-solving. We instinctively search for patterns, recognizable shapes, and formal figures within the abstraction. We want to impose a rational explanation onto the work, but abstract and minimalist art resists this. It makes our brains work in a different, harder way, at a subconscious level. Though we don't articulate it as such, perhaps that is why people find abstract art more intimidating and are quicker to dismiss it: It requires their brains to function in a different, less comfortable, more puzzled way—more puzzled even than when looking at a formal puzzle painting.

Kandel found that the connection between abstract art and neuroscience is about reductionism, a term in science for simplifying a problem as much as possible to make it easier to tackle and solve. This is why he studied giant sea snails to understand the human brain. Sea snails have just twenty thousand neurons in their brains, whereas humans have billions. The simpler organism was easier to study, and the results could be applied to humans. "This is reductionism," he said, "to take a complex problem and select a central, but limited, component that you can study in depth. Rothko—only color. And yet the power it conveys is fantastic. Jackson Pollock got rid of all form." In fact, some of the best abstract artists began in a more formal style and then peeled the form away. Turner, Mondrian, and Brancusi, for instance, have early works in a quite realistic style. They gradually eroded the naturalism of their works—Mondrian, for instance, painting trees that look like trees early on before abstracting his paintings into a tangle of branches, and then a tangle of lines, and then just a few lines that, to him, still evoke tree-ness. It's like boiling away apple juice, getting rid of the excess water, to end up with an apple concentrate, the ultimate essence of apple-ness, a simile I've already used.

We like to think of abstraction as a twentieth-century phenomenon, a reaction to the invention of photography. Painting and sculpture no longer had to fulfill the role of record of events, likenesses, and people—photography could do that. So painting and sculpture was suddenly free to do other things, things photography couldn't do as well. Things like abstraction. But that's not the whole story. As we've seen, a look at ancient art finds it full of abstraction. Most art history books, if they go back far enough, begin with Cycladic figurines (dated to 3300–1100 BCE): abstracted, ghostlike, sort-of-human forms. Even on cave walls, a few lines suggest an animal, and a constellation of blown handprints floats in absolute darkness.

Abstract art is where we began, and where we have returned. It makes our brains hurt, but in all the right ways, for abstract art forces us to see, and think, differently.

On Selfies and Self-Portraits

We'll get back to Kandel in a moment, but for now let's turn to one of art history's great quotations, attributed to René Magritte: "A face isn't a face unless it's facing you." And now, a brief foray into Bosnian stand-up comedy.

A Bosnian comedian resident in Slovenia isn't the sort of person you'd expect to inspire deep thoughts on Surrealist painter Magritte, Existentialist philosopher Jean-Paul Sartre, the neuroscience of facial recognition, and

the history of self-portraiture. But then again, Perica Jerković is no ordinary comedian. There are comics whose only goal is to be funny, and then there are those who have a message, a philosophical bent, and their means of delivery, of prompting you to think deeper, is through comedy. Lenny Bruce was perhaps the ultimate example of this—he wasn't particularly funny, just a sly and subversive observer. Louis C.K., until his recent sex scandal the most successful comic in the world, is another such performer, though his intellect is disguised by the thicket of outrageous, potentially offensive things he spouts. Dave Chappelle offers true sociopolitical insight, but with a down-to-earth delivery that disarms the listener and allows deep ideas to infiltrate, flying in through the open-mouthed laughter of his audience. There are comics who sound (or look) dumb but are actually cloaking insight: Steven Wright and Mitch Hedberg, for instance. In a recent one-man show by Jerković, *The History of the Dumbass Selfie*, all were wrapped into one. My inner art historian laughed his inner ass off, and it got me thinking. Add to this my interest in self-portraiture, a wild trend in "selfies" plus a jigger of Magritte, and that interview I did with Eric Kandel. This odd, but surprisingly apt, cocktail was all inspired by a stand-up comedy performance that was much smarter than it needed to be. The theme of his show is how selfies, this wildfire phenomenon defined as "a self-portrait photograph taken with the intent of posting it online," is really a cry for attention in a world overrun by images and information. Some statistics: around 93 million selfies are taken worldwide each day; the average millennial will take more than twenty-five selfies in their lifetime; 24 billion selfies were uploaded, according to Google statistics, in 2015.

This is nothing new. Millennia of portraiture has maintained the same goals. Instead of the selfie stick and that democratic, worldwide instant gallery called the internet, past eras have employed pens, brushes, and chisels, and understood that the memory of how artists or their subjects looked was limited to what artists could craft and by the knowledge that relatively few people would ever see them. Artistic skill was needed to produce a true likeness (though realism was not always the goal), so "selfies" of the pre-photography era were limited to artists and often took the form of carved signatures rather than pictures. Commissioned portraits, therefore, should enter the discussion, since there are far fewer historical self-portraits than portraits. As noted earlier, until the eighteenth century, artists' materials were expensive enough that artists rarely painted or sculpted if not on paid commission. Heads of state, clergy, and wealthy patrons would commission portraits in order to preserve their likeness, but, official state propaganda aside, this was often just for their family and honored guests, not

intended for the general public, and certainly never envisioned for whitewashed gallery walls hundreds of years into the future.

Portraits, like selfies, were curated by those who made them. A survey of two thousand women found that they spend an average of sixteen minutes a day taking selfies, which means that a lot of pictures are being deleted for every one that makes the cut. Now, imagine that only one photograph of you would ever exist to preserve your likeness. You'd think pretty carefully about how it should look, right? Those who commissioned portraits would ask to be shown as they liked to think of themselves and as they would like to be remembered: often prettier than they were in person, surrounded by positive attributes that may or may not have actually featured in their lives. Remember that when Piero della Francesca painted Federico da Montefeltro's circa 1465 portrait in profile, he was not only referencing ancient Roman portraits of emperors in profile on coins but also hiding the battle-scarred right side of his face by showing only his left. The bridge of his nose had been smashed and his right eye lost in a tournament. Airbrushing is another long-standing tradition. Thus selfies, like portraits, are not completely honest records of appearance, but rather a carefully selected version of how we would like to be seen by others.

But how, exactly, are our faces seen? Kandel has something to say about this, too. He found parallels between how the brain processes art and how it deals with faces. In fact, the same part of the brain covers both art and facial recognition.

The inferior temporal gyrus helps us distinguish and categorize things we see. Within that section of the brain there are several subsections, including the fusiform gyrus, also called the fusiform face area, which specializes in recognizing faces (as opposed to objects and landscapes, which are the realm of the parahippocampal place area). The extrastriate body area distinguishes the human body from other objects, while the lateral occipital complex analyzes specific shapes as opposed to abstract or indistinct ones. It turns out that the lateral occipital complex, which processes abstract art, is also in charge of face recognition.

When I played hide-and-seek with my daughters when they were little, they were fine with my lurking in a shadowy corner and jumping out as they approached. But if I stood anywhere, even in full light, with my face covered, they totally freaked out. They logically knew it was me, but when my face was obscured, a part of their brain kicked into panic mode because I just might be a monster.

And so we come to Magritte.

A Face Is Not a Face Until It Is Facing You

Consider Magritte's 1964 painting *Son of Man* (the key work in this chapter). It portrays an anonymous businessman in a bowler hat and a suit, his face obscured by a floating green apple. Magritte most admired the philosopher Sartre, who wrote of the confrontational nature of the exchange of gazes between people. The refusal to meet the gaze of another is akin to the refusal to acknowledge the humanity, the soul, the existence of the other. The refusal to offer another person your gaze, to obscure your face from them, is, for us humans, monumentally creepy. (Just ask my daughters.)

We do not feel that we understand a person if we do not see their face. Could you recognize the businessman in Magritte's *Son of Man*? Perhaps, you might suggest, by his clothing. But what about another Magritte painting, titled *Golconda*? This portrays a suburban street, with hundreds of identical businessmen in bowler hats suspended at various points in the sky, as if it is raining businessmen. Their faces are blank. And his *Not to Be Reproduced* shows the back of a man's head as he stares into a mirror—which reflects only the *back* of his head. It's the stuff of horror films.

In portraits, self-portraits, and selfies, we create a version of ourselves that we want the world to see, and by which they should remember us. It is an art form, and because faces are its subject, it happens to provide double duty for the same part of our brains. We feel we understand someone, identify them, remember them, "read" them only when we see their face. To deny someone sight of our face is to deny them our humanity, to monsterize us.

"A face is not a face unless it is facing you." A person is not a person if we cannot see his or her face. And we would have you believe that we are who we are, based on the face of ours that we carefully select to show you.

Art and Value

The Market, Digitalization, and How to Shop

Key Work: JAŠA, *Within This Touch* (*Ever More*)

WHEN I WAS AN INTERN WORKING AT CHRISTIE'S IN LONDON, A DRAWING BY Michelangelo sold for £13 million (around $17 million). It was bought by a private collector, as almost no institutions have high enough acquisitions budgets to afford such treasures. I was once told that the British Museum in London had a total annual acquisition budget of around £100,000 (around $135,000). These numbers change, but it's useful to know how limited is the audience that can drop millions on art. *New York Magazine* art critic Jerry Saltz estimated that there are about fifteen hundred players worldwide. That's it.

High-end art is sold through fancy brick-and-mortar galleries, which traditionally take a 50 percent cut from the sale price when working with living artists, or from auction houses, the most famous and storied of which are **Christie's** and **Sotheby's**, which normally take a 17.5 percent fee, paid by the buyer (so the buyer pays 117.5 percent of the total "hammer price," the final sale price at auction). **Auctions** are where the best prices are fetched, as sales are heavily promoted and bidders around the world can fly in, phone in, or register bids ahead of time by contacting the auction house. The adrenaline of the sale encourages higher bidding, so the prices are usually higher than sales at galleries, which employ a single fixed price and entertain one potential buyer at a time. Lower-end artworks (priced five figures and less) sell at less glamorous galleries or online.

London hosts an annual Affordable Art Fair. This has been a staple since 1999, with around a quarter-million visitors each year, and parallel fairs in ten cities. The definition of "affordable" is works priced under £2,500 (around

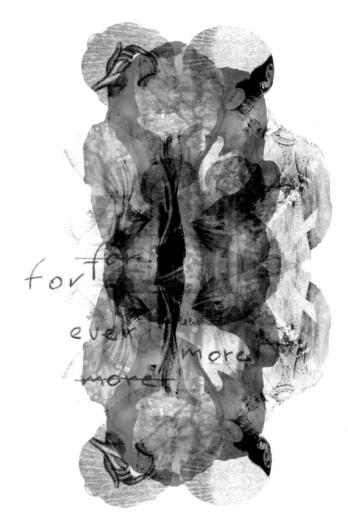

Within This Touch (Ever More),
an NFT by JAŠA (2021).
PHOTO COURTESY OF JAŠA.

$3,300), with some sold for as little as £50 (around $65). But while the prices are low, the quantity is high: The fair handles over $400 million in sales. There is clearly a large market of people who want to own original, unique artworks but have what might be considered "normal" incomes. Most high-end art and antiquities are collected by a tiny minority of extremely wealthy individuals, institutions, and families, a sort of private club of just a few hundred millionaires the world over, many of whose families have been collecting art for centuries. This clubby atmosphere is cultivated by galleries and auction houses. Having worked at Christie's and knowing the art world from behind the scenes, I can attest to the widespread proactive encouragement of this sense of exclusivity. One of the reasons online art sales have never caught on for high-end objects is the social element of collecting: seeing and being seen, catching up with old

friends, popping over to Milan for the Sotheby's sale, chatting about your latest purchase while poolside in St. Tropez, ostentatiously lending to the Met.

At the top level, art collecting has always been about two things: demonstrating one's erudition and showing off one's wealth. This dates back to Renaissance patrons: princes, aristocrats, cardinals, and popes who sought top artists to decorate chapels and palaces that were designed to give the owner pleasure, sure, but just as much to awe his guests.

While you won't find big-name collectors browsing the Affordable Art Fair stalls, I wondered how the price of art affects desirability at all levels, and also how living artists price their works, striking the balance between a price someone might actually pay and a price high enough to make a potential buyer feel the artist is serious and the work desirable.

In my book on art forgery, I proposed an equation for the value of art: value = perceived (rarity + authenticity + demand). Most art is unique, so rarity refers to how many works by an artist exist at all. (For example, Giorgione died young and made far fewer paintings than his contemporary Titian, so a Giorgione is far more valuable than a Titian.) Authenticity is an issue for antiques and Old Masters, not usually a factor for the contemporary artists of the Affordable Art Fair. Demand, or the perception of it, is key to drive up the price. You need at least two people who really want to buy something, and that competition, particularly at auction, can make prices rise dramatically. The price for works by established artists is usually based on past sales—a Picasso with a similar provenance, importance, quality, and size that sold a few decades ago will be compared to a Picasso newly on the market and, after inflation, an estimated price is chosen. But the category of museum-quality art and antiques is its own rarefied world, with a minuscule number of potential buyers functioning in a sociological bubble distinct from what might be called "normal folks."

Art is always a good investment, provided it is deemed authentic. Prices rarely drop, especially in the internet era, where bargains are hard to come by because the world has access to information about the most esoteric art at the click of a mouse. Art tends to maintain its value or rise in value. This is why banks will buy art to store in vaults—art by established artists is considered a wise investment. For those with a modest amount to spend, like me, the best place to start is in the world of prints. Prints are made in limited runs but are not unique; therefore, they are much more affordable. You can get authentic prints by big-name artists like Picasso, Dalí, and even Old Masters like Dürer, for prices in the low thousands. That's a lot of money, but not in art world terms.

Art collecting must be divided into two spheres for separate consideration. High price does encourage interest in the thin air of museum-quality sales and auctions. Back here on earth, price gives the impression of an artist's growing fame, but it does not encourage purchases, largely for the reason of the limited wallet power of potential buyers. In both worlds, price is equated with the (presumed) fame of the artist (a living artist can set very high prices and hope to impress), but in only one world does it encourage desire to own. For most, it's about the initial aesthetic and emotional impact, with the price tag as an afterthought. As painter Harry Hancock says, "The Affordable Art Fair is great because it provides a venue for art that shows virtuosity and originality, but no fame." It's fame, in the end, that pays.

—❦—

The same might be said when it comes to museumgoing. **Museums** were established in the eighteenth century to display collections of objects of interest, ranging from natural history to archaeology to fine art. This period, the **Enlightenment**, championed the human capacity for reason as setting humans above animals and sought to exert some measure of control of the world and its science, history, and mystery by cataloguing and organizing it. The physical manifestation of this sorting and filing was the encyclopedia (in print) and the museum (in the form of a building one could visit to see, move through, study, and exert control over). At this point in the discussion, it may be unsurprising to learn that Giorgio Vasari was responsible for the way we conceive of museums today: arranged into periods, geographies, and art historical styles, taking the guest on a chronological tour.

Most museums do not own all the works they display. Many are on long-term or permanent loan, with the owner benefiting through the prestige of lending valuable, admired objects to a respected institution and also sometimes enjoying tax breaks for doing so. Those works that do enter museum collections are usually categorized as **priceless**. This is a term that we now use to mean "very valuable," but in fact it literally means that the object has no price because it cannot be sold. Museums can **deaccession** works, meaning remove them from their collection and, in some cases, sell them, but depending on the type of museum (especially if it is public or government owned) this is complex. This distinguishes museums from galleries, where collectors can buy the art that is displayed. Once acquired by a museum, art disappears from works that might potentially enter the market. The museum's charge is to preserve the art (protecting it from theft or deterioration) and to display it for public education and pleasure.

I spent the 2020 lockdown virtually visiting museums with my six- and eight-year-old daughters. Many museums have excellent virtual tours or walk-throughs. After the lockdown, I still think virtual tours are a fine way to "travel" without leaving the couch.

DO NFTS MEAN THE END OF REAL-WORLD ART?

There have been art thefts in which works were swapped. In 2014, Matisse's 1921 *Odalisque in Red Trousers* was recovered following an FBI sting operation and returned to the Caracas Museum of Contemporary Art in Venezuela, from which it had been stolen. Yet it took two years for anyone to notice that the painting had been stolen. The real Matisse was taken back in 2000, but no one was aware of the theft until 2002, because the thieves had swapped a very good forgery in its place.

But that was a swap. How about stealing by only adding? In 2021, we witnessed a case in which the illusion of adding an artwork could have resulted in lowering the value of other artwork by tens of millions of dollars.

On April 4, 2021, the artist Beeple's account was hacked. His claim to fame is having created and minted **a non-fungible token** (NFT), *Everydays—The First 5000 Days*, which was sold at Christie's for $69 million, making it one of the most expensive artworks in history. NFTs are like cryptocurrency (Bitcoin and the like) but cannot be directly cashed out. Instead, they are a way of linking a file (a jpeg or mp3, for example) to **blockchain** to demonstrate its authenticity and rarity. NFTs were all over the news in 2020 and 2021. The value of an NFT like Beeple's, as with the value of *all* art (digital or otherwise), is in a combination of its perceived rarity plus perceived demand plus perceived authenticity. Because there's only one original *Everydays—The First 5000 Days* (the file is huge, so the images of it available online are miniature thumbnail derivatives for promotion only) it has value.

But if there were *two*, then suddenly the value would be significantly less—tens of millions less. While Beeple was the one hacked, it was MetaKovan, the buyer of the original, who was almost "robbed"—not of the NFT itself but of its perceived value. This was the trick being pulled by a hacker who calls himself Monsieur Personne (French for Mister Nobody) and who said that his goal was "not out of malice" but merely to point out the silliness of the NFT craze. The hacker did so by "sleepminting," or registering a new NFT as if it came from an artist. It was as if Beeple woke one morning to see a forgery of a Beeple sitting in his studio on the easel. The thief (if we can even call him that) has coined the term "sleepminting" and launched a website, NFTheft (https://nftheft.com/). It

is all a publicity stunt, but one can see how it could be used for ill purposes. And if the truth had not been outed so swiftly, MetaKovan might have been robbed of most of the value of his $69 million NFT. (Ironically, I tried to license image rights to *Everydays* for this book, but no one replied to my queries. I could have right-click saved and gone rogue, but I wanted to do the right thing, so you'll have to go online to see an image.)

We are entering what experts call a megacycle of NFTs. They may seem like just the latest overhyped trend, and it is easy to see it from that perspective, but I see it differently. To me, they're just the latest incarnation of using technology to create art.

In the 1980s, when video art was introduced, many thought that it was a silly trend that would never last. How, they wondered, can you give value to something that can be copied from VHS to VHS? The answer was that there was one or more originals (a unique "mother" VHS of the video artwork or a limited series endorsed by the artist). The value was in the limited number of the series endorsed by the artist. Sure, there were pirated versions, but they would not be accompanied by provenance, documentation attesting to their authenticity as part of the artist's vision. So while you could view the video, it would not have resale value and therefore value to collectors. The system worked and endured. Going back still further, some wondered, circa 1500, how prints by master artists like Albrecht Dürer could have value if they were produced on a mechanical printing press and existed in extensive series. But they retained value and still do because of perceived rarity, demand, and authenticity.

NFTs look set to last not only for this reason but because they have a number of advantages that will help them endure. One is the ability for artists to release their work directly. That has not quite happened yet; at the moment artists still need a platform. But the platform is essentially a way to announce to the world that the artist has a new product, as is the case with Open Sea (https://opensea.io/), which seems to be the most popular for proper artists. It functions much like an online art gallery, but with fees far lower than the 50 percent art galleries usually take.

There is also the immediacy of delivery and absence of significant costs for transport and handling and insurance. The downside of this is that the only way to look at your art or display it is in virtual online galleries, like those in Decentraland (https://decentraland.org/), a website comprising a virtual world where virtual versions of users can explore virtual collectibles that they bought with virtual currency.

Yes, we've entered the Matrix.

But one imagines that it is just a matter of time before technology will catch up and make enjoying NFTs as easy as it is to collect them. Crypto wallets will likely have art gallery features in the future, and there will be the ability to loan your unique digital image to galleries and screens the world over—MetaKovan has talked about loaning his Beeple NFT, for instance. I curated a virtual exhibition in 2020—the heart of the COVID-19 lockdown—called *Missing Masterpieces*. It was visible only on Samsung's The Frame televisions, and a digital screen like that is ideally suited to present a collection of NFTs.

Another advantage is that, theoretically, blockchain technology makes NFTs immune to theft or forgery. The promise of blockchain technology is really just digital **provenance**. Provenance describes the documented history of an object: its ownership, where it has been displayed, and so on. Blockchain technology simply takes this and digitizes it in immutable code that cannot be altered or erased but only added to. This means that there can never be any doubt as to whether someone who is in possession of an NFT is actually the owner or whether that NFT is original or not, because the blockchain provenance will trace it back to its creator.

Yet for every brilliant technological innovation, there is someone with too much brain power and too much time on their hands who will come up with a way to defeat it. This was made evident by Monsieur Personne, whose quite ingenious action was merely a way to show that the emperor has no clothes. The "sleepminting" hack was sufficiently skillful that it seemed that this new NFT had indeed come from Beeple himself. This was quickly set right and there was no harm done. It may even be considered an artistic action in the form of illegal activity, along the lines of Ulay's *Irritation: There's a Criminal Touch to Art*, a 1976 artistic action in which the German artist stole a painting from a Berlin museum.

In the end, the NFTheft, as Monsieur Personne calls it, actually publicized NFTs more than undermined them, perhaps even underscoring their relevance, because if something is worth hacking, then it is worthy of attention. But it does show that even foolproof technology sets a bar that some people will try to leap over or crawl under.

NFTs do not spell the end of IRL art (that's short for "in real life"—don't worry, I had to look it up, too). They are simply a new chapter. Artists are now racing to create their own NFTs, as most of what exists now is mediocre and uninteresting from an art perspective, and yet people are throwing money at it. Banksy has created them. In 2021, Damien Hirst announced that he would, too. Others will follow suit. That same year, European conceptual artist JAŠA

released a series called *Within This Touch* (see the key image at the beginning of the chapter) on Open Sea and is planning to release what will be the first durational performance artwork as an NFT. It is early days and so there are myriad opportunities for firsts. JAŠA's next project, *The Monuments Fragments*, will allow patrons to buy NFTs and, in doing so, fund the construction of an architectural space in which durational performances will take place. (JAŠA's best-known project, *Utter*, which was part of the 2015 Venice Biennale, had a similar format.) Those NFTs will also function as tickets for the patrons to attend the performances, which are otherwise closed to the public. Patrons can also print and frame the NFT images, thereby making an IRL artwork out of a digital one—the opposite of what we're used to when we take a digital photo of a physically existing artwork. Once sold, the sixteen fragments available will fit together, like Voltron, into a *Monuments Mother Image*, a new NFT, which will likewise be available for purchase. The possibilities are endless.

We are just at the start of a long extension of the megacycle. NFTs should indeed be considered a new art format, one that is in its nascent years—or rather, given the speed of the digital world, its nascent weeks. It is not so different from video art or other technological leaps forward that left many people scratching their heads. The value of NFTs is directly parallel to the reasons art has always been valued. My prediction is that the tsunami of uninteresting NFTs will cool and recede, but now that proper artists and creators are entering the fray, the collecting of blockchain-provenanced, digital-first (and often only) artworks will endure and thrive.

How to Avoid Buying Stolen, Looted, or Forged Art

No one wants to be the subject of a big "oops." The Del Sole family bought an $8.3 million Rothko painting from the Knoedler Gallery that turned out to be by some Chinese guy they'd never heard of. Oops. Steven Spielberg bought a $200,000 Norman Rockwell that turned out to have been stolen from a St. Louis gallery. Oops. And if you buy an antiquity these days that emerged from Syria, your purchase might be funding fundamentalist terrorists. Big oops.

In order to avoid mistakes like these, art collectors need to be informed. But the art trade has long thrived on the fact that so-called experts know much more about the works in question than the buyers do. The high-end art market is, and always has been, one of the least transparent multibillion-dollar markets in the world. Can you imagine buying, say, a very expensive house for $10 million, when you don't know the current owners or how they acquired it, there is little or no paperwork attesting to its ownership history and upkeep, its price

feels fairly arbitrary, you can't really be certain what it's made of, the sellers insist on cash (possibly wired to a Swiss bank account), and you're not permitted to investigate further before purchasing? Welcome to the art world, where this sort of thing is normal and has been for centuries.

The opacity of the art trade has several facets. When the first auction houses, Sotheby's and Christie's, were established in the eighteenth century, their main business was liquidating the art collections of once-wealthy aristocrats who could no longer afford a life of luxury, what with the Industrial Revolution changing the way money was earned and the feudal system out the window. Those aristocrats didn't want to advertise their financial straits, and the auctioneers obliged by refusing to divulge the seller, referring to them simply as a "lady" or a "gentleman." Even today, police sometimes need a warrant to oblige galleries or auction houses to reveal who consigned works to them. Then there's the knowledge gap. Although there probably should be, there's never been a tradition of buyers insisting on seeing forensic test results indicating the authenticity of a work that is for sale. Buyers are told about the work by the expert—as much as the expert is willing to reveal about its authorship, subject matter, state of conservation, background story, and provenance—and that's it. Take it or leave it. If I were dropping a million on a painting (or a house, for that matter), I would not buy anything without knowing the owner and without independent test results that indicated that the work was what the expert was telling me it was. But then again, I'm a professor specializing in the study of art crime (and I don't sell enough books to drop a million on anything).

As the author of several books on art crime and having taught the history of art crime for many years, I know scores of tricks that thieves, forgers, and con artists have used successfully in the past. We study history so as not to repeat past mistakes, and from these case studies, we can draw lessons for how not to be fooled in the future. Clever con artists will always find new ways to deceive, and it is much more likely that an expert will err without malicious intent than proactively try to commit fraud, but forewarned is forearmed. For those interested in buying, what follows are five tips for how to buy legal, authentic art, wherever you may be, in whatever style you prefer, and whatever your budget (and whether you are buying online or in person).

Check with a Stolen Art Database—but That's Only the Start

In order not to be criminally liable should you (inadvertently) purchase stolen art, you need to be able to demonstrate two things: due diligence and a good-faith purchase. **Good faith** means that you must be able to argue that you

genuinely thought the object was legitimate when you purchased it. **Due diligence** means that you checked around, for example, with **stolen art databases**, and the object wasn't listed. This is a bare minimum, but just because a work is not listed as having been stolen doesn't mean it's not problematic (for example, any antiquity looted directly from the earth will not appear in a database because it was last seen centuries or millennia ago).

Ask about the Provenance, Then Actively Check It

If you can't trace the entire history of an object, that is not in itself cause for suspicion—few objects, aside from the very recent, have a complete ownership history. But ask about provenance. Antiquities must be accompanied by documentation that proves they were excavated and exported prior to 1970 in order to be tradable. (Prior to the **UNESCO convention** that year, laws were disjointed and irregularly enforced, so a sort of amnesty is given to objects traded before that date.) The more provenance there is, the safer you can feel that the work is (a) authentic, if it has a charted history of people thinking it was authentic, and (b) not stolen or looted. But few people check the provenance itself. If, say, a painting is purported to have been exhibited at three different galleries, each of the galleries and exhibition dates should be checked. Red flags are raised when none of the provenance can be easily double-checked (if, for example, all three galleries are now closed or the past owners are all deceased). Sometimes crooks indicate provenance that is not actually related to the object in question.

Look at the Back of Works, out of Their Frames

Backs of paintings and prints (and bottoms of sculptures) contain a wealth of information: things like stickers or stamps from past owners or sellers, customs permissions, as well as the normal wear-and-tear that you'd expect from an object that may be hundreds of years old. Forgers tend to be lazy about doctoring the parts of the works that are normally hidden. The most frequently forged type of art are twentieth-century lithograph prints by the likes of Dalí, Miró, Chagall, and Picasso (who is also, by far, the most frequently forged artist). These are normally sold nicely matted and framed, and it seems a shame to dismantle them to look at the back of the work. But a quality laser print on fancy paper made last Tuesday looks almost exactly like a lithograph from the 1950s when encased in glass, so collectors should feel empowered to insist that they see all sides of the art they're planning to buy.

Ask about Forensic Testing

There's no good reason why forensic testing of artworks prior to sale is not standard. Buyers don't insist, so there's no incentive for sellers to do it—we're supposed to rely exclusively on expert opinion. But I always advise collectors to inquire about forensic test results, and if there are none, to ask if they could pay for forensic testing themselves prior to purchase. Testing these days is not necessarily invasive and might cost as little as a few hundred bucks—not much for peace of mind when you're about to pay six or seven figures. Then gauge the reaction of the seller. If he or she refuses, consider walking away.

Do Not Buy Any Antiquity That May Have Come from a Conflict Zone

Recent documentaries and investigations have shown how some bad seeds in the art trade knowingly sell antiquities looted or stolen from conflict zones, which can mean that your purchase is funding terrorists. (If you want to see how this works, check out the film *Blood Antiques* or see some of my other books on art crime.) Don't be a party to this, even unwittingly. It's hard to request a moratorium on buying antiquities from the Levant, but unless they come with extensive (and verifiable) provenance to show they've been in foreign collections for decades, I wouldn't even consider them.

❧

Entering the art market is exhilarating and needn't be expensive. I have a modest income and a modest collection of art, but one that I love. When I was still a student, I liked to collect prints by Arthur Rackham and Gustave Doré. These prints are beautiful but also plentiful—each one cost just around $50. I recently found an authentic forgery—a print made by Marcantonio Raimondi circa 1510 that was a copy of an Albrecht Dürer original. Dürer had sued Raimondi and his employer, a print shop in Venice, for selling forgeries of his work and passing them off as his. This anecdote opens my 2015 book *The Art of Forgery*, and I was thrilled to find one of the forgeries online for $350. The best advice on collecting is to buy what you can afford comfortably and what delights you. Don't think about selling-on value or name recognition to show off. Choose what you love. No matter the price, to you it will be priceless.

Art History as Mystery

New Discoveries (and What Happens When the Experts Get It Wrong)

Key work: *Saint Sebastian*, attributed to Leonardo da Vinci

THE DRAWING CERTAINLY LOOKS RIGHT. IN PEN AND INK AND LIGHTLY SHADowed, it portrays an anguished-looking Saint Sebastian tied to a tree, wide-eyed and wild-haired, before being shot through with Roman arrows for being a Christian who refuses to convert. (Miraculously, he will survive the arrows, though later he was clubbed to death, according to *The Golden Legend*.) The saint is naked, aside from a loincloth, his neck craned toward the heavens, arms bound behind a serpentine-bent tree trunk, awaiting the bite of the first arrow. Interestingly, Leonardo could not decide whether the saint's right leg should be bent at the knee or leaning extended across the left, so he drew both. The flip side (the verso, as opposed to the recto side of the drawing) contains some optical studies (line and planes) and some sketches of light and shadow (crosshatching), as well as text that appears to be in Leonardo da Vinci's hand.

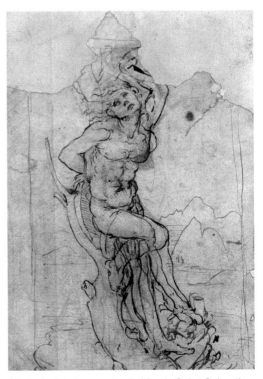

Attributed to Leonardo da Vinci, *Saint Sebastian* (circa 1520). PHOTO COURTESY OF WIKICOMMONS.

The drawing has been called "quite incontestable." The French government agrees, calling it a "national treasure," a "rare item" that "is a precious testimony to the genius of Leonardo da Vinci." Much is in the balance. To find a new Leonardo is to strike the purest vein of gold in the art world. There are but a few dozen of his works worldwide, and, as noted in chapter 8, one of them sold in recent years for more than any other artwork in history. Leonardos have become a cultural currency, so to have discovered a once-lost drawing is a position of enormous potential power—if it is authentic, of course. The French seem to think so, but are they right? And how can they be sure?

When a doctor brought in a package of fourteen drawings collected by his father to the Tajan auction house in Paris in March 2016, they were shown first to the house's Old Master specialist, Thaddée Prate, then to a local expert, Patrick de Bayser. One of them stood out from the rest, and by a long margin. De Bayser recalls the moment: "When I saw the work it was mounted, and on the mount was indicated 'Michelange.' When I saw the drawing, I immediately thought, 'It's not Michelangelo, it's Leonardo.' The first thought I had. It's an enormous thing. I look at the drawing itself more precisely. The technique was one I knew, the pen and ink from the first period of Leonardo. I remarked that it was a left-handed work, which I could tell from way the shadows were made." Leonardo was left-handed; his students were not—and left-handed forgers are even rarer than right-handers skillful enough to pull this off. It was a compelling clue: "My first perception was a good one. Then I saw that the drawing was not glued onto the mount, and on the left you could see that it had been turned often. When I turned it, I saw the inverse inscription. When I saw the optical sketch, I was even more certain. I had adrenaline running through me. The text was left-handed."

This particular drawing rang a bell somewhere deep inside this connoisseur's mind—or perhaps soul, if we're being poetic—because connoisseurship is nothing if not a resonance in the soul. It has also become something of a naughty word in art history circles: the deep, innate understanding of an artist's hand, what might prosaically be called getting a "vibe" when confronted with an authentic work by someone whose oeuvre you know inside and out, is dismissed by many as something of a parlor trick. There is an element of divination to the way many art experts describe, or insist on not describing, just how they "know" that a work is authentic.

This attitude ("I know this and you do not, and I'm not bothered to explain myself to the likes of you") can be off-putting and deepen the sense of elitism in the art world. But the art world has always been elite, particularly at the high

end of the trade and in academic fields, where experts dig out trenches of specialization and stave off rivals with weaponized journal articles and acidic footnotes. To be the world's go-to expert in your chosen subject is the goal, and that means that any colleague with a claim to expertise is also competition. When De Bayser wondered if he might have a Leonardo drawing suddenly upon his desk, he logically turned to arguably the leading Leonardo drawing expert in the world, Carmen C. Bambach, curator of Italian and Spanish drawings at the Metropolitan Museum of Art.

Bambach quite literally wrote the book on Leonardo drawings: She organized the catalogue for the Met's 2003 exhibition *Leonardo da Vinci, Master Draftsman*. In the world of Leonardo scholarship, she has perhaps only one peer: Martin Kemp, emeritus professor of the history of art at Oxford University. But while Kemp may be the most prominent Leonardo scholar in general, Bambach is a subspecialist: When it comes to drawings, she's the one to call.

But how, precisely, would her conclusion be reached? How does she determine whether or not this is a Leonardo drawing? More to the point, should we believe her—and what happens if she's wrong?

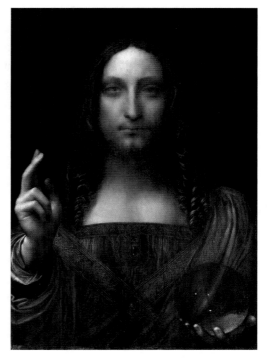

Lost works by Leonardo have resurfaced with encouraging, even surprising, frequency in recent years. In 2005, Leonardo's *Salvator Mundi* was acquired by a consortium of New York–based dealers who had it restored because centuries of grime had clogged its somber beauty. It was so unrecognizable that it had been sold in 1958 for just £45 (around $60), its authorship long forgotten. After featuring in the blockbuster 2011 Leonardo exhibition in London, it was sold to Russian billionaire Dmitry Rybolovlev in 2013 for $127.5 million, which was a record price increase for an artwork (around 283 million percent)—until it sold again, in December 2017, to the Louvre Abu Dhabi for $450.3 million.

Leonardo da Vinci, *Salvator Mundi* (1499–1510). $450.3 million. That would buy you a lot of donuts. PHOTO COURTESY OF WIKICOMMONS.

With *Salvator Mundi*, the work looked good and the provenance checked out. Conservator Nica Rieppi, who examined the painting and corresponded closely with the hands-on team of conservators over several years, reassured scholars, the interested public, and potential buyers that the investigation was undertaken with a healthy initial skepticism that was wiped away by deep forensic analysis—it is her account of its authenticity that reassures me, which is why I take the Prado's estimation that it is by a follower of Leonardo as opinion, not fact. But it was the painting's inclusion in the London exhibition that was the official stamp of approval, guaranteeing its authenticity—and its notoriety.

Traditionally, drawings and prints circulated around collections, and artists often created their own versions of works based on prints and drawings by artists they admired. There are many paintings of *Leda and the Swan*, for instance, inspired by Leonardo's original (which is lost, last seen in 1625 at the Chateau de Fontainebleau in France), with numerous artists trying their hand at copying it. Then there are works created not by Leonardo but by his studio—apprentices, students, and assistants. A copy of *Salvator Mundi* by Leonardo's pupil Salai sold at Sotheby's in 2007 for $656,000. That's a nice chunk of change, but a far cry from $450.3 million. It looks Leonardo-ish, just not as good. Why is this distinction important? From a historical perspective, there are precious few Leonardo paintings that survive: between fifteen and twenty, depending on which scholars you agree with, so any new Leonardo painting is big news. But financially, there is a world of difference. A copy of a lost Leonardo original, even by an established artist like Salai, is worth around 686 times less than the original would be.

———

Before France put a blockade on *Saint Sebastian*, it was due to go up for auction in early 2017, and it would have gone to the highest bidder, likely someone abroad. Bambach would have published the first academic article on it shortly afterward. Most experts I spoke to while researching this essay are convinced: The drawing looks like the real deal, and only a hidden piece of suspect provenance or an awkward forensic test result would trump expert opinion. Belgian conservator Bart Devolder says, "I think they did the right thing, judging from what I read about it. A curator looked at the drawing with the unaided eye, but with lots of experience. Following this, it was shown to Dr. Bambach, which is what I would have done, too. It also seems that the drawing (and the text on the reverse) are such a perfect match with several other sheets that exist, that there is not much doubt." But one prominent Leonardo specialist, who prefers to remain unnamed, is not at all convinced.

It would be nice if Tajan laid all its cards on the table, publishing test results and the complete provenance. But there is no precedent for this in the art trade. The general attitude toward opacity, centuries old, remains: We are the elite experts; we have specialized knowledge that you do not; we will tell you what is genuine and you will believe us. Consider the three steps to the authentication process: connoisseurship, provenance, and forensics. All three bases were covered with *Saint Sebastian*, although precious little information has been made public to date.

The aesthetics are in its favor. For one thing, the drawing doesn't look too perfect, too refined. The artist wasn't sure how he wanted the saint positioned—he drew the legs in several different positions, as well as the tree before the saint (we can see lines delineating the tree trunk through those that define the saint's legs). As the *Guardian*'s art critic Jonathan Jones pointed out, the sketch has "blobs of ink . . . gathered on the figure's raised arm, and also to form his dark, shadowy belly button. That pooling of ink is so Leonardo. To me, that's a massive clue." He's right, but also correct in his use of "to me," because aesthetic judgment calls are notoriously subjective. Recall that some past connoisseur wrote "Michelange" on this very drawing, thinking the contorted pose more resembled Michelangelo than Leonardo. But those are the details that distinguish authorship and help determine that a work is not a copy. A copy, made when looking at a finished original, will be more studied, carefully drawn, less likely to feature drips, splotches, and scribbles.

There are similar, established works by Leonardo to which this can be compared. He is known to have sketched in a similar manner, with shifts in positioning (as in Saint Sebastian's legs) drawn onto the same picture. A drawing of a horse with multiple leg positions comes to mind, as well as his most famous drawing of all, *Vitruvian Man*. Then there's the fact that recto and verso were used. This is not unusual—vellum paper was a prized commodity in the Renaissance, and all parts were used whenever possible. But the combination of a preparatory sketch for a painting on one side and optical diagrams, plus Leonardo's distinctive handwriting, on the other adds to the aura of authenticity.

If a work like this satisfies the expert's naked-eye scrutiny, then it goes on to the second test of authenticity: provenance research. Historical documents suggesting the object fits into known history—that there is some trace of or reference to its having existed—lend credence to the possibility that it is a lost work, now found. *Saint Sebastian* fits the bill in the latter category. In one of Leonardo's notebooks, called the *Codex Atlanticus* (filled between 1478–1519), he mentioned eight drawings of Saint Sebastian made in preparation for a painting of the

subject that he would never complete. One of those eight drawings is extant (at the Hamburg Kunsthalle). This would appear to be another of them.

The ownership history trail remains obscure to the general public. Tajan will have looked carefully at the doctor's story, at whether it added up that this was one of fourteen drawings collected by his father, and will have tried to learn as much as possible about the chain of ownership from Leonardo's studio to the present day. The more background an auction house can fill in, the more interesting the item (perhaps it played an important historical role, passing through major collections), and also the safer the purchase appears, for a thorough backstory reassures that the object is neither forged nor stolen. De Bayser does not know the whole story, but he immediately saw clues as to the provenance in the object itself: "The other 13 works in the same collection were also Old Master drawings, some of them are copies, two or three are quite good quality, but we don't know the artist yet. All on the same mount, which is interesting for the provenance. All the mounts seem to be circa 1900, they all have the same hand inscription on the mount. The drawing comes from an album, because on the stretcher you can see that it was cut down and taken from a larger album. This means that there must be other drawings from the same collection and the same mount. But I didn't find any myself." Since the provenance findings have not been made public, we can only assume that Tajan has done its proper due diligence.

The final hurdle in establishing an artwork's authenticity is forensic. An array of noninvasive scientific testing methods is available that can help assure an object's age, but these cannot guarantee authorship. Perhaps surprisingly, forensic testing is rarely turned to in the art trade, even with extremely expensive items like this one. If an object looks good and the provenance checks out, then it is usually accepted as genuine and sold. Forensic testing usually takes place when some red flag is raised in the connoisseurship or provenance studies, or if someone who acquires it later grows suspicious. In this case, *Saint Sebastian* was likely tested at the Louvre last November: "It was listed as a 'tresor national' by the Ministry of Culture shortly after, we can assume the results were positive," says De Bayser. Besides, the government wishing to keep the work in France would have wanted to confirm its authenticity before committing tax money to purchasing it.

Forensic tests are best at spotting anachronisms, details that might give away an object's imposture, like some pigment or material found in an artwork that postdates the period in which the work was supposedly created. Forger Wolfgang Beltracchi, for instance, was caught when titanium white, a modern substance, was found in a painting ostensibly created before titanium white was available.

Testing can also date organic material (like paper) to a certain period, often accurate to within a few years. What forensic testing almost never does is guarantee authorship. It is better at weeding out than honing in. Presumably, when this work was tested, no flags were raised—everything dated as it should to feasibly allow authorship by Leonardo. Effectively, science offered a double-negative to support the conclusions of the connoisseurship and provenance examinations.

But art history is pocked with compelling copies, often by members of an artist's studio, as well as forgeries. Katy Blatt wrote a book dealing with questions of originality and differences in two versions of Leonardo's *Virgin of the Rocks*—both by Leonardo. Even when works are considered authentic, publishing forensic results proving what experts have long thought can be a good PR move. As Blatt told me, "Historically the second *Virgin of the Rocks*, at the National Gallery, London, has been seen by scholars as a lesser copy. Of course, it was in the interests of the National Gallery to have their version of

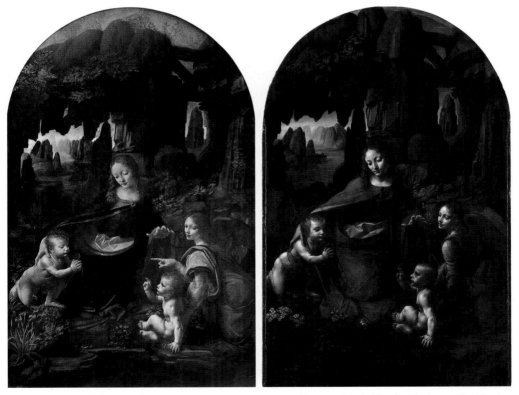

Though it sounds like a cocktail, these are two versions of Leonardo da Vinci's Virgin on the Rocks (oh, sorry, *Virgin of the Rocks*). The lighter version is in the Louvre Museum and was painted in 1483–1486. The darker, more ghostly version is in the National Gallery in London and was painted from 1495 to 1508. PHOTOS COURTESY OF WIKICOMMONS.

the *Virgin of the Rocks* authenticated; it was helpful to maintain their standing as a global center for art treasures; and it certainly boosted their ticket sales (the 2011 Leonardo exhibition attracted 323,897 visitors, more than six times the numbers normally admitted to exhibitions)."

Concern was such that *Salvator Mundi* might not have been the real McCoy that the scholar Jehane Ragai added a section on it to the second edition of her book *The Scientist and the Forger*. Books such as these, and Bambach's work on Leonardo drawings, are there to set the record straight and help others identify the truth—they contain images and descriptions of generally authenticated works and can function as manuals for hunters of lost Leonardos, presenting examples before which any new find claimed to be an authentic Leonardo will have to pass muster. But it is not uncommon for scholars to disagree about authenticity, hence muddying the waters and leaving room for interpretation. Art history is an inexact science, with a measure of subjectivity, of that divination, still very much present and respected, sometimes with millions in the balance, hanging on opinion.

—✦—

When Patrick de Bayser called Carmen Bambach—whose informed, yet inevitably subjective opinion can add so many zeros to the value of an artwork—she proclaimed the *Saint Sebastian* drawing to be "quite incontestable." It was, she added, "an open-and-shut case." Most of the world agreed, but it was her revered opinion among Leonardo scholars that propelled agreement. France was all in. On January 5, 2017, the Ministry of Culture announced a temporary export ban on the drawing, giving it thirty months to match the €15 million (around $16.8 million) asking price and win first dibs on buying it. It failed to do so, and the drawing was auctioned in 2018.

It would be nice if the provenance and forensic test results were published alongside every artwork of significant value prior to its sale. But this is not always the case. Owners and dealers are notoriously reticent about provenance, considering it a private matter—but in recent years the most conscientious members of the art world have taken care to be transparent and publicize as much of an object's history as is known, thereby demonstrating that there's nothing to hide. It remains unusual for forensic test results to be made public (if they are made at all), but they remain the most compelling way to ensure that an object is not a forgery: Almost no fraudsters in history have bothered to create forgeries that would fool conservators in their labs. They don't have to. If the work and the provenance (which, alas, can also be forged or doctored) both look good, forgers know that it is highly unlikely that the work will be tested at all.

One thing is for sure: the French government has given the drawing its stamp of approval, which means that the world believes this to be a Leonardo. The government's entire decision, and the attempted €15 million investment, rests largely on the personal opinion of a single expert, Bambach. "My heart will always pound when I think about that drawing," she told the *New York Times*. That is not to say that she is wrong. But for all the technical gadgetry available, art world decisions still rest largely on the subjective conclusions of individual, ultimately fallible, specialists. In our modern society of CSI and DNA evidence at trial, the general public is more comfortable believing forensic results over personal opinion. Yet personal opinion has dominated the art world for millennia and continues to play the strongest role.

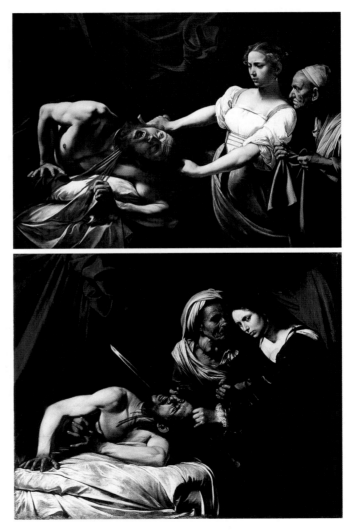

Here is an authenticated Caravaggio *Judith and Holofernes* (circa 1602) and a version of the painting discovered in an attic in Toulouse and thought by some to also be by Caravaggio, while others question the attribution (some suggesting the artist is Louis Finson, and the work is a copy of Caravaggio's original, made anytime from 1598 to 1610). Compare them also to the version by Artemisia Gentileschi we saw in a previous chapter. PHOTOS COURTESY OF WIKICOMMONS.

There is much hanging in the balance for only a "feel" as guide. In 2008, what appeared to be a newly discovered Caravaggio, a second version of his *Judith and Holofernes*, was discovered in someone's attic in Toulouse, France. But scholars were divided as to its authenticity, which remains in question. As we have seen with the acquisition of *Salvator Mundi* by a Saudi billionaire, Leonardo's works have become trophies that indicate cultivation, wealth, and cultural preeminence. To own a Leonardo is the highest sign of erudition. The fact that *Salvator Mundi* is, by several hundred million, the world's most expensive artwork, is seen as a bonus in a world in which superlatives summon the most headlines, and where wealth and cultivation are thought to go hand in glove. Now the Louvre Abu Dhabi has its iconic showpiece, effectively putting Abu Dhabi on the high-culture map. This was a clear desire from the moment the emirate struck a deal with the Louvre, that highest of high-culture institutions, to open a branch there. The Louvre Abu Dhabi itself is the throne, and now it has its crown. With only a few dozen works across the globe certain to be by Leonardo's hand, even a relatively simple and small drawing, like our *Saint Sebastian*, bears a weight of expectation—and quiet desperation—for its authenticity far greater than its few grams of mass.

The Future of Art

Key work: Refik Anadol, *Quantum Memories*

Art's getting weird. How's that for the introduction to a conclusion? The **Postmodern** era (the 1980s to the present) is marked by proactive attempts on the part of artists to do what has not yet been done. In keeping with the Duchampian trajectory discussed in chapter 2, artists focused on work that was interesting but not necessarily beautiful or "good." **Video art** was one direction, embracing the newly accessible culture of home videos. This sometimes took the form of high-end, beautifully filmed features, as in Matthew

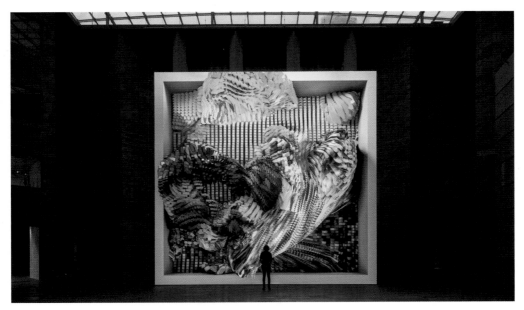

This is the newest artwork that totally floored me. I could write a book about it. *Quantum Memories* by Refik Anadol (2021) is a kinetic painting, sculpture, piece of architecture, video art . . . and much more. PHOTO COURTESY OF REFIK ANADOL AND PHOTOGRAPHER TOM ROSS.

Barney's haunting *Cremaster Cycle* (1994–2002), or as enthusiastically amateur-looking VHS cassettes like Bill Viola's *Reverse Television* (1983), a movie of people watching video cameras as if they were watching television. Another was Body Art, in which the artist used (sometimes sacrificed) their own bodies, often in painful ways, as when Stelarc did one of his *Suspension* performances, piercing his body with metal hooks and hanging from the ceiling supported by them. **Conceptual Art** is the catchall term for the Duchampian, interesting-only avenue. **Avant-Garde** is another term for anything that is new and tests the boundaries. Piero Manzoni released *Artist's Shit* (1961), discussed in chapter 6, consisting of cans of the artist's own poo. (I warned you it gets weird.) Conceptual and avant-garde, but how interesting is it?

Perhaps the most interesting of the new movement is performance art. This involves artistic actions that are durational—instead of making a sculpture once that can be looked at forever, these performances take place in a specific location on specific dates for a specific number of hours, and that's it. You were either there or you weren't. The only relics of them may be videos or photographs of the performances or objects used within them. Joseph Beuys was a German artist who helped to establish performance with famous works like *Coyote: I Like America and America Likes Me*. This took place over three consecutive eight-hour days in May 1974 at the Rene Block Gallery in New York

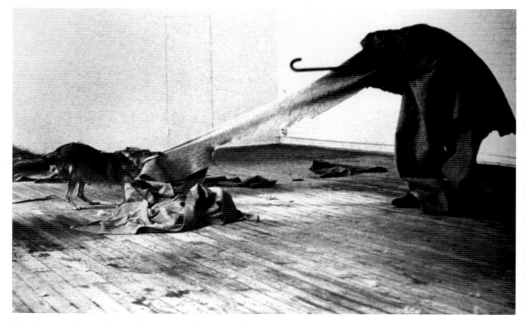

Photograph from the performance *Coyote: I Like America and America Likes Me* (1974) by Joseph Beuys. One of the few relics of durational performances. PHOTO COURTESY OF WIKICOMMONS.

City. The artist spent those hours wrapped completely in a felt blanket, holding a shepherd's crooked staff, while a wild coyote roamed around the room, which otherwise contained hay, piles of *Wall Street Journal* newspapers, and an old hat from a fancy London hat shop.

This is totally weird, of course, but I like it. There was a tension throughout, as this was indeed a wild coyote and at times it looked like it might attack Beuys. (It tore off part of the artist's glove and tried to rip the felt blanket off him.) Coyotes also have symbolic meaning in North American native cultures, representing the Loki-like trickster, and there are myths about how coyotes taught humans how to survive. Beuys saw this as America's spirit animal. But it's a loaded term. In slang, a "coyote" is a smuggler of human beings from Mexico into the United States. It's a clever performance, with tension and interesting, memorable (if not beautiful) images (who can forget a man pancaked into a blanket waving a shepherd's staff at a coyote?)—and it makes you think.

Photograph of the performance combined with kinetic sculpture called *Silenzio: Eternal Loopholes and Braided Line* (2017) by Meta Grgurevič. PHOTO COURTESY OF META GRGUREVIČ.

But part of what is new in art is crossing disciplines, media, boundaries. Video artist Christian Marclay's 2010 film *The Clock* is a montage of scenes in various films that include a clock or a watch. The film is exactly twenty-four hours long. It is video art. It is durational performance. It makes you think.

Slovenian kinetic sculptor Meta Grgurevič is a category smasher. She makes sculptures that move, so you must observe them over time as they engage in or complete a cycle of movements. Moving sculptures were dabbled with as far back as the Renaissance—Leonardo da Vinci is supposed to have invented a mechanical lion that could open its maw and present a bouquet of flowers within it, and mechanical clocks equipped with moving metal statues were erected in places like Orvieto. But what was, in retrospect, an obvious-sounding concept—moving statues—has been little used by artists. Grgurevič's installations are like elaborate mousetraps, every component of which she makes by hand, and they sometimes integrate performance. In the case of *Silenzio: Eternal Loopholes and Braided Line* (2017), the kinetic sculpture could be visited throughout its exhibition, but there was also a one-time durational performance featuring Grgurevič and the artist JAŠA (lying on the floor in the photo of the work).

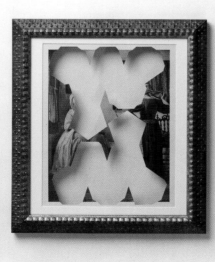

Letter by Meta Grgurevič (2021). Is it a print? A sculpture? You betcha. PHOTO COURTESY OF META GRGUREVIČ.

Another of her works, *Letter* (2021), blows up the concept of artworks being limited to any one medium. It consists of an antique print into which Grgurevič intervened, cutting it out and creating an origami-style faceted polygon out of it. This polygon, a sculpture made of paper, is displayed beside the framed remnants of the print, held in place by a brass socket that is invisible when looking at the work from the front. The result is a hybrid print/sculpture, with the polygon having "escaped" the frame, appearing to move away from it or float beside it. It gives the illusion of something kinetic, though nothing actually moves. Is it a print? A sculpture? An avant-garde conceptual installation? Yes.

The key work of this chapter, an installation by Turkish artist Refik Anadol, embodies the future of art. It is an enormous digital screen measuring 10 by 10 meters, dwarfing those who stand before it. The monumentality of the screen makes it a sculpture crossed with architecture, even if it is turned off. But when it is turned on, it shows an undulating, morphing cascade of colors that appear to flow and splash out of the screen, giving the illusion of not only three dimensions but of "breaking the fourth wall" and flowing out of the frame of the digital screen. This works because the white frame we see around the edges of the screen isn't an actual frame but a digital image of a frame. This recalls the Magritte painting *The Treachery of Images*, which we encountered in chapter 2. It's not a pipe, it's a painting of a pipe. This is not a frame, but a digital image of a frame that the digital "painting" within, moving like a kinetic sculpture, appears to splash past on its way to soaking the viewer in bright paint. Is it painting, sculpture, video art, installation, durational performance with no performers? All of the above.

Postmodernism is about defying definition. We may be past the postmodern era. (Cultural critics love to debate this sort of thing. I can't really be bothered, because the terminology is just a shorthand and doesn't tell us much of anything; it's each object that should be considered on its own.) So what comes next?

Particularly emerging from the enforced isolation of the pandemic in 2020, the consumption and creation of art have shifted away from public gatherings, gallery openings, and work in busy studios and toward working solo and presenting exhibits virtually. There will be plenty of the old-school approach returning when the pandemic allows (as I write this, in 2021, the situation is not yet back to anything like "normal"). But just as the pandemic opened up the option of remote work for the business sector, it likewise did so for art. Exhibits have gone virtual. Buying has gone remote, with purchases made online. Even the art itself has gone digital, with NFTs rising in tandem with lockdowns.

Crypto wallets like Exodus are incorporating NFT galleries, so that you can acquire digital art with digital currency, like Bitcoin and Ethereum, and display it in a digital gallery within your digital wallet or on your digital television. That's a lot of digital, I know, but that's the key word of the future of art.

But while the newest of the new is virtual, the pleasure in analog, traditional art remains. When the Renaissance launched an interest in the avant-garde of the fifteenth century, single vanishing point perspective and foreshortening, it didn't mean that Gothic-style painting and religious icons vanished. They remained, just overshadowed by the dazzle of the new. There are still artists who paint traditional icons, and there is a market for them. They just cease to be newsworthy and tend not to get attention if they are not doing something groundbreaking. It is the same with analog photographs. The silver gelatin prints of great twentieth-century photographers like Robert Doisneau, Henri Cartier-Bresson, and Brassai still have a market, and contemporary photographers still take and develop such works. Photographer Borut Peterlin specializes in archaic nineteenth-century photographic techniques today, even as photographer Matjaž Tančič makes headlines taking the first three-dimensional digital photographs in North Korea. You can't spell "news" without "new," but high-quality works in styles and media of the past endure.

The most important lesson: what you like is up to you. Don't feel any silly peer pressure to like what's edgy. If you dig Mannerist Florentine oil-on-panel paintings (my favorite), then let it be your thing.

Here Is Your Hogwash Horn

Don't be afraid to call "hogwash" (or its synonym, BS) on artworks that you've given an honest chance, that you've examined with an eye toward liking, but which, in the end, you just think are hogwash. I do it all the time. The percentage of contemporary of works that impress me is very small indeed. Part of this is because I'm old-fashioned and prefer the Aristotelian approach to art. I want art to exhibit skill and to be beautiful *and* to be interesting. But part of this is because too much of the art I see today is trying too hard. Usually, it is trying to be notable, which means proactive attempts at shock—violence, sex, intentional ugliness, projectile bodily fluids. The internet provides a tsunami of information and images every day. Social media drowns us in it. In order to stand out, to not be lost in the crush, artists—and everyone else, for that matter—must be loud. If you want attention, you have to do things that grab attention. Subtlety is no longer an effective approach. And so we find too many artworks that are the creative equivalent of one of those boat safety horns: You press a button and

they make the loudest, most look-at-me sound you can imagine. Once they have your attention, it's a real question as to whether or not they reward it by showing you something of merit.

There are works of art these days that cross genres or invent new ones. An art group called IRWIN have an ongoing, careerlong concept that has resulted in books, installations, exhibits, and performances. Called *NSK State*, they invented a country, NSK (which stands for *Neue Slowenische Kunst*, "New Slovenian Art" in German). They printed stamps and currency for this fictitious state and set up a performance at the Venice Biennale in which refugees were tasked with issuing passports to visitors, inverting the cliché of the European elite deciding which refugees are permitted entry into a country. It was total genius, but what genre, medium, or *-ism* is it? It is many and none. The point is that it's useful to know the *-isms* of the past, but each new work you encounter should be considered on its own. Does it move you in some way, make you feel different than you did before your encounter with it? Does it make you think about things you hadn't thought about before you saw it? If so, it is successful, and it is "safe" to like it.

You have the subtlety of IRWIN on the one hand, while on the other you have actions like this: Russian artist Pyotr Pavlensky got naked, went to Red Square, and nailed his scrotum to the cobblestone ground. An extroverted artistic action, a durational performance, an attempt at shock art—but beyond the shock (and wincing), what's there? For this art historian, the answer is "nothing much." It's a way to get attention—it made international headlines—but as a means to protest against the government (as Pavlensky explained was his intent), I'm not sure what it accomplished or how we, the public, were enlightened by it.

So now that you know a good deal about art—much more than most—I hereby grant you your "hogwash horn" and license to use it as you see fit. Dismissing something out of ignorance or fear is deeply uncool. But now that you know your way around the art world, feel free to dismiss what doesn't suit you, since you are now armed to do so with intelligence and context.

WHAT TO DO WITH YOUR REMAINING HOURS

Check the clock. I'm guessing that reading this book took less than twelve hours. That's cool. If you have extra time, there is more you can do to augment your immersive first dive into art. And there is no need to stop at twelve hours. That was just a convenient (and hopefully catchy) affectation for the title of this book. Let this be your first day in the warm, alien waters of art, full of strange

fish. The more exposure you have to art, in any capacity—visiting exhibits and museums, reading books, watching documentaries, making art yourself—the deeper your understanding will be and the more pleasure you'll derive. As your comfort increases, inhibitions recede and you'll find yourself entirely comfortable swimming, even with all those crazy-looking creatures in the waters around you.

On my website (www.noahcharney.com), I've provided a list of recommended reading, viewing, and doing for your next "day" in the art world. But there's not a thing that you "must" do, read, or watch. Art should be a pleasure and a positive stimulation. If it's not, if it feels like work, then why bother? So let your enthusiasm be your guide. Digging pre-Columbian figurines? Prefer NFTs of exploding cartoon kittens? Whatever you're into is good and okay and right for you. Run with it.

Three, two, one . . .

Now *go*.

Notes on Sources

You'll notice that this book contains neither citations nor a bibliography. That is by design. Since this is to be a first stop for those interested in learning about art but perhaps previously intimidated to do so, I decided to keep it streamlined and chill, uncluttered by citations, which are primarily used by researchers and scholars to delve deeper. This isn't the book an art historian will grab off the shelf (though if you are reading this and you're an art historian, sweet—lets go for a beer). This is for potential and novice art enthusiasts.

I likewise chose not to include a bibliography because it would have either been far too long or far too short. My approach here is a picaresque of stories, ideas, and artworks; a mosaic of hundreds of tidbits from even more sources. Each artwork mentioned would, in principle, need its own clutch of reference books to indicate where their stories were previously mentioned. With around one hundred images included and as many more artworks referenced, that would make for an elephant of a bibliography.

In lieu of a "selected bibliography," which would likewise not be particularly useful, because there are no books I know of that mirror this one enough to mention them as singular references throughout, I'll place here some suggestions for further reading if, as I hope is the case, this book has whetted your appetite to engage more with art.

What follows are some suggestions for next ports of call.

The Books from Which I Learned Art History 101

Ernst Gombrich, *The Story of Art* (Phaidon, 1995)

Frederick Hartt, *Art: A History of Painting, Sculpture and Architecture* (Prentice-Hall and Harry N. Abrams, 1989)

Fred S. Kleiner, *Gardner's Art through the Ages* (Cengage Learning, 2019)

Alternative Art History Starter Books

Julian Bell, *Mirror of the World* (Thames & Hudson, 2010)

David Hockney and Martin Gayford, *A History of Pictures* (Abrams, 2016)

Hal Foster et al., *Art since 1900* (Thames & Hudson, 2016)

Kelly Grovier, *A New Way of Seeing* (Thames & Hudson, 2018)

Ossian Ward, *Ways of Looking: How to Experience Contemporary Art* (Laurence King, 2014) and *Look Again: How to Experience the Old Masters* (Thames & Hudson, 2019)

James Fox, *The World According to Color: A Cultural History* (St. Martin's Press, 2022)

Shameless Self-Promotion (Selected Other Books of Mine)

The Devil in the Gallery: How Scandal, Shock and Rivalry Shaped the Art World (Rowman & Littlfield, 2021)

Making It: The Artist's Survival Guide (Rowman & Littlefield, 2021)

The Art of Forgery: The Minds, Motives, Methods of Master Forgers (Phaidon, 2015)

The Museum of Lost Art (Phaidon, 2018)

Collector of Lives: Giorgio Vasari and the Invention of Art (W. W. Norton, 2017)

Stealing the Mystic Lamb: The True Story of the World's Most Coveted Masterpiece (PublicAffairs, 2010)

Index

About the Author

Dr. Noah Charney is the internationally bestselling author of more than a dozen books, translated into fourteen languages, including *The Collector of Lives: Giorgio Vasari and the Invention of Art*, which was nominated for the 2017 Pulitzer Prize in Biography, and *Museum of Lost Art*, which was the finalist for the 2018 Digital Book World Award. He is a professor of art history specializing in art crime, and has taught at Yale University, Brown University, American University of Rome, and University of Ljubljana. He is founder of the Association for Research into Crimes against Art (ARCA), a groundbreaking research group (www.artcrimeresearch.org), and teaches in its annual summerlong Postgraduate Program in Art Crime and Cultural Heritage Protection. He is a regular on television and radio, presenting programs for the BBC and Discovery, among others, and his TED Ed videos have been viewed by millions. He writes regularly for dozens of major magazines and newspapers, including the *Guardian*, the *Washington Post*, the *Observer*, and the *Art Newspaper*. His other books published by Rowman & Littlefield include *The Devil in the Gallery: How Scandal, Shock and Rivalry Shaped the Art World* and *Making It: The Artist's Survival Guide*. He lives in Slovenia with his wife and children and their hairless dog, Hubert van Eyck (believe it or not). Learn more at www.noahcharney.com.